THE ART OF
TRACEY EMIN

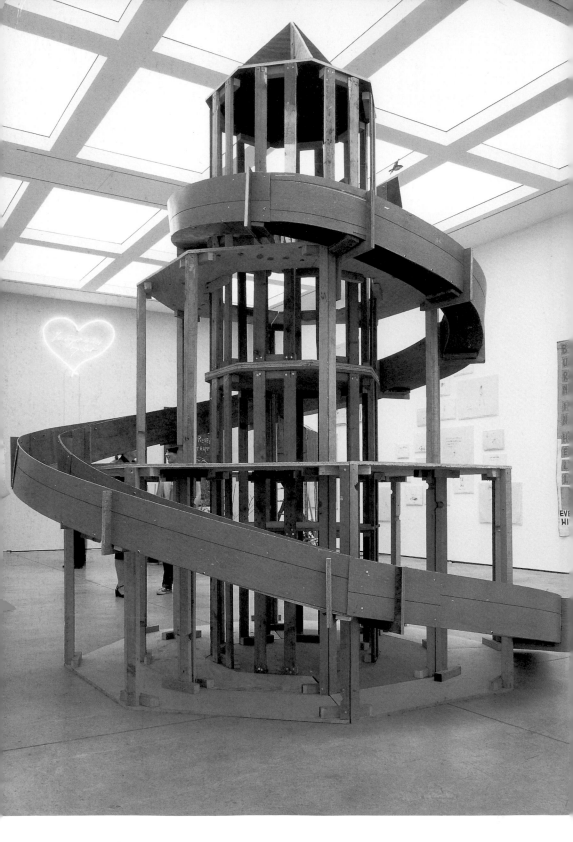

THE ART OF
TRACEY EMIN

edited by

Mandy Merck and Chris Townsend

with 54 illustrations

Thames & Hudson

CONTENTS

Frontispiece
Self-portrait, 2001
reclaimed timber and sparrow
365.7 x 355.6cm (144^{1}/$_{10}$ x 140in)

First published in the United Kingdom
in 2002 by Thames & Hudson Ltd,
181A High Holborn, London WC1V 7QX

www.thamesandhudson.com

British Library Cataloguing-in-Publication Data
A catalogue record for this book is available
from the British Library

ISBN 0-500-28385-0

Printed and bound in Singapore
by C.S. Graphics

EMINENT DOMAIN
The Cultural Location of Tracey Emin

CHRIS TOWNSEND AND
MANDY MERCK

A collection of critical essays on the most famous living artist in Britain, a celebrity more familiar to us from television and the tabloids than the fine-art library, is a risky business. 'High art lite', as its detractors term the young British artist (yBa) phenomenon, has given rise to a corresponding critical brew, in which the writer seeks to engage a vastly enlarged public, and elude Pseuds' Corner, by streetwise straight-talk about stuff working OK as art. The principal publication devoted to the work of Tracey Emin to date contains three essays. The first begins: 'Tracey Emin has big tits and comes from Margate.' The third is titled 'Just How Big Are They?' The one in the middle is headed by an epigraph from Emin opening with 'I feel terribly depressed... I'm starting to panic... It's quite obvious I'm useless.' Tits 'n' terror are not irrelevant to the work of an artist who draws female nudes and writes meditations on panic. The nudes may represent the artist's body and the poems describe her state of mind, or they may not. But drawing and writing are neither flesh nor emotion, and the apparent immediacy of Tracey Emin's work is both artful and ambiguous, the product of formal, technical and generic strategies that are anything but unmediated.

This was wholly ignored in the critical reception of Emin's best-known work, *My Bed*, 1998, as it was installed at the Tate Gallery during the exhibition of Turner Prize nominees in 1999. That work became the source of comment both through interpretations that authenticated the object as Emin's real bed, rather than a constructed artwork, and the emotional and material disturbance associated with it. That a work of art could be received in this manner displayed an extraordinary naïveté – or feigned ignorance – on the part of the critics, particularly since Emin had already

alluded to the degree of its constructedness in an interview, remarking that she was making the work to represent particular situations and feelings. (*My Bed*, in the best tradition of young British art, was received as an overnight sensation on the occasion of its Tate installation, despite its prior exhibition in both Tokyo and New York). However chaotic it may have seemed, *My Bed* was *made*.

Central to the critical purpose of this collection of essays is an examination of the extent to which meditation and construction are true of Emin's work in general. That the work is thought, and at times complex in the multiplicity of its meanings, challenges easy reception of Emin's oeuvre as immediate and unproblematically autobiographical. Such an appeal is, of course, a reprise of persistent strategies of representing, and living, the artistic life. As Peter Schjeldahl remarks: 'It is a recurring project of modern youth... to seize on and interpret the basic experiences of living, particularly love and death, as if they were being experienced for the first time, as if no one ever lived, loved, died before. It usually follows social changes that make its presumptions largely correct: no one ever lived, loved, died in quite this way before.'[1] Writing about Edvard Munch – one of Emin's great influences – Schjeldahl accurately divines a recurrent strategy of repetition and difference that informs self-representation. That Emin's work is made and thought does not deny its authenticity or its affect, the reality of the experience it conveys; that it is a reprise of the bohemian injunction that 'thou shalt write thine own life'[2] does not diminish its originality for our time. Indeed, we might, after the reflections of these essays, understand that Emin's work is far more sophisticated, and far more likely to endure, than if we apprehend it in the credulous and superficial perspective from which it is more usually approached.

Where the work of an older or male artist might be read less confessionally, Emin's age and gender, combined with her thematization of intimate relations and artistic production, make her a spectacular emblem of her own oeuvre. In electing to work in media such as video, to model fashion and appear in advertisements (1), she has gone with the grain of mass celebrity, reaching a status previously unimaginable for a contemporary British artist. For much of this audience, Emin is 'modern art' in all its provocation and newfound popularity. In this sense she is genuinely eminent

– prominent, distinguished, remarkable – as well as in the term's more narrowly legal application: 'eminent domain' is the power to take something previously conceived as private property into public use. Although Emin was a somewhat marginal figure in the founding of the young British artists, she has exceeded the movement's wildest dreams of promotional success, while developing and challenging the complex forms of repetition that characterize so much of its work.

For a movement so relentlessly appraised in terms of novelty, and however problematic their affinities as 'a movement', the yBas seem to depend markedly upon strategies of the 're'. Think reprise; think reply; think repeat; think reinterpretation. Whether it was a recycling of earlier themes and subjects (Rachel Whiteread's and Bruce Nauman's treatments of 'negative' space, Ron Mueck's and John de Andrea's imaginations of the body) or a reiteration of strategies of exhibitionism (Hirst and Warhol, Hirst and Dalí) and exhibition (the artist staged shows of the late 1980s and early 1990s in ephemeral London spaces reprising the activities of New York in the early 1970s which reached their zenith in that 'apotheosis of the crummy space', as *Artforum* called it, the opening of P.S.1 in 1976), the yBas insisted on the re-presentation of representation, non-representation and conceptualism. We might even understand those jamborees staged by the late Joshua Compston – now collectively known as the 'Fêtes Worse than Death' – as going some way in reiterating an impulse towards a self-awareness of artistic community that had previously manifested itself in Gordon Matta-Clark, Caroline Gooden and Tina Girouard's 'Food'. For a moment, back then, and perhaps the memory is both too recent and too clouded by the sense of fun that pervaded that time, Shoreditch and Hoxton (ShoHo) replayed SoHo in the early and mid-1970s. To this accumulation of 're' we might add, with less historical specificity, the Chapman brothers' strategy of shock as both knowing replay of the modernist desire to 'épater le bourgeois' and recycling of a wonderfully vicious streak of satire that has characterized certain, often marginalized, tendencies in British art since the eighteenth century. Add too the critique of canonized artists through the reprise of their work or their strategies: Martin Creed's institutional and economic ironization of Duchamp and Manzoni (the ultimate ironists) – the volatility of their interventions in spaces and economies

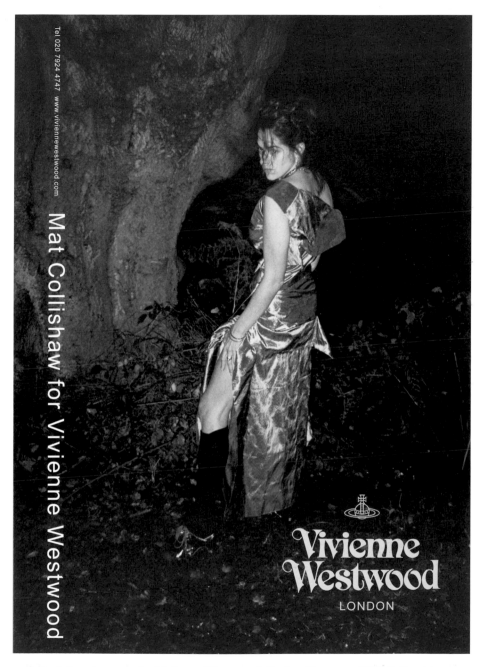

Mat Collishaw for Vivienne Westwood

Vivienne Westwood
LONDON

1 Advertisement for Vivienne Westwood, Spring/Summer 2001 Collection
November 2000
photograph by Mat Collishaw

of art defused by official sanction within both space and economy – or Glenn Brown's depthless photorealist pastiches of Frank Auerbach's painstakingly realized 'in-depth' portraits.

How, and where, does one place Tracey Emin in this matrix of doubling, this folding-in of practice upon itself? There are few knowing smiles within, or about, Emin's work. Rather, in the decade or so of its reception – years characterized wherever possible by a glib rejection of both representational and theoretical depth and a privileging of surface that, had it even been theorized that far, would have done Frank Stella proud – Emin's oeuvre has been offered to the world with the tear-stained and torn guarantee of authenticity. What is there of the 're' in this proliferation of work and media, seemingly rough-hewn from feral existence to tell, with its furious insistence on the artist's past and present experience, how the life was, or is, lived?

Emin has consistently put herself in the line of fire in defending, discussing or promoting her work, and since so much of that work is so readily appreciated as being 'her', that convergence of biography and creativity has, in an age of ubiquitous celebrity, configured her as Britart's very own. Emin is that figure – the art voice and face – to whom editors in television and the press, to whom ad-agency account directors, turn to direct speech towards a particular constituency, to introduce variety and controversy to the gameshow that passes for British culture. We might recognize, perhaps, a strategy of self-promotion in all this: a reiteration of the 'famous artist' pose cultivated by Warhol and Dalí, and reprised to a degree, in Emin's own generation and locale, by Damien Hirst. There are, however, even in this contingency, a number of qualifications to be made. Warhol and Dalí never promised depth, any more than Jeff Koons or Hirst do; Emin proffers the cut, the wound, a still suppurating incision into body and soul. Warhol et al exude 'cool' or, in Dalí's calculated example, a 'mondo bizarro' lifestyle designed to exploit an established perception of the artist as 'wacko': theirs is an art of detachment and consciousness, just as Gilbert and George, micro-celebrities and saving graces to the British art world for the two largely dismal decades prior to the yBas, had practised distance with their uniformity, their suits, their impeccable manners and accents (which the

studied obscenities hyperbolized rather than ruptured). Emin, by contrast, is 'hot': not simply in her current status as media property, but in the temper of her work, with its dependence on what is apparently the spontaneous articulation of anger, rather than rational reaction. Where Dalí played the world for laughs, Emin's approach to the public persona of the artist is to take it all very seriously indeed. That seriousness does not, however, seem to extend to composition: the work is urgent, quick in its transmission of emotion, and part of its urgency seems to derive from hurried production. Even in her public life, to contrast Emin to her near neighbours Gilbert and George, where the dynamic duo are, literally, 'buttoned up', Emin will be stepping out in a glamorous dress (probably by Vivienne Westwood).

Famous though she is for being famous, Emin is not following the prescribed model for artistic celebrity. Indeed, even as she practises it, she inverts it. Those strategies – inversion, intensity, instantaneity – suggest that, rather than being a practitioner of the 're', Emin is in with the 'in' crowd, an expression of profound distinction in a group of young artists who have distinguished themselves, appropriately enough for a generation that grew up in front of British television, as purveyors of the repeat. However, we might, especially after reading certain of the essays in this collection, want to include a few more 'ins' as signs of Emin's difference. These are 'ins' that not only seem to challenge the pervasive notion of unthinking immediacy propagated by newspaper critics too lazy to read beyond the press releases, but which also open up readings of Emin's work that reveal its contingencies with the larger constituency of the yBas. Think 'introspection', think 'intention', think 'intelligence' and – conditioned as we are by the proliferation of her mass-mediated presentations as 'Mad Tracey from Margate', the erratic, overwrought, oversexed, impulsive woman, rising from her soiled, unmade bed to grab time on a talkshow – we do not readily conjoin these terms to our understanding of Emin's art.

Demonstrating that conjunction – reading the art as well as the publicity handout – is the proper task of the critic. What emerges throughout the diverse studies in this collection is an affirmation of a reflective critical agency that articulates a clear artistic strategy, one which (for here is Emin's contingency to her generation)

reprises canonical tropes with a studied application that is every bit as 'thought', if less transparently ironic, as the practices of Martin Creed and Glenn Brown, every bit as 'meditated' as, if considerably more heated than, the output of Marc Quinn. Emin's reprisal is generally upon Expressionism and modernism, rather than the still ossifying canons of postmodernity (although in this volume Rosemary Betterton establishes a compelling case for a special relationship to recent feminist art), but it is a reprise nonetheless: one effected by strategies of introspection and reflection, reversal and inversion. It is through these practices, the doubling and displacement of earlier artworld forms and agendas, through the application of a critical intelligence, that Emin can perhaps be connected to 'her generation', where she becomes an artist of reinterpretation as much as one of intensity. But they are practices that demand a reading of her work beyond the surface: instead perhaps, they necessitate an examination of the play between surfaces, for repeatedly Emin uses the apparently unthought – immediacy of expression – as a strategy that occults the reality of an ethical engagement both with her own time and personal history, and with the history of art.

Rosemary Betterton's study of Emin's relationship to previous generations of more overtly 'politicized' feminist art is both a critique of those contemporary writers who have seen in the artist's highly personalized approach little more than a fulfilment of apolitical, libertarian agendas, and also a rewriting of the cultural context in which Emin's work is understood. Betterton's analysis of the ways in which Emin makes the personal political – without her ever overtly arguing that it is political – and study of her mediating strategies – the sewn, the handcrafted – demonstrates continuities between the yBa generation and a now largely neglected group of British women artists of the previous two decades. Even as she 'articulates a new kind of independent and iconoclastic femininity in all its complexity and ambiguity', the present substance of Emin's work is inconceivable without the influence of earlier generations of women artists. That Emin's work reiterates many of the same urgent issues of identity and history suggests not that her work is mere pastiche, but that historical circumstances may have changed less than we imagine. Emin's address to history through the personal thus seems like one of those cyclical

revisions of artistic strategy discerned by Hal Foster in *The Return of the Real* – though here thrown forward to be revisionism within the postmodern, rather than the postmodern retrospectively imaging modernity that Foster describes – in which the practicalities of confronting a discourse left unresolved by previous generations are articulated not through novelty but reprise.[3]

'Greedy *Kunst*', Peter Osborne's essay on Emin's *I've got it all*, 2000, suggests that, if there is a context for the artist's work, it is not in that strategic confusion of high and low culture that Julian Stallabrass condemns as 'high art lite'[4] but precisely in the post-Romantic conception of art which the practices of yBa artists are understood, by Stallabrass and others, to displace. As Osborne observes, despite the challenges of semiotic critical programmes and the Duchampian conception of the art object (in both its 'original' manifestation and its contemporary revivals), the inability of these paradigms to account for art's specificity as a cultural form has led to an implicit reliance upon Romanticism for the identity and cultural authority of contemporary art. In his interpretation of *I've got it all*, Osborne makes a case for a fundamental ambivalence in Emin's work, an instability between irony and hypostatization, between flagrant display and solipsism, which is raised to become 'a structuring principle of female existence' through its symbolic condensation into the representational history of her own body. The gathering gesture by the self-representing artist of *I've got it all* is, furthermore, understood as allegorical, representing a drawing-in of all forms of culture onto contemporary art, so that the work is a shimmering multiple portrait – simultaneously signifier of self, reflective representation of the social whole, and exemplar of the reflectivity of the artwork.

Ulrich Lehmann, in his analysis of Emin's relation to the world of fashion and the brand, provides us with an exemplary model of her approach to ethical and figural inversion: the *Kippfigur*. As Lehmann remarks, the *Kippfigur* offers a recognizable image which must be reversed and reread to reveal its counterpart or opposite. Far from being unproblematic novelty or toy, however, the *Kippfigur* bears a moral charge, reminding its audience of an 'uncanny potential' that is masked by the appearance of a superficially satisfying image. Lehmann's essay is, in some senses, a metonym for this entire collection's rereading of Emin as a *Kippfigur* whose moral

economy is concealed behind the superficial lure and reception of her work's 'artless' presentation. Lehmann's specific emphasis is upon the trademark or *poncif* as Emin deploys it, a statement of artistic and personal subjectivity, a recognizable logo of artistic and commercial distinction in a world of competing signs.

The *poncif* tells us who Emin is, both in terms of personal style and as marketable commodity. That mark, however, is not all there is to Emin. Lehmann shows us that, like the *Kippfigur*, there are two sides to every *poncif*: the conceptual trademark and the commodified logo, subjective idea and reified appearance. Emin tilts her identity between the two, to reflect on the construction of the artist and the self in the world of commodities, and to achieve a recognizable, and commercially successful, identity within that world. That very tilting, which Lehmann discerns in a close and compelling reading of her 'Vivienne Westwood' monoprints, suggests a critical scrutiny by Emin of both her own practice and the more general function of the contemporary artist.

Critical reflection through a play of surfaces, and specifically the surfaces of the print, of impression and registration, is central to Chris Townsend's essay on Emin's relationship to the work of the Viennese Expressionist Egon Schiele. In a reading of the figural and textural reversals of Emin's monoprints, and the stylistic debt to certain of Schiele's works in the contemporary artist's oeuvre, Townsend discerns a shared recourse to the trope of the *mise-en-abyme* within self-portraiture – the medium used as self-reflective commentary on its own mediation, and a means of articulating artistic distance from, and control over, historical contingency. For the two artists, however, their deployment of the *en-abyme* figure operates in two strikingly different ethical domains. Schiele uses the motif to comment upon his authorial power over, and appropriation of, feminine characteristics – and in particular that characteristic emotional and psychic distress (hysteria) which in his time is simultaneously read as a signifier of creativity and of sexual abandon. He displays himself as feminine, hysterical and wanton in his self-portraits and – while sometimes using as models young prostitutes (who themselves are already discursive conflations of those terms) – figures women in the same way. Within this body of work, however, Schiele draws himself, drawing a young model, holding

a posture strikingly similar to one already used in one of the artist's 'feminine' self-portraits. Emin, by contrast, uses an *en-abyme* strategy to give voice to the muted model, her sexuality appropriated, her emotiveness denigrated. Emin reiterates passages of her life history through a reflective medium that seems to communicate with the immediacy of the drawing, but which in reality demands a degree of preparedness and self-awareness. Inverting the appropriations of femininity by male artists – a practice that extends far beyond Schiele, into the work of, among others, Vito Acconci and John Coplans – Emin steals the role of the artist and reverses the relations of authorial power which Schiele manifests in his work.

Doubling as an aesthetic strategy is also central to Jennifer Doyle's reading of intimacy of sexual disclosure in Emin's work. In this case Doyle's reference is to Michael Fried's figure of the metalepsis, the confusion of effect with cause, in the apparent fidelity of realist painting. Doyle's question, and it is one that hangs over much of Emin's work if we wish to go beyond the immediate sensation and affect of its popular reception, is to ask to what degree intimacy here is itself an aesthetic strategy, a cause, rather than simply a condition or effect, of the artwork. For Doyle, 'Emin stages her work as a failure of objectification', which has two effects: the first a profound identification with its subject by the spectator (an effect upon which Doyle expounds through an effusive presentation of her personal relationship to the work), the second a framing, through the strategic deployment of the artist's body, that renders disinterested contemplation almost impossible without flirting with the conservative models of artistic identity which Emin appropriates, and denying the bodily and emotional investments which spectators make in art. In outlining this double effect, Doyle unearths a provocative correspondence between 'conservative' critics, such as Fried – one of whose primary art-historical critiques, a wariness towards the delights of feeling and bodily expression, effectively reiterates Diderot's insistence on the painting as a site of 'moral improvement' rather than pleasurable affect – and certain 'radicals' such as Laura Mulvey, in her polemical (and profoundly influential) treatise against pleasure in visual representation as figured through the woman's body. Even though Emin's work would suggest she's having the worst time imaginable, hers – and by association her spectator's – is an art and a

15

life predicated upon the possibility of pleasure, figured through corporeal experience that confirms individual subjectivity. Even when it's bad, it's good.

Indeed, looking back at the reception of Emin's work in the 1990s, one might conclude that life had to be bad to be good enough for artistic significance in the era of abjection. Reviewing the decade's engagement with an aesthetics of trauma in which, Hal Foster has argued, 'the subject is evacuated and elevated at once', Mandy Merck considers the emphatically autobiographical reception of *My Bed*. Confronted by a celebrated display of everyday anguish – and here the extent to which it was not read as representation is crucial – critics, amateur and professional, were incited to reply in the first person: What about *my* bed? *My* art? *My* pain? Whether one reads these declarations as therapeutic self-assertion or the narcissistic guilt-tripping that Nietzsche called *ressentiment*, *My Bed* touched a nerve of the 1990s, in which personal suffering often seemed the only route to public entitlement.

Emin's apparent emergence from this troubled persona at the millennium's end may simply confirm the newspaper narrative of suffering leading to success. Conversely, her own insistence on *My Bed*'s fabrication may yet again demonstrate the error of reading any oeuvre as sheer self-expression, or at least suggest less anguished identities for artists. But, as Deborah Cherry points out, Emin's identity never could contain the forms or meanings of *My Bed* as the installation moved from Tokyo to New York to London. Placed next to a coffin in Japan, juxtaposed with the apparatus of pregnancy-testing in the US, the bed became part of a meditation on nationality in Britain. Invoking Derrida's observations on the inconclusive limits of the work of art, Cherry follows *My Bed*'s border crossings to the trans-European thematics of its exhibition at the Tate. As the installation's scuffed suitcases travelled around the globe, so migration itself became one of the work's allusions. At the Turner Prize exhibition the punk pessimism of 'No Chance' inscribed on the Union Jack was reconfigured for a Cool Britannia growing increasingly cooler to asylum-seekers. Eventually, in its circulation through space, time and the market, *My Bed* lost its original pronominal reference and became, not Tracey Emin's, but Charles Saatchi's.

Turning to the artist's use of pop-cultural forms and her audience's indifference to the protocols of high art, Lorna Healy wryly observes that Emin's fans treat her like

a star, shouting 'I love you' to her at the opening of White Cube[2]. Healy's scrutiny of Emin's recourse to traditional narrative modes and the tropes of the pop-music video suggests that it is not simply the mass-media attention directed towards the artist that promotes this response. Rather, the broader reception of Emin's work by audiences new to contemporary art's use of language and narrational forms is facilitated by a recognition of familiar visual strategies and ways of storytelling, even when their content is unorthodox and profoundly personalized. Not only are Emin's videos often like music videos, but her narratives have much in common with the confessional traits of popular-music genres. As Healy observes, Emin's recording with Boy George starts to look like a key work within her oeuvre.

Alongside the complexity of a cultural location that confuses the role of the 'fine' artist not only with the notion of celebrity but with other types of mass-cultural producer, the idea of Emin as pop star also brings us back to the artist's techniques of reinterpretation and recycling. Here the material is both high art – Edvard Munch and Expressionism – and 'low' culture – whether Sylvester's 'You Make Me Feel (Mighty Real)' at the end of *Why I Never Became a Dancer*, 1995, or the narrative trajectories of Hollywood melodrama. Some years ago a critic at the *New Musical Express*, extending the Keats–Dylan debate that periodically circulates in higher culture to a register where it might have more currency, suggested that no one became a poet when they could be the lead singer in a band. That critic was talking about Morrissey, and just as there is a shared articulation of pathos, loathing and allegiance between Emin's films about Margate and a song such as 'Everyday Is Like Sunday', whose lyrics could have been written for an Emin film, so there is a common confusion of creative identities: Morrissey poet/pop singer, Emin artist/'star'. Even a recent 'sculptural' work such as *Self-portrait*, 2001 (**frontispiece**), a scaled-down version of the carnival helter-skelter, incorporates popular-music references, just as it knowingly cites Tatlin's *Model for the Monument to the Third International*, 1919, as metaphor for Emin's turbulent autobiography and memorial to Margate. The popular-music reference is to Lennon and McCartney's 'Helter Skelter', a Beatles number covered in the punk era by Siouxsie and the Banshees. The line – as rendered by Siouxsie – that seems most germane to Emin, and one that, in the kind

of reflexive doubling that characterizes her work elsewhere, strangely brings us back to the top of the slide (the triumphant dance to Sylvester), is: 'You may be a lover, but you ain't no (fuckin') dancer'.[5]

The emphasis on materialist critiques of art and its histories has caused a certain neglect of the spiritual in art, and is responsible for a degree of embarrassment when the subject is broached. Spirituality – and in particular an investment in what might be termed 'Spiritualism', rather than conventional religion – is however of vital importance to readings of Emin's work, just as it is personally significant to the artist in a life that does extend beyond the work and that is not, always, wholly reflected in it. Emin comes from a family with a firm belief in the powers of the paranormal. These powers are held by many believers to be manifested in successive female generations, and constitute the basis of roles as psychics and mediums which, historically, were often a means of obviating class and gender discrimination and transcending social boundaries. Vara traces the presence of this spiritual interest alongside the engagement with Spiritualism by modernist artists, including – crucially for Emin with her longstanding influence by Expressionism – Edvard Munch. The familial influence is apparent in early performances by Emin such as the 'Essential Readings' offered at the 'Fête Worse than Death' in 1993. Vara charts the emergence of a second, more sophisticated, engagement with Spiritualism through the artist's encounter both with the philosophy of Spinoza and Nietzsche and, crucially, texts such as Raymond Buchland's *Doors to Other Worlds*, which clarified the cultural context of what had previously been a wholly experiential encounter. The result has been, as Vara concludes, a realization of the female, psychic voice in the legacy of male-dominated modernist art, repositioning the ambiguous role of the medium – as a correspondence to the equally problematic one of the female artist – at the heart of contemporary art.

Conversations with artists are a notoriously problematic species of critical discourse. Artists frequently have particular agendas which they wish to highlight, with merely tangential relationships to the work under discussion. Others repeat familiar routines and stories, so that one interview reads very much like another. Even the best exchanges in this field – for example, David Sylvester's with Francis Bacon –

often only bring subjects to attention through a conspicuous neglect, made apparent by the density and reach of their scrutiny upon all others. The inclusion here of Jean Wainwright's interview with Tracey Emin is not, therefore, in the hope of authorial confirmation of all the critical discouse that has preceded it, nor to establish some final limit to interpretation. Nor again should we seek a fragment of the 'real Emin' here: if we accept that her entire oeuvre rests upon intimate disclosure of auto-biographical detail, there is little point in looking to a single interview either for a different form of personal narrative or startling confidences. If we read the artist's output as simultaneously authentic personal expression and carefully mediated art-work – the critical position that most of the scholars in this collection adopt – then the hope of an unproblematic confession in that critical exchange which the artist can most easily manipulate requires the surrender of the very faculty that has informed this study since its inception.

Wainwright's exchange with the artist, resting upon a decade of growing familiarity with each other and the common milieu of the London avant-garde in the 1990s, adumbrates certain subjects raised in the essays of this collection. Where, for example, Emin talks about Picasso's relationship to his models and his exploitation of them, she articulates a concern that is identified in her work by both Rosemary Betterton and Chris Townsend, and that is itself a reiteration of earlier feminist critiques of male modernist artists. Recently encountering Emin's embroidery piece *Picasso*, 2001 (**2**), at Lehmann Maupin was a sharp reminder that, while Emin's polemic had been addressed in this collection largely through her response to Schiele and feminist practive strategies, the artist herself is less limited in her scope. There is a further justification for including the interview, and it concerns the relationship of artists to (largely) academic critics. The conversation to some extent 'binds' Emin to this critical project in a manner that is novel, but hope-fully to some extent proleptic of future exchanges. This collection of essays is written from an academic perspective, even if some of its contributors were chosen for their specialist knowledge and cultural perspective outside the cloisters of the university or fine-art institution. Living artists, and perhaps more so their gallerists, tend to be suspicious of such attention. What passes for critical writing on contemporary art –

especially the catalogue essay – is often little more than an exercise in hagiography carefully regulated by, because commissioned by, the gallery. With the support of both galleries (in this case White Cube and Lehmann Maupin) and artist, but with the independence offered by an academic situation, this collection of essays is perhaps a model for future critical discourse in which artists not only accept a closer, tougher form of attention but also participate in it, recognizing its value both to their current status and their longer-term stake in art history. Given her present cultural and art-market profile, this wasn't exactly a project which Tracey Emin needed to do. Her presence here is an important mark of her willingness to embrace a scheme of which she was at times suspicious, and some critical positions with which she didn't necessarily agree (and probably still doesn't).

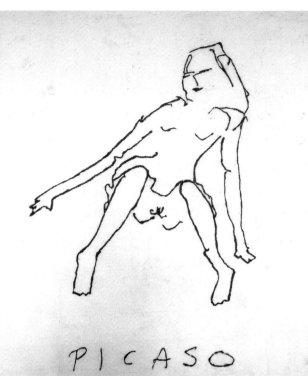

2 *Picasso*, 2001 (detail)
used sheet with embroidery
140 x 155cm (55 x 61in)

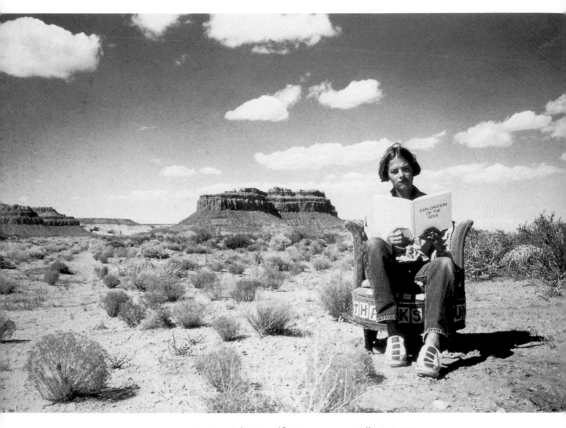

3 *Outside Myself (Monument Valley)*, 1994
colour photograph
65 x 81cm (25⅝ x 31⅞ in)

WHY IS MY ART NOT AS GOOD AS ME?

Femininity, Feminism and 'Life-Drawing' in Tracey Emin's Art[1]

ROSEMARY BETTERTON

In the photograph *Outside Myself (Monument Valley)*, 1994 (**3**), taken during a series of readings at various sites in the USA, Tracey Emin is shown in the wilderness, sitting in her grandmother's chair, which she has made into one of her own appliquéd artworks. She is holding up to the viewer's gaze her autobiographical text *Exploration of the Soul*. She is not reading the book but, posed against the dramatic backdrop of landscape and sky, returns the look of the camera. We are not used to seeing Emin outside the metropolitan iconography of London, but in what sense here is she also 'outside' herself? I suggest that this photograph plays on an ambiguity to be found in much of Emin's work, oscillating between truth and disclosure on one hand, and performance and artifice on the other. In the photograph, Emin's presence is simultaneously registered in three ways: as a portrait image, in the material form of her artwork, and as a confessional written text. It is this layering of self and representation that I want to explore further. Why does Emin trace her own presence recurrently through her work? What impels her to register herself so obsessively through the various media of painting, photography, monotypes, sculpture, appliquéd blankets, writing, neon, video, film, performance and installation? By putting her own body and experiences so centrally in the work, Emin poses questions about the relationship between representation, lived experience and the construction of self in art. This essay explores how Emin's type of 'self-life-drawing' both draws on and departs from genres of written and visual autobiography that emerged with second-wave feminism. It also raises critical questions about how authenticity, aesthetic conventions, social construction, identity and subjectivity shape representation of the autobiographical.

It is a truism to say that artists who were born in the 1960s and grew up in the 1970s received unparalleled exposure to television, video, magazines and the tabloid press, but critical writing on art has paid little attention to the implications for the construction of artistic identity of these subjective and gendered pleasures of consumption. If contemporary art now asserts a continuity with, rather than difference from, popular culture, it is because artistic identities are increasingly shaped within a shared sphere of popular consumption. As consumers look to cultural artefacts as markers of their identity, so artists of the same generation increasingly define their artistic subjectivity in terms of a shared consumption of mass culture. Recent British art has played with this contradiction between concepts of uniqueness and authenticity, traditionally the hallmarks of art, and the transitory and reproducible characteristics of the cultural industries. This perhaps accounts for the fact that it has been simultaneously attacked for being too conceptual and too consumerist.[2] As Andreas Huyssen argues in his analysis of the relation between modernism and mass culture, mass culture has been persistently feminized in avant-garde writings as 'Modernism's Other'.[3] Since the middle of the nineteenth century, relations between production and consumption within capitalist economies have been gendered. When mapped onto art, this gendered split was reproduced as a division between the male creator (producer) and the woman artist (a second-order creativity linked to her domestic role as decorator and consumer). Rather than, as Huyssen suggests, this gendering device becoming obsolete as more women entered the art world, the destabilization of gender roles has foregrounded questions of artistic identity in new ways. Furthermore, as contemporary art differentiates itself from modernism by embracing mass culture, it also becomes linked to the 'feminine' sphere of consumption. This blurring of the lines between forms of artistic production and mass consumption is partly what underpins practices such as those of Tracey Emin, which draw on a variety of feminine confessional modes while assuming the status of uniquely authored artworks.

John Roberts has suggested that one key change in the art of the 1990s was its 'loss of guilt in front of popular culture'.[4] He argues that the 'bad behaviour' of the

young British artists – 'playing dumb, shouting ARSE and taking your knickers down' – should be read neither as apolitical, nor merely infantile, but as 'a celebration of aesthetically despised categories of popular language and culture in deliberate reaction to theory-led, deconstructive art practices of the 1980s'.[5] Rather than deconstructing forms of popular culture from a critical distance, these artists go out and 'live' them, identifying positively with their values: 'there is a way of reading the new art, then, as a generation moving the critique of representation out of the domain of academic reference onto the "street".'[6] This distinction might aptly be drawn between an artist like Mary Kelly, whose work during the 1980s engaged in a critical practice of representation, and Tracey Emin, whose work, I suggest, draws on affective experiences largely shaped within mass culture. While Kelly brings the cultural codes of femininity into view in order to develop a sustained critique, Emin's work deploys the feminine subject as her central material to very different ends. In *Interim Part I: Corpus*, 1983–5, Kelly interrogated images found within commodity culture and invited her viewers to question their own positioning in relation to the production of the feminine. Items of the artist's clothing acted as surrogates for the female body as it was positioned within the discursive systems of fashion, medicine or romance, while the handwritten text offered a different way of negotiating gendered subjectivity through an implied, albeit fictive, first-person 'narrative'. If Kelly's work explored the cultural and political dilemma of being a middle-class, middle-aged woman, Tracey Emin's work inhabits a different gendered territory, one of female adolescence and the artist's struggle to establish her own identity as a working-class girl growing up in Margate in the 1970s. Significantly, whereas Kelly sought strategically to distance the viewer from identification with the autobiographical content of her work, Emin insistently adopts a confessional mode in which she herself is the 'star' of her own narrative.

Conventional critical wisdom places younger 'Bad Girls' like Emin at the opposite end of the artistic spectrum from Kelly, one of the leading practitioners of British feminist art. This opposition is constructed in part as generational – Kelly was born in 1941, Emin in 1963 – but more especially as one between feminism

25

and post-feminism, a position which argues that the feminist political project is either achieved or no longer relevant to 'ordinary' women. For example, Roberts suggests that Emin's work is a 'proletarian-philistine reflex against '80's feminist propriety about the body' and, further, that 'embracing the overtly pornographic and confessional have become a means of releasing women's sexuality from the comforts of a "progressive eroticism" into an angry voluptuousness'.[7] Within the sexual politics of the 1990s, of 'New Lads' and 'Ladettes', not only men, but women also are licensed to talk dirty and behave badly. By positioning Emin's work as a 'reflex' against a negative stereotype of feminist political rectitude, Roberts resists a more complex reading of her work within the context of previous women's art practices (as well as conflating the differently gendered genres of pornography and confession). I suggest, on the contrary, that Emin is consciously engaged in sexual politics, albeit of an individualized kind, and that her use of genres and techniques historically gendered as feminine would be impossible without the histories of feminist debate and practice that preceded it.

26

The highly mediated procedures involved in Emin recreating her own life narratives as 'art' are acknowledged neither in her own comments nor in those of critics happy to take her word for it when she has, I believe disingenuously, described this confessional art as 'truth'. Typically, Matthew Collings commented on Emin's first one-person show at White Cube in 1993: 'The exhibition told her life story in notes and diary and memorabilia form. It was a story which seemed tragic and hard and mostly set in Margate, with a disturbing streak of sexual abjection running through it, but it was full of passion and striving and liveliness. It was a good idea to do art that had a lot of warmth and feelings but some irony too.'[8]

Collings's *faux-naïf* rhetoric disguises the complexity of Emin's relationship to her source materials. The exhibition, entitled 'My Major Retrospective 1982–1992', included reproductions of many of the artist's early paintings as miniature photographs placed individually on shelves. In this transposition from painting to photograph, the image becomes not so much a reproduction as a *memento mori*, a replacement for an object that is no longer present. Susan Sontag has described a photograph as 'not only an image (as a painting is an image), an interpretation of

the real; it is also a trace, something directly stencilled off the real, like a footprint or a death mask'.[9] In Emin's work there is a similar stencilling 'off the real' of traces, material vestiges of life experience that appear to be indexical rather than iconic. For example, Emin's monoprints, such as *Beautiful child*, 1999 (4), are drawn directly onto the plate so that they have both the vivid immediacy of the direct trace of her hand and, through the technical procedure of reversal in the printing process, also articulate a sense of otherness, of that which is familiar having become strange. The vulnerability of the child's naked body, threatened by the enormous penis that leans towards her, is rendered with a slight delicacy that both touches and distances, like fragile traces of memory. These memorializing tendencies in Emin's work go unrecognized by many critics, for whom the sensational content and the unflinching honesty with which she confronts her life experiences displace any real consideration of her skills and practices as an artist.

Emin frequently uses images, objects and materials from her own life to address difficult subjects such as rape and abortion, but her work consciously reworks her 'life story' as a set of narratives and memories. She produces her life as a series of texts in a deliberately unrefined autobiographical form, aiming at immediacy and intimacy in relation to herself and her early sexual experiences. What the viewers of Emin's work see is a form of discourse constructed from, but not identical with, the experiences it recalls. It is perhaps significant in this context that, until recently, much of her material was derived from the period before she became an artist: that of her childhood, adolescence and early adult sexuality. The highly verbal (and vocal) characteristics of Emin's work suggest a loss, a gap that is repeatedly filled with words in disordered feminine speech, evident for example in certain video pieces where her voice insistently retells stories of growing up as a sexually active teenager. As she describes using the graphic Margate vernacular, 'being broken into' – sex without consent – was something that had to be sadly accepted as part of life.[10] Emin gives to that earlier self the opportunity to speak back through her art, a means of resistance against her former silencing, and thus gives form and narrative to an experience that was, at the time, unspeakable. In the video *Why I Never Became a Dancer*, 1995 (5),

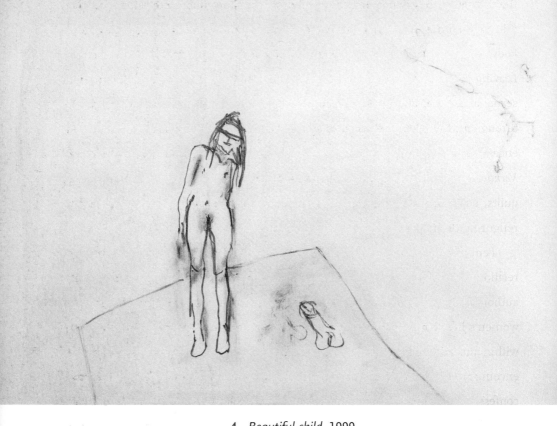

4 *Beautiful child,* 1999
monoprint
65 x 81cm (25⁵/₈ x 31⁷/₈in) framed

the traumatic experience of being jeered off the dancefloor with shouts of 'slag' during a competition is re-presented through Emin's jubilantly gyrating adult body, which performs as a powerful antidote to the memory of humiliation. Leaving Margate meant survival, leaving the site of trauma, of family disruption, sexual abuse and attempted suicide, but it remained the focus of Emin's practice throughout the 1990s, returned to again and again as a catharsis.[11] These experiences are represented in other video works including *Tracey Emin's CV. Cunt Vernacular*, 1997 (**42**), in which her mother also appears, as well as in etchings, quilts, sculpture and diaries, in ways which suggest a constant return to and refiguring of the past.

Feminist theorists of autobiography have argued that women have a complex relation to memory work, which differs from a tradition of masculine self-authorship as authoritative narrative. Writing from a position of marginality, women's life writing can be seen as a means of constituting new social subjects within the autobiographical tradition. As Laura Marcus suggests, such writing encompasses diverse forms of 'self-fashioning, subjectivities, collective memory, confession and the social construction of childhood' in ways that 'rework the concept of autobiography in new and challenging forms'.[12] Similarly, it can be argued that Emin's recurrent representations of herself through her work refigure the traditional concept of self-portraiture as a mirror of the whole subject. The repetition, fragmentation and layering of images and words across a range of diverse practices imply a more contradictory and ambiguous sense of self than can be held within a single, unified image. While the tracing of particular aspects of her past experience suggests a pressure to represent what cannot wholly be contained within memory, this does not imply an unmediated outpouring of the truth. As Annette Kuhn comments: 'Though perhaps for those of us who have learnt silence through shame, the hardest thing of all is to find a voice: not the voice of the monstrous singular ego but one that, summoning the resources of the place we come from, can speak with eloquence of, and for, that place.'[13]

One of the strongest aspects of Emin's work in the 1990s was the eloquence with which it spoke of the place from which she came: literally the seaside town of

29

Margate, but also, by extension, a particular form of subordinated femininity at a precise social moment. In doing this, Emin exposed the inadequacy of the classless, value-free nature of much contemporary art by giving space to the marginalized experiences of working-class femininity. Through her work she territorialized her own body as the signifier of 'Mad Tracey from Margate', who operated as a transgressive figure within the conventions of the art world.[14]

For an earlier generation of feminist artists, theorists and writers such as Jo Spence, Carolyn Steedman, Valerie Walkerdine and Annette Kuhn, the autobiographical provided a means of interrogating the construction of their working-class femininity and the complex relations of family life that informed their own childhood and adolescence.[15] At the same time, they recognized the processes of mediation involved in autobiographical accounts and the ideological environments in which these were produced. While less consciously theoretical, Emin's insistence on the specificity of her experience, in its time and location, delineates the particularity of the social context in which gender is performed. Although Emin's work offers different identities and identifications, it is no less engaged with a gendered social context in the 1990s than were earlier feminist autobiographical practices. As Paula Smithard has commented of women artists of Emin's generation: 'The use of the self in these artists' works is one of the more striking ways in which an engagement with gendered identity is played out. Through the constructions of such works a complex interplay of roles, behaviours and gestures coalesce which highlight the social formation of such identities in sophisticated ways.'[16]

Joan Smith has made a distinction between 'truth' and 'autobiography', suggesting that current self-revelation by many women artists is not so much a form of exhibitionism as a 'counter aesthetic', a conscious reclamation of female identity and sexuality in what she calls 'a transgressive voyeurism of the self'.[17] But the degree of its transgression seems less, however, if we read the work not only within the context of the art world, but within an increasingly confessional culture in which women, in particular, are incited to reveal their intimate selves on TV. As we have learnt, confessional talkshows such as 'Vanessa' and 'Kilroy' are in fact carefully crafted to convey artless self-exposure. The artfulness of Emin's work is to

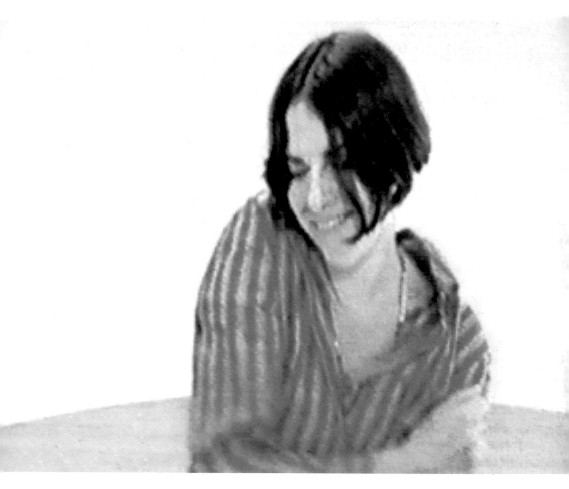

5 *Why I Never Became a Dancer*, 1995
single-screen projection and sound, shot on Super 8
duration: 6 mins, 40 secs

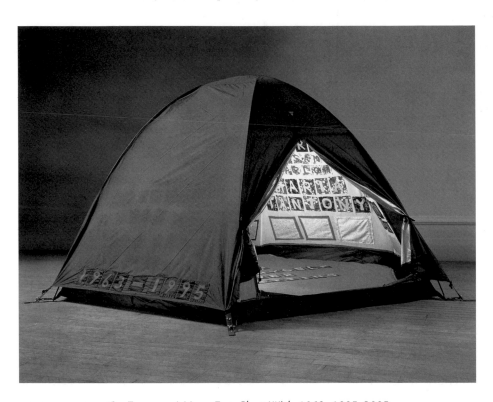

6 *Everyone I Have Ever Slept With 1963–1995*, 1995
appliqué tent, mattress and light
122 x 245 x 215cm (48 x 96½ x 84½in)

present itself in a similar way so as to convey an unmediated intimacy, but – unlike those women who confess their life experiences on television – Emin retains the ownership of her own stories. She reworks and represents them in ways that assert her agency as an artist. In this sense, Emin's work is a form of 'self-life-drawing' or purposeful reconstruction of the past as a set of stories, rather than the 'truth' of a life. As Laura Marcus suggests, to put a life into a narrative or to make stories out of personal experience implies a creative 'staging of memory' in a way that resonates with the performative character of much of Emin's work.[18] Through her work and performances, she brings 'Tracey Emin' into being as an artistic identity whose honesty of self-exposure is her trademark. I'd suggest that to state, as Waldemar Januszczak does, that 'Emin is astonishingly, fearlessly, exemplarily true to the voice she was born with' misses the point of her employment of a range of different artistic strategies to frame her experiences.[19]

This collapsing of the identity of the artist and her work is a common practice in critical traditions of writing on women's art. As Claire Macdonald comments in a discussion of feminism, autobiography and performance art: 'Women artists had long struggled to negotiate the relationship between woman as the object of artistic representation and woman as agent and author of her own work.'[20] Macdonald suggests that the live presence of the artist in her work is one way in which she can assert her agency as a woman and as an artist, thereby confronting directly the relationship between the two. 'In a work where the self is the subject, the relationship of the artist to herself as subject of the work can be a complex one, but it is a complexity that is often overlooked.'[21] In a similar way, Emin's insistent registration of herself as the text of her work can be misread as a direct expression of identity, but the complex and often indirect ways in which she represents her experiences imply a more complex set of mediations between her life and her art. For example, *Everyone I Have Ever Slept With 1963–1995*, 1995 (6) – which has been understood by most critics as an assertion of 'in-yer-face' female sexuality – is about the intimacy of sleep, and relies upon the painstaking inscription of the names of all Emin's sleeping partners in an appliquéd litany of lovers, friends and family members, including her twin brother, Paul, and two aborted foetuses, on the inside

of a small tent. The experience of viewing the work, which can only be seen fully by peering or crawling into the interior, suggests that the audience is being offered an experience of revelation which may be intimate or voyeuristic, depending on one's viewpoint. The slow and considered process of embroidering each name on the tent's sides invites, however, a more considered viewing that reflects on the labour involved, not only in the making of the work itself, but in the making of relationships, traditionally a feminine task. It is the ways in which Emin deploys the 'feminine' as a site of gendered identification that can be seen both to connect her work to, and distinguish it from, artists working in previous decades in an explicitly feminist context.

The use of a domestic aesthetic, a personal life story and craft techniques in *Everyone I Have Ever Slept With 1963–1995* clearly connects Emin to earlier practices of feminist artists working in Britain and the United States in the 1970s and 1980s, but Emin herself resists any assimilation to feminist traditions.[22] In what ways, then, is it appropriate to delineate particular continuities between her work and previous feminist art practices, given their differences in political and generational affiliations? One evident similarity is that Emin has consistently used techniques and genres historically gendered (albeit not exclusively) as feminine, such as embroidery and patchwork quilts, handwritten diaries, self-portraiture and autobiography. Like the British feminist art project Feministo, begun in 1975, in which women exchanged 'domestic' art objects through the post, Emin's work establishes a visual dialogue that derives from a specifically gendered experience and is rendered through an apparently raw aesthetic. It can also be compared to the work of another early feminist art group, FENIX, whose co-operative installation by Monica Ross, Sue Richardson and Kate Walker was shown in the exhibition 'Issue: Social Strategies by Women Artists' at the Institute of Contemporary Arts, London, in 1980. The installation told 'a female life story... in shoes from babyhood to motherhood' and combined memorabilia, artworks and personal statements with invitations to audience participation.[23] In both these examples, women artists used traditional craft techniques to express their feelings about children, housework and marriage within a collective exchange of skills and support. While Emin's

work, until recently, has typically explored sexual rather than domestic relation-ships, her emphasis on the representation of female subjectivity and a first-person mode of address is similar. The informality of their exhibition practices are also echoed in later exhibitions by Emin such as 'I Need Art Like I Need God' at the South London Gallery in 1997, which included items of clothing and memorabilia as well as art objects. This use of domestic objects is quite different from that of Sarah Lucas, with whom Emin is often associated. Whereas Lucas's mundane household objects perform ironic parodies of sexual acts and stereotypes, Emin's objects are chosen for their personal resonance, such as her grandmother's chair, partly embroidered as she travelled across America in 1994, giving readings from her book *Exploration of the Soul*. Emin's representation of her relationship with her grandmother in *There's Alot of Money in Chairs*, 1994 (**48**), is one that is laced with affection and humour, marked by the appliquéd text 'Thanks Plum' and their dual dates of birth, which imply a specifically female genealogy.

There are other reasons for suggesting that, while Emin's work is not deriva-tive of such practices, it may well have been informed by them during her period of development as an artist. The early 1980s witnessed an unprecedented growth in feminist publications and exhibitions about women's contemporary art practices, which were widely reviewed and discussed in the mainstream and art press.[24] Emin graduated from Maidstone College of Art in 1986, where the staff included Janis Jeffries, a feminist practitioner and theorist of textile art. (Though Emin does not remember being taught by Jeffries.) Roszika Parker's influential book, *The Sub-versive Stitch*, was published by the Women's Press in 1984, and in her final chapter she explores the role of embroidery in the Women's Liberation Movement in the 1970s. Parker cites the work of artists such as Kate Walker, Margaret Harrison, Catherine Riley, Monica Ross and Phil Goodall (the last two both members of Feministo) as having made a crucial contribution to feminist understanding of the uses of embroidery and textiles in socially specific and gender-specific ways. I would suggest that Emin, as a young woman on a Fine Art course who worked hard, was talented enough to get a first-class degree and who went on to a master's degree at the Royal College of Art (RCA), would perhaps have been aware of such debates,

35

although she does not refer to them. She does, however, cite her time at the RCA as the worst two years of her life, attributing this in part to alienation from the Thatcherite values, with their emphasis on selling for the art market, that prevailed there under direction of Sir Jocelyn Stevens in the mid-1980s. It was after leaving the RCA that Emin gave up painting and destroyed all her previous work, in reaction to what she saw as the redundant identity of the bourgeois 'picture-maker', turning instead to herself as source of her art. 'I realized I was much better than anything I ever made... I was my work.'[25] It is interesting in the light of her reaction against the competitive individualism and the sense of being an outsider that she experienced at the RCA, that Emin explains her own shift in practice in similarly individualistic terms. There is no reference to the broader political reactions against the commodity consumption of art that characterized feminist and conceptual art movements of the time, nor of their critique of the figure of the individual artist.

It is this difference that primarily distinguishes Emin from her feminist precursors, for if her aesthetic practices bear a resemblance to those of earlier women artists, they are fundamentally different in their strategies and politics. Feminist artists in the 1970s subverted the conventions of art in order to challenge the notion of individual genius, and to assert a collective female experience and aesthetic lineage in opposition to an established, male-dominated art practice. Their use of domestic imagery and materials was an attempt to place art in the directly political sphere by drawing on the contemporary feminist credo of 'the personal as political'. Bringing domestic imagery into the public sphere of art was a means of challenging the split in identity between 'woman' and 'artist', arriving at a shared sense of experience and collective action from a position of isolation and alienation. As Monica Ross explained: 'Contemporary standards either ignore our creativity or rate it as second class. We communicate, we don't compete. We share images and experiences. The posting of one piece of work from one woman to another makes ownership ambiguous.'[26] Emin's friendship and sometime partnership with Sarah Lucas in 'The Shop', which they set up together in 1993 in Bethnal Green to sell work, might suggest a similar sense of exclusion from and rejection of the formal ethos of the art world, but it has to be seen in the context of the increasing use of

alternative spaces and informal networks that characterized the London-based 'young British artists' in the early 1990s. Like the 'Tracey Emin Museum' in Waterloo, which Emin set up to show her own work in 1995, this proved to be a temporary arrangement before the artistic and commercial success she had achieved by the end of the decade. The co-operative aspects of earlier feminist artists' work and their commitment to the collective practices of the women's movement were very different from Emin's position within the anti-intellectual, bohemian artistic networks of the 1990s. Furthermore, while her identity as a woman is central to the content and making of her work, this is not necessarily located within any context of wider gendered identifications. As Katy Deepwell has commented of earlier 'Bad Girls', Emin's work can be seen to stem from 'libertarian individualism, rather than a liberationist politics'.[27] While the assumption that, as women, feminist artists necessarily shared a politics and aesthetics could and did lead to the theoretical impasse of essentialism and denial of difference, the assertion of individual artistic identity by a woman takes on a very different significance in the cultural context of the end of the twentieth century.[28] In the expanded cultures of consumption that have emerged over the last two decades, artistic identities have shifted in line with popular culture's fascination with stars and celebrities. As Jane Beckett notes: 'What has emerged through young contemporary artists is a cult of subjectivity, the cultivation of the self and its public identities, which has much in common with contemporary advertising and media strategies for representations of masculinities and femininities.'[29]

This means that, while Emin's representation of her identity in sexual and class-specific terms may indeed provoke, it does not necessarily transgress widely gendered assumptions about art. The personal is not always political, and the autobiographical voice in women's art does not guarantee a feminist politics. So what is the purpose of tracing a prehistory of feminist practices in relation to Tracey Emin's work? Many artists of Emin's generation have grown up with the artistic legacy of feminist practice, but their relationship to it is highly ambiguous. To a certain extent, the gains made by women in entering the critical, curatorial, prize-giving and dealer networks of the art world are now taken for granted.

Furthermore, as in other professions, women's success as artists is seen as a measure of their individual achievements rather than of any shared endeavour. Younger women artists are in various degrees informed by feminist practice, but many have rejected what they see as the puritanism of its politics.[30] The ambiguities and contradictions in Emin's work, I suggest, lie precisely in this ambivalence and tension between feminine and post-feminist identities and positionings.

One of her recent appliquéd blankets exemplifies the femininities and 'feminisms' with which her work engages. *Hellter Fucking Skelter*, 2001 (**7**), illustrates Emin's awareness of the dual female genealogies of her practice. On the one hand, the patchwork quilt was a confirmation of daughterly or wifely skills and virtues, a symbol of the long tradition of domestic femininity in Britain and the United States. On the other, appliquéd texts and banners were used in Suffrage demonstrations and were revived in women's peace protests in the 1980s as public and political statements of women's rights and identities.[31] The underlying field of Emin's work is made up of pink and white material onto which multicoloured patches of flowered, patterned and plain cloth are sewn. This decorative feminine ground is partially overlaid with texts, which radiate an aggressive, tense and sometimes hostile energy: 'HELLTER FUCKING SKELTER' and 'TOTAL PARANOIA' appear in uneven black lettering at the top and centre of the blanket, surrounded by other comments and threats: 'I FIND YOUR ATITUDE A LITTLE BIT NEGATIVE'; 'BURN IN HELL YOU BITCH'. The iconoclasm of the texts is at odds with the painstaking and detailed procedure of sewing each letter one by one onto the ground, just as the violent expression of the words belies the warmth and security implied by the blanket. Active and passive, contrived and confessional, performative and truthful, the work refuses any simple reading of female identity. Emin has developed her own language for dealing with sexual inequalities, which is neither traditionally feminine nor feminist, but articulates a new kind of independent and iconoclastic femininity in all its complexity and contradictions.

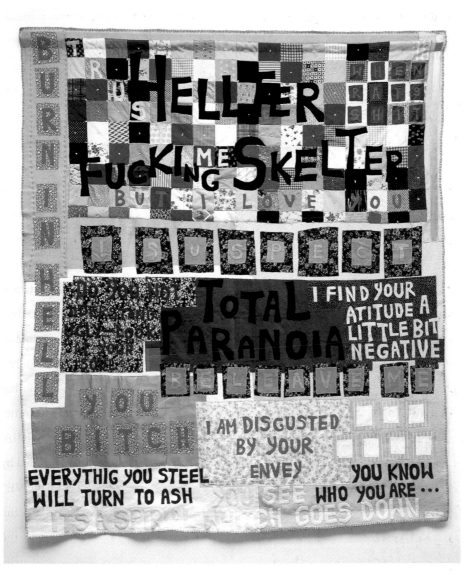

7 *Hellter Fucking Skelter*, 2001
appliqué blanket
253 x 220cm (99⅝ x 86⅝in)

CHAPTER 2

GREEDY *KUNST*

PETER OSBORNE

It is a distinctive feature of what was for a time known as 'young' British art that its public success has been in inverse proportion to its critical reputation. Indeed, for some, its level of public recognition is sufficient in itself to impose a negative judgment upon it as art. Yet there is actually very little serious critical discourse about recent British art. As Matthew Collings has put it, being at a seminar about young British art is 'like being stuck behind children or old or blind people in a crowd at an underground station, when you're in a hurry for a train'. The questions are generally 'idiotic' and the replies are 'inane'.[1] This is, of course, in part a deliberate result of the artists' anti-intellectualist stance. On the other hand, on one notable occasion that intellectual criticism has turned its attention to this art, Julian Stallabrass's *High Art Lite*, 1999, it has been in such a hurry to reach its destination (Condemnation) that it seems barely to have paused for reflection upon its objects, let alone to have considered the possibility that they might pose genuine problems for its established critical terms.

The work of Tracey Emin occupies a predictably prominent position on Stallabrass's itinerary of British art in the 1990s. It is characterized there in terms of a combination of pop-cultural consumability and knowingly regressive expressionism. As such, it is understood to promulgate a populist version of the hackneyed Romantic myth of the artist as creative primitive, while nonetheless, in the more sophisticated context of the art world, cunningly exploiting the incongruity of its own naïveté for conceptual effect. It thus manages to achieve the marketing coup of being simultaneously popular and elitist, 'a conceptual sign of the exercise of knowing taste'. Yet Stallabrass can find little depth, ambivalence or complexity within the work itself. Indeed, he argues, 'the work virtually disappear[s]

as Emin herself, and any statement she makes, any act she performs (such as behaving drunkenly on television), becomes art'.[2]

This alleged failure to mark out a separation between life and art is a central feature of what Stallabrass calls 'high art lite'. This is 'an art that looks like but is not quite art, that acts as a substitute for art' because, in the constant filtering of its presentation of the world through media representations, it has 'dissipate[d] outwards, losing itself in the culture as a whole'. For Stallabrass, Emin occupies 'a discrete, logically necessary place' within this scene as its 'postmodern primitive', moving seamlessly between the worlds of art, fashion and celebrity.[3] As such, her work comes to epitomize everything that is brash and commercial yet ultimately mystical about recent British art.

But is Emin's art really no more than a symptom of a commodified fusion of cultural forms, peddling regressive stereotypes of the artist, which is amenable to diagnosis and explanation, but interpretively barren, because 'not quite art' in the critically proper sense? Or does it *address* this condition within which it is located, artistically, and, in the process, tell us something about it, and with that, something about the conditions of contemporaneity in art?

This essay offers an interpretation of a recent work by Emin – *I've got it all*, 2000 (**8**) – in the context of an emphatic post-Romantic conception of art, the supposed disappearance of the manifestations of which Stallabrass decries. Tracey Emin in 'cultural context' is first and foremost Tracey Emin in the context of art. The cultural identity of art is the broader part or social force of its art identity. Art identity, on the other hand, is given in and as critical identity, since 'art' is nothing if not a critically constructed notion, a reconstruction or 'after-construction' (*Nach-konstruierung*), as Friedrich Schlegel called it, however historically 'positive', or given, the rules governing its institutional conditions may be. Art institutions socially embed, reproduce and transform critical definitions of art.[4]

The problematic critical status of much contemporary art is the product of a profound doubt about the continuing viability of the network of conceptual rela-tions between *art*, *culture* and *criticism* that was established at the end of the eighteenth century, by the early German Romantics. This network provided the

philosophical basis of a conception of art as the site of a distinct, metaphysical form of experience – a modality of truth – that became the legitimating ground of the cultural authority of art in modernity. This philosophical inflation of art, as a constructive secular alternative to religious experience, was subject to corrosive intellectual scepticism for much of the last century, especially in the Anglo-American context, although it continued to have practical effects. It was largely replaced as a foundation for art criticism by an empirical variant of the more sub-jective Kantian notion of aesthetic judgment in combination with an extension of Lessing's purist conception of the distinctions between artistic media – a combina-tion popularly known as 'formalist modernism'. That critical framework collapsed in the course of the 1960s, in large part because of its inability to engage produc-tively with new kinds of intermedia and transmedia work. The concurrent revival of a Duchampian tradition of 'generic' art practices placed philosophical concep-tions of the artwork that go beyond its aesthetic dimension back at the heart of the critical agenda. However, the metaphysical presuppositions of philosophical Romanticism remain unsettling, if not preposterously overblown, to most contem-porary critics, schooled in the more narrowly semiotic critique of aesthetics, which was the mainstay of the art theory of the late 1970s and 1980s. Saussurean semio-tics undertook a theoretical dissolution of the experience of art into the *menstruum universalis* of the sign.[5] Yet it thereby became unable to account for art's specificity as a cultural form, other than on positive grounds alone. In the absence of a cred-ible alternative, some version of the philosophical presuppositions of Romanticism thus remains the implicit basis upon which both the specificity and cultural author-ity of contemporary art depend, as a distinct sphere or 'subsystem' of the social.[6]

What we understand by 'art' today, and what kind of claims it is appropriate to make about it, are themselves at stake in the interpretation of a work like *I've got it all*. Emin's is a body of work that poses these troublesome questions in a parti-cularly acute form – as Stallabrass's reaction displays. Indeed, it is this very entanglement – the entanglement of the work in the question of criticism – that registers the most general critical claim to be made about the work: namely, that it *reflects* the culturally problematic character of contemporary art and art

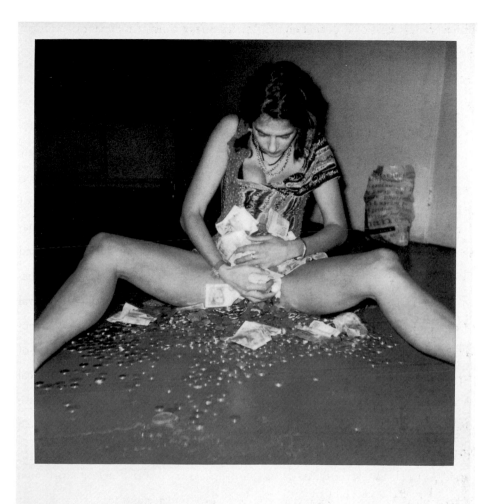

8 *I've got it all*, 2000
ink-jet print
121.9 x 91.4cm (48 x 36in)

criticism, as inextricably linked, mutually determining aspects of a single cultural complex; and that it does so in a manner that is distinctive of art, but which Stallabrass is unable to see.[7]

SHE'S GOT IT ALL

I've got it all is a four-feet by three-feet ink-jet colour print of a photographic image of the artist sitting, bare-legged and legs apart, on a red-painted concrete floor, caught in the glare of the camera's flash, her face angled downwards, looking towards her hands, as she concentrates on clutching an overflowing pile of paper money and coins to her lower abdomen and crotch. Emin is wearing a short-sleeved, patterned, multicoloured (red, brown and ochre) dress – low-cut tight across the chest – a gold chain necklace, gold bracelet on the left wrist, gold ring on the middle finger of the left hand, a watch with a large face and light-brown strap on the right wrist. The fingers of her right hand are tensed and point inwards towards her genitals as she clasps the money. In the blurred foreground of the image, left of centre, at the receding edge of the flow of coins, is a circular blue plastic seal of some sort. In the middle distance, some feet behind the artist on her left-hand side (the viewer's right), a three-quarters-full plastic carrier-bag from Ryman's stationery store leans up against a white painted door. In the background, behind the artist to her right (the viewer's left), just visible in the gloom at the back of the room (it appears to be night), is a white radiator on a white wall underneath what looks like a large metal-framed window, the frame of which is also painted white. An object of indeterminable character, in the shape of a rectangular cube about a foot high, is similarly just visible in the far corner of the room behind the artist's right arm. Emin's body fills the centre of the picture, dividing the image with its upper half and spread-eagled legs into three discrete areas (two background, one foreground). The artist's legs extend to left and right beyond the edge of the picture, cropped above the ankles by its composition. The lighting is focused on the centre of the image, bleaching white the paper money that obscures Emin's crotch.

The title, *I've got it all*, may be taken to refer to the artist's recent commercial and public success, represented here by the cash and (less obviously) the dress.

44

The pose is, characteristically, at once brazen, vulnerable and meditative (downcast eyes); simultaneously exhibitionist and self-absorbed – a combination of traits familiar from the portrayal of female sexuality in the Western visual tradition, most famously perhaps in Bernini's much-analysed sculpture *The Ecstasy of Saint Teresa*, 1642. Here, however, the self-absorption is embodied and task-orientated, rather than otherworldly: symbolically filling the vagina with money, a blatantly profane, onanistic act of consummation, in no need of spiritual communion or angel-proxies. Emin's pose may be spiritualizing in its meditative self-absorption, but it is hardly ecstatic. Rather, it registers a retreat into the self, as much a defence against the voyeurism provoked by the camera and spotlighting – evoking some well-known feminist art of the 1970s (Hannah Wilke's *What Does This Represent? What Do You Represent? [Reinhardt]*, 1978 (**9**), for example) – as it is a sign of any absolute inwardness. Saint Teresa is oblivious of the leering carved figures who complete Bernini's work in the galleries above her; Emin's act is for the camera. Nonetheless, its connotations are (once again, characteristically), in part, those of isolation, psychic distress and compulsive behaviour, as well as of spirited independence, humorous celebration and self-gratification, not to mention a certain tabloid triumphalism of the 'loadsamoney' variety. (Pictures of pools/lottery winners covered in cash – sometimes posed naked on beds – are a staple of British tabloid journalism.)

The title indicates that the work is self-consciously ironic ('Is this all there is?'), constructing an ambivalent relationship to the multiple and contradictory discourses on consumerism and female sexuality that it evokes. This is an ambivalence that, in her work as a whole, Emin raises to the power of something like a structuring principle of female existence, via a symbolic condensation of the female condition into the representation of the (class-specific) history of her own body. 'I am International Woman', the text on the appliquéd blanket *Terminal 1*, 2000 (**10**), concludes, rendering propositional the symbolic load presented by the oeuvre as a whole. It is odd that Stallabrass can find 'little ambivalence' in Emin's work; if anything, one might accuse it of providing little else.

This description attempts to grasp something of the immediacy of the image: its subject matter, visual form and most general iconic associations – associations

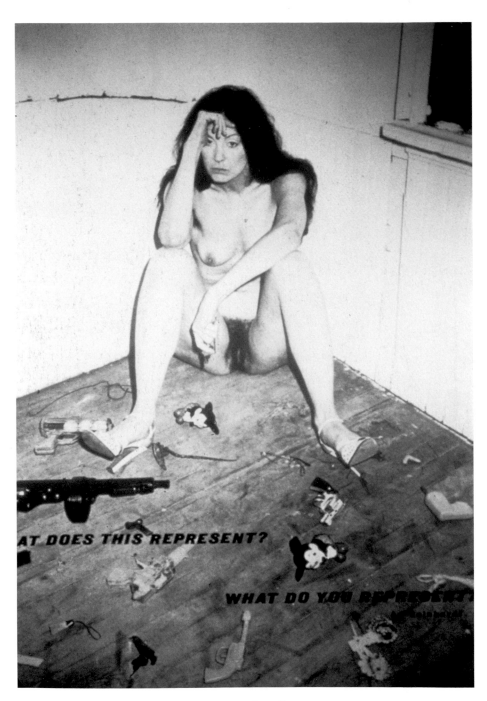

9 Hannah Wilke
What Does This Represent? What Do You Represent? (Reinhardt), 1979–84,
black and white photograph
152 x 102cm (60 x 40in)

HOW COULD I EVER
LEAVE YOU

I LOVE YOU

I SEARCH THE
WORLD
I KISS YOU
I'M WET WITH
FEAR
I AM
INTERNATIONAL WOMAN

10 *Terminal 1,* 2000
appliqué blanket
230 x 210 cm (90^{1}/$_{2}$ x 82^{11}/$_{16}$in)

that may be assumed to function at the level of a cultural unconscious, rather than through any explicit system of art-historical or pop-cultural references. In each of these respects, it is a conventional work, its ostensibly shocking, but actually merely eye-grabbing (at most, disturbing) sexual frankness notwithstanding. In fact, in its copious covering-over of the genital area with paper money it is actually rather chaste – certainly in comparison with much contemporary mass-media imagery in advertising and fashion. It is qualitatively different in this regard from, for example, a work like Gerhard Richter's photo-painting *Student*, 1967 (**11**) of a piece of domestic pornography. And while, in an art-historical context, it might be taken to allude to the more explicit sexuality of, say, Courbet's *Origin of the World*, 1866, in being a picture, broadly speaking, about the cunt, it is not a picture of one. And it requires a good many more mediations to work out precisely what it might be saying about it. What we have so far, then, does not add up to an interpretation, let alone a critical one, since the description remains at the first level of material content: depicted subject matter and its elementary associations.[8]

In fact, is 'Emin as International Woman' even what the photograph is ultimately about? It might be naïve to think so. *I've got it all* is best viewed neither simply as an autobiographical piece (though it is also that), nor as a straight-forwardly symbolic work (though it is that too), but rather, more fundamentally, as a work about the representational means and symbolic forms available to women in our society for self-fashioning; the constraints they impose, the possi-bilities they embody, and the contradictions they involve, in their codings of subjectivity via sexuality. Furthermore, in its presentation of omnivorous desire, it is an allegory of contemporary art itself. *I've got it all* is indeed a work that draws upon media representations and forms (tabloid exposé and humour; the photo-shoot), but rather than thereby 'dissipating outwards', it draws 'the culture as a whole' inwards, into itself. Contemporary art is a greedy consumer of cultural forms. Mass-media receptions may reduce the work to a mere sign of Emin's public persona, but its critical construction as art suggests the opposite: the presence within this image of Emin of the reflective work of a representation of the social whole.

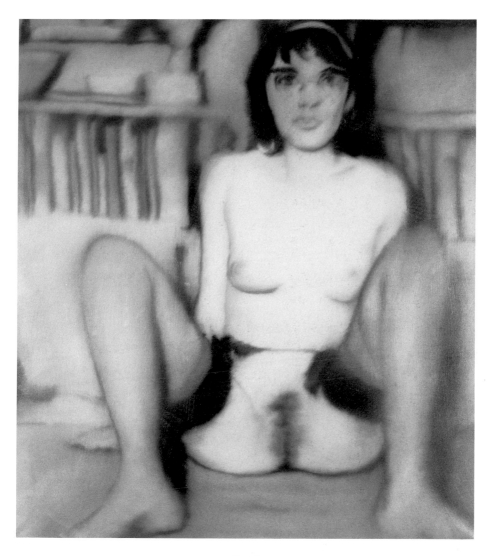

11 Gerhard Richter
Student, 1967
black and white photograph and paint
105 x 95cm (41^{1}/$_{3}$ x 37^{4}/$_{10}$in)

Let us consider the articulation of cultural materials presented in the image – the money, the body, the dress and the carrier-bag – before concluding with some discussion of its photographic form.

'FOLLOW THE MONEY'

A first move in uncovering the 'systematic referability' of the work is to locate its declarative act of self-revelation – 'I've got it all' – reflectively, within what Foucault famously described as our culture of 'the medicalization of the effects of confession': specifically, the sexual confession as the locus of a discourse of truth about the self. One need not be a Foucauldian, or a Freudian, to agree with Foucault that we have come to 'demand that sex speak the truth... the deeply buried truth... about ourselves' and that our society is characterized by a proliferation and inten-sification of forms of sexual representation: 'the solidification of the sexual mosaic and the construction of devices capable not only of isolating it but of stimulating and provoking it, of forming it into focuses of attention, discourse, pleasure; the mandatory production of confessions and the subsequent establishment of a system of legitimate knowledge and of an economy of manifold pleasures.'[9] Familiarity with the main products of the culture industries of developed capitalist societies is evidence enough.

The pleasures of sexual representation and the pleasures of the commodity have become inextricably intertwined and increasingly central to our sense of ourselves. 'I've got it all' is thus simultaneously an economic and a sexual claim, an identification of economic and sexual freedoms. It may also be a maternal one, a shout of victory over the constricting alternatives facing the modern woman: economic and sexual independence and a baby too! (Hence the parentally enhanced iconic status of Madonna – that material girl – as modern woman.) The left hand clasps the money over the stomach as if holding a pregnant belly. '[I]n the products of the unconscious – spontaneous ideas, phantasies and symptoms – the concepts *faeces* (money, gift), *baby* and *penis* are ill-distinguished from one another and are easily interchangeable' (Freud).[10] The extra-economic dimension of the title claim is thus itself equivocal: motherhood or sexual freedom? The ambiguity is mediated

– the conjunction affirmed – by the multiple meanings of money: economic free-dom/baby. (Money on a dress carries the added signification of a Mediterranean wedding, the subject matter of a related digital video work, *Sometimes the Dress is Worth More Money Than the Money*, 2000–1 [12]. Pregnancy in a wedding dress – a shotgun marriage – becomes, I'd suggest, an additional, submerged theme.) Emin's image condenses this complex of relations into a single graphic form. One could not be more direct: the artist appears to be fucking money itself.

Fucking or being fucked by? The structure of the image is appropriately indeterminate. The artist's right hand is forcing the money in towards her vagina: money as dildo. Phantasmatically, this literalizes the mysterious subjectivity of the value-form in capitalism's inverted world: money as capital (self-expanding value) is money as subject (of which sex is the truth). Money is a sexual subject: money fucks; money fucks you; money fucks with you; money fucks you over. Paradigmatically, as capital (that is, as self-expanding), money is a male sexual subject: money is a penis or penis-substitute. On the other hand, as dildo, money is an intermediary (medium of circulation, the circulation of desire). Emin is fucking herself, with the money, and the money is flooding all over the place: money as orgasm. (The money is not figurally phallic; it suggests a more diffuse sexual pleasure.) Symbolically, this would appear to be both a reappropriation of the alienated subjectivity invested in money in the inverted world, and its turning inwards, in an ambiguous act of sexual self-reflection. In sexual self-use, one might say, the ineluctable duality of self-consciousness (as immediate, practical self-consciousness and as consciousness of self as the object of knowledge) achieves a mediated unity through an objectified substitute for those other self-consciousnesses, upon which it actually depends. In capitalism, money (as universal equivalent) is the alienated stand-in for, and mediation of, social relations as a whole. What better substitute for the social subject of desire? The image is thus simultaneously an affirmation of economic and sexual freedoms (from the stand-point of those to whom they are denied) and an acknowledgment of the alienation of their available forms: a double-edged affirmation of economic and sexual free-dom *in* alienation, as the only available form.[11]

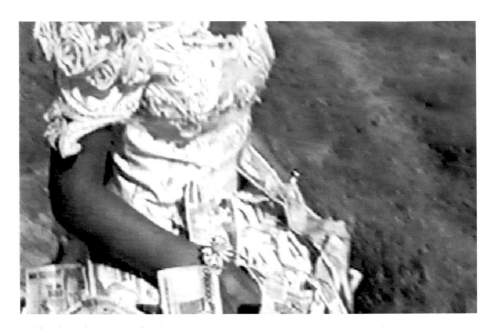

12 *Sometimes the Dress is Worth More Money Than the Money*, 2000–1
single-screen projection and sound, shot on Mini-DV
duration: 4 mins

Or at least, this is one level of meaning, around which a more complicated set of associations coalesces. For, as already suggested, this is not just, or even primarily, an image of masturbatory, money-assisted sex. It also has strong competing and overlapping connotations of defecation (the coins are pouring out of the artist's 'slot'), pregnancy (the protective left hand), menstruation and possibly miscarriage (the wadding of the paper money in the right hand to contain bleeding, perhaps; the left hand soothing a stomach in pain): a full array of possible states of the lower part of human female anatomy, in fact.

Fucking and defecating and giving birth are, of course, famously associated by Freud via the interchangeability of '*faeces* (money, gift), *baby* and *penis*' in the products of the unconscious, cited above, which, he claimed, come to acquire the unity of 'an unconscious concept (*sit venia verbo*) – the concept, namely, of "a little one" that can become separated from one's body'.[12] In holding on to the 'little one' (money-faeces-penis-baby), Emin appears to be repeating the primal act of 'first' repression (the prohibition of immediate pleasure in anal activity, through which the infant separates herself from a hostile environment) after the act. This is an act 'after the act' in two quite different senses: first, in the sense that the unrepressed pleasure has already been taken (the coins are already out), hence a sense of guilt and the dream-like quality of the image; second, in the sense that this is the act of an adult, hence an enactment of what Marcuse called the surplus repression required, by our particular society, of adult relations to pleasure ('Don't spend it all at once').[13] *I've got it all* stages this double act, in the full dynamism of its psychic tension (is the money going in or coming out?), as both confession and celebration. And in *staging* it, it posits a reflective relation to its historical conditions.

The invitation to psychoanalytical interpretation is sufficiently explicit to be, itself, a part of the work – a part of its content – rendering such interpretations themselves at best partial, even if fully achieved. (The possibilities are considerable.) Psychoanalytical interpretation functions in this context largely as a recovery of the materials and dynamics of unconscious significations, the precise meaning of which *within the work* requires further interpretation, of a different order, mediating them with the reflective character of artistic presentation, along with other

53

aspects of the work. Much of what passes for psychoanalytical reading in cultural theory is actually a reconstruction of the sexual theories of children.[14] (Freud himself seems on occasion to forget this; or rather, on such occasions, to forget himself.) In this respect, for all its evocation of psychoanalytically coded materials, *I've got it all*'s staging of it might be considered critical of aspects of Freudian theory: specifically, its reductive and fatalistic coding of the economy of female genital sexuality in terms of the phantasy of the castration complex, as the site of a fundamental 'wound', the terms of which Emin parodically enacts. The free parodic enactment of a supposed fate places both that fate and the terms of its conception in question.[15]

In evoking psychoanalytical theory via the unconscious but by now familiar sexual significance of money (faeces-penis-baby), *I've got it all* subjects two separate systems of equivalence (economic and psycho-sexual) to its singular stony gaze. In its structural condensation of materialisms – each offering freedom only in an alienated form – it is in many ways a deeply sarcastic work. But what of its other, more conjunctural connotations? It is at this point that we can begin to see the way in which 'the culture as a whole' is drawn inwards, into the work, not just through its symbolic properties (above) but through the indexical significance of its contingent materials: the carrier-bag and the dress.

PARAPHERNALIA

In common with many of her contemporaries, Emin's art is an art of everyday objects, everyday objects invested with the fading traces of everyday desires. But everyday desires are not, primarily, desires for everyday objects, but for extraordinary ones. Hence the privileged place within contemporary culture of those everyday objects the specific function of which is to represent extraordinary (for most, unobtainable) objects of desire and phantasmatic identification: fashion and celebrity magazines, films and pop videos. As 'absolute commodities' (Adorno) – exchange-values with no functional use-values, but high cultural status, precisely because of their specific uselessness, the forms of experience they embody – works of art are themselves inscribed within this circuit of desire as extraordinary objects

of a special type. It is a feature of the British art of the 1990s that it takes this fact about art as one object of its reflective work. It exploits the much-misunderstood dual character of art as autonomy and social fact[16] to reflect upon the dialectic of the ordinary and the extraordinary within commodity culture. *I've got it all* has emblematic significance in this regard, since it uses Emin's recently acquired celebrity status to introduce a fresh level of content into her work: economics as cultural form. This dialectic is presented within the image less through the money than by the dress.

The artist is wearing a Vivienne Westwood dress. As in the portraiture of an earlier era, she has dressed 'up' for the occasion. In the language of women's magazines, for 'today's woman' dressing up means expressing your individuality and sense of style through the choice of a garment with a designer label. A Vivienne Westwood dress is an extraordinary object of an ordinary desire. Designer clothing was at the forefront of the consumer booms of the 1980s and 1990s. A new type of retailing was developed based on greater market segmentation of goods, but ongoing concentration of capital, with increased speed and flexibility of distribution, designed to overcome crises in the realization of value (overproduction). Central to this new regime of accumulation in the consumer goods sector is an intensification of the integration of the fashion, advertising and entertainment industries and a renewed emphasis on branding. Labels such as Vivienne Westwood in the upmarket, more rarefied zone of branding function to help define branding itself as the offer of ostensibly 'quality' goods for all.

Emin's dress, then, is a sign of success. Nonetheless, Emin is sitting barelegged on a cold concrete floor in an empty room with a plastic carrier-bag propped up against the door. She has crossed the divide from the ordinary (the world of that carrier-bag, the high street) to the extraordinary (the dress and the occasions to wear it) and both must be present in order to see it. The photograph announces the transition, but it also reflects upon it. *I've got it all* is a fairytale image, but this is a dialectical fairytale. The abundance of coins is the currency of the treasure-trove; the small-change savings jar is its dialectical opposite. For this is a transition within a single imaginary: the fulfilment (not the transformation)

55

of everyday desire in the culture of advanced capitalism. The element of pathos associated with the gendered dimensions of the work has its economic correlate in the bathos of such fulfilment. In this respect, *I've got it all* is an unusual work within Emin's oeuvre, although it is continuous with what has gone before. It exhibits greater structural depth and range of reference because it overlays the familiar psycho-sexual concerns with psycho-economic ones, and each reinforces and is condensed into the other. This broader aspect has widened further in the work's immediate afterlife, to incorporate the apparatuses of publicity and self-promotion, characteristic of the culture industries with which she and her gallery have become associated.

Emin has begun advertising Westwood's label. In a 'natural' extension of the publicity generated for the label by its being worn by a celebrity, Emin began to appear in, and then herself to shoot, Westwood advertisements for fashion magazines. In the May 2001 issue of *i-D*, for example, Emin appears in a double-page

spread in a Westwood dress and Wellington boots, in a forest at night, in an image shot by Mat Collishaw (1). Furthermore, to make the connection fully explicit, in its September 2001 issue, *The Face* ran a feature asking for 'the stars' favourite photos of childhood outfits, coolest moments and happiest memories'. Tracey Emin was represented by a photograph from the same shoot as *I've got it all* (the same dress), with the by-line 'The only really good moments are Westwood moments'. *I've got it all* was thus retrospectively, but indirectly, turned into an advertisement for Vivienne Westwood clothing. However, the differences between the images are instructive. In the setting-up shot shown in *The Face*, Emin is laughing, clearly enjoying herself (not meditative, not staged); the money is all on the floor (not yet over her body); the image is a snapshot (rather than being geometrically and symbolically composed) and by the door behind her sits a box of Beck's beer, icon of corporate sponsorship of contemporary art. There is no carrier-bag. (The box of beer turns out to be the indistinguishable object in the murky background of *I've got it all*. She's got it all: free beer too. But, significantly, the beer was replaced by the carrier-bag.) How are we to understand the effect of this type of intertextuality upon the work?

For Stallabrass, it would doubtless be confirmation of the collapse of the boundaries between art and other cultural and economic spheres. Yet this is true only at the superficial level of imagery, in a manner similar to Pop art. More fundamentally, it functions to draw the experience of contemporary culture further into the work of art. This becomes apparent once we move to the level of the work's photographic form.

PHOTO-FORM

Photography was the dominant form of image-production in economically developed societies for most of the twentieth century. To a great extent, it remains so. Its dominance was not merely quantitative but structural – one might say, ontological. That is, as the epistemically privileged, because most technologically developed, form of image-production, it defined the contemporaneity of the image, and all other forms of image-production had to derive their contemporaneity from their relations to it. In particular, all other forms of image-production had to accommodate themselves to its form in order to produce credible denotative effects. This was as true in different ways, in the history of painting for example, of those forms that defined themselves in opposition to it (abstraction) as it was of those that mimetically identified themselves with it (photorealism). Furthermore, in the wake of the photograph's indexical realism, 'the logical distinction between what is imaginary and what is real tends to disappear. Every image is to be seen as an object and every object as an image.'[17] The world and its photographic mediation merge into a new ontological realm of the object-image. Each photographic image becomes a fragment in the Romantic sense of a part that does not simply refer to, but contains the whole within itself, as a negative totality, as a condition of its signifying function. At the same time, through its reproductive function, photography became the privileged medium for the representation of other forms of representation. In the diversity of its social functions, photography colonized, expanded and technologically unified the entire range of representational genres: from still lifes, portraits and landscapes, via urban scenes and scientific and documentary record, to the capturing of current events, advertisements, souvenir snapshots, pornography

57

and surveillance. Its privileged forms are those in which its social function most tightly matches its technological means of indexicality and instantaneity: the capturing of the everyday.[18]

I've got it all is a domestic ('homemade') appropriation of fashion photography. The Ryman's carrier-bag, on which the word 'photo' is clearly discernible, suggests the ready availability of its means. The bag is also a synecdoche for the female office worker, representative reader of women's magazines. Both the character of the lighting and the quality of the image indicate a low-tech pastiche of a high-tech genre, in which the image itself nonetheless actually participates by virtue of the presence of the dress. In a sense, it *is* a fashion shoot, as the photo in *The Face* retrospectively confirms. In fact, the *appearance* of a low-tech pastiche is itself a recognizable genre of fashion photography, to which the image consequently alludes. However, both the character of the act depicted and the formal composi-tional features of the image put paid to that interpretation and indicate what is in any case clear from the cultural space it inhabits: namely, its character as, or claim to, art. The success of this claim turns on its capacity to mediate its material content, reflectively, in an ongoing and ultimately infinite process.

As a mediation of photographic forms, the image functions in a number of ways. At one level, it brings together the worlds of fashion and the everyday by registering the mimetic power of fashion to compel re-enactment of its forms. At another, it applies the informal documentary use of photography in conceptual art to new subject matter. Perhaps most significantly, it registers the primacy of the Polaroid format as the most instant, informal and democratic of photographic forms, at the historical moment of its disappearance. (Technologically surpassed by digital photography, Polaroid recently filed for bankruptcy in the US.) *I've got it all* is a large-scale ink-jet print of a scanned and enlarged Polaroid image (although it will undoubtedly be encountered more often as a cropped small-scale reproduction, complicating the issue of its cultural form). However, the work does maintain the Polaroid form, with its democratic indifference between landscape and portrait, its shallow field, its restricted lighting (suggesting a cheap shutter mechanism and automatic flash) and its digitization to mimic the Polaroid's border.

The Polaroid is a reductive form privileging content, the close-up and strong cropping. It stands for a certain investment in immediacy and it inevitably evokes its greatest practitioner, Andy Warhol, and his relationship to celebrity society. In fact, in an extended sense, despite their rarity in her oeuvre, one might think of Emin as a Polaroid artist, whatever the actual medium of particular works: Polaroid Tracey. It is the pack of Polaroid film and the stack of Polaroids on the bedside table in *My Bed*, 1998 (**31**), more than anything else, that defines the reflective character of that work – structuring the viewer's gaze in a way that is voyeuristic while nonetheless participating in, rather than separating the viewer from, the scene. For this is a voyeurism (and a society) of self-examination, in which subjects slide easily between interpretive positions, identifying at one moment with the position of the viewer, at the next with the object of vision. *I've got it all* enters into a secret relationship with the Polaroid self-portrait visible on the bedside table in *My Bed*. The chain of references and associations set in motion by its subsequent literal inscription within the field of the fashion magazine serves only to enhance its capacity for reflective meaning. For the desire to have and to be 'everything' is one that underlies and structures the consumption of commodities and the production of art alike.

THE TRADEMARK TRACEY EMIN
ULRICH LEHMANN

'Créer un poncif, c'est du génie. Je dois créer un poncif,' exclaimed Charles Baudelaire halfway through the nineteenth century.[1] 'To create a trademark, that's genius. I must create a trademark.' A clichéd trademark that is at once recognizable and which identifies the artist as the creator of a work emerging through and existing within its subjectivity. Not a work of art for the sake of art, but for the sake of its progenitor, a testimony as much to creative will as to the aesthetic experience that is propagated for its reception. The subjectivity that makes the work of art come alive also determines to some degree its survival. It binds the artistic object to the creative subject and assures their mutual existence within the art world. The *poncif* therefore is an intimate part of the artist, a personal mannerism and aesthetic marker that distinguishes his work.

However, *poncif* literally translates also as a 'pattern' in a commodified world; a recognizable formal trait that distinguishes the artist's output from works by other artists competing in the market. The recurrence of the pattern curiously individualizes the work of art by tying it repeatedly to the artist, and thereby constructing a serial reference to his subjectivity. The pattern needs to repeat itself for its effect to be noticed. Its first occurrence is an invention, its second an artistic strategy, the third a gesture no longer to the viewer but to the market. The *poncif* here becomes, in today's parlance, a logo. It is reified and separated from its creation and cast into the realm of commerce. It is at this point that Baudelaire's double coinage of the *poncif* emerges as both commonplace trademark and commodified logo, as idea and reified appearance. It becomes an epistemological *Kippfigur*, an image that can be turned around to be read as a different image altogether. These *Kippfiguren*, very popular in Baudelaire's time, present us with readable figures (a young woman in a feathered

hat, for instance) that we have to invert to reveal their counterparts or opposites –
in this well-known example it is the gnarled face of an old woman. The *Kippfigur* is
meant to innocently amuse, yet it is, more often than not, morally charged, because
the secondary image reminds the spectator of the first image's uncanny potential.
The inversion into the second image reveals what we unconsciously perceived in the
first image. This is why Freud (and later Wittgenstein in his *Tractatus*) demonstrated
thought processes and logical perception with the aid of the *Kippfigur*.

The *poncif* can be understood as a semantic *Kippfigur*, for it draws its potential
from a metaphorical pairing of its secondary meaning, the pattern that occupies the
surface of the image, with its primary effect. The underlying trademark stands for
the subject that created it. So, on the one hand, there is the trademark-*poncif* as a
substantial trait, an (at times clichéd) characteristic of the artist; on the other hand,
there exists the pattern-*poncif* as formal stylistics, ephemeral elements of fashion
that have to constantly rejuvenate themselves. No doubt, artistic autonomy – the will
to let subjectivity distinguish the work, as opposed to an expressive religious, poli-
tical or even artistic programme – is embedded in the *poncif*. Despite his sarcasm,
Baudelaire deemed it desirable, nevertheless, because it ensures independence from
prescribed aesthetic experience, creating its very own experience through the pro-
cess of entering into the world. The *poncif* is the creative calling card that is handed
out not only prior to the performance, but actually, when it is well conceived, prior to
its creation proper. It exists ideally as a mental guideline that, although it might be
objectively planned, only truly works when it emerges from within the creative pro-
cess, when it bears strongest testimony to the artist's subjectivity. Or so Baudelaire
might have insisted ironically. However, the *poncif* is also responsible for a formal
objectivity, it works towards its application to the marketplace and its significance in
positioning the artefact within a commodified art world. The more memorable the
pattern, the quicker the viewer's transposition from object to subject, the closer
the connection of the work of art to its creator. When one is able to instantly deter-
mine the object as being 'made by so-and-so', then one can adjust one's aesthetic
experience accordingly and forsake any imperative in one's possible interpretation
in favour of simply arranging the work as part of the oeuvre of a particular artist.

('Made by' can today obviously have a different meaning: the artist no longer neces-
sarily needs to physically make his *poncif*, its intellectual conception or design – as
Baudelaire rightly foresaw – suffices.) As with the *Kippfigur*, the flipping back and
forth between the two meanings is often significant in heightening the effect. If the
trademark-*poncif* is so powerful that the artist is immediately identifiable through
his subjectivity, then the pattern-*poncif* is allowed to vary in order to accommodate
changing trends or fashions. Indeed, this might prove prudent for the *poncif*'s
survival in a world of commodities where aesthetic parameters shift very rapidly.
Baudelaire reserved the dismissive term 'chic' for such adherence to mere stylistics.
Yet he also realized the marketability of something that is 'du chic' and his pattern-
poncif retained a (perhaps laboured) degree of credibility, to the extent of becoming a
popular commonplace and commercially viable. As a pattern or logo, the *poncif* is no
longer appraised for its autonomous subjectivity but for its material success. Many
artists in modernity felt alienated through such a perception, while others, like
Baudelaire, welcomed it with weary irony, recognizing the inevitable change in the
artwork's reception during the nineteenth century and sensing the coming shift
towards an art for bourgeois consumption alone.

Inversely, if the pattern-*poncif* proves strong enough – in nineteenth-century
France one could cite examples such as the orientalist paintings of Horace Vernet or
Jacques Offenbach's operettas – the trademark-*poncif* can allow itself to shift and
explore various interpretations. The same musical idea of a cancan by Offenbach, for
example, might appear season after season, but its placement within the dramatic
action would vary. Rather than closing the scene as a turbulent finale, it might begin
the operetta as a dream sequence establishing the story. Vernet's costume dramas of
oriental bazaars express themselves at one moment as moral analogies, at others as
erotic titillation.

This interplay between trademark and pattern, between individual world-view
and commodified rendition, occupied both fiercely independent as well as openly
commercial artists in modernity – even if most of them, unlike Baudelaire, did not
consciously reflect on the creation or exploitation of a *poncif*. With the growth of a
bourgeois audience in the mid-nineteenth century the demands for novelties and

constant change correspondingly increased. Although a moral (or at times political) status quo was desired, culture was no longer required to choose themes of 'eternal' value. New trends were demanded and art was quick to oblige by creating a profusion of *poncifs*, each catering for a section of the audience and each carefully constructed around the artist's subjectivity to ensure his reputation and recognizable character.

However, it is important to emphasize that the creation of a *poncif* is not simply a marketing strategy. It is not about selling the artist, it is about making his subjectivity recognizable in his work and subsequently creating a pattern that will allow for easy identification. It might seem therefore that the *poncif* would work best when the epistemological *Kippfigur* dissolves itself, that is, when the trademark becomes a pattern or, better still, the pattern becomes the trademark. This confluence, however, can be problematic, as we will see in contemporary art. For when pattern or logo equals trademark, the artist's subjectivity is consumed in artifice and the autonomy that is necessary for progressive artistic creation is lost in the constant hurrying after fashion rather than instigating trends. For the male modern artist the subjectivity that might serve as his trademark could be separated quite easily from his person, since his own body, subjectivity *per se*, was not thematized as a consumable object. Traditional mores that shaped a commonplace view of the body, and of sexuality, positioned the male as active subject in contrast to the female as passive object. The dominant action of socially sanctioned desire therefore had to be directed outwards, away from the male body, and did not permit a self-reflective investigation through the male artist's creativity. Even in dandyism, the prevalent practice for objectifying the male body in nineteenth-century culture – and Baudelaire's early trademark-*poncif* was partly his extreme fastidiousness of dress (later it would be a shaved head and torn clothing) – the body was still distanced by irony. For the dandy the decorated male body might have become a cliché and trademark but only through ironically cultivating appearance as its raison d'être, forsaking the claim for any corporeal or sexual contents. In dandyism the male body appears as an over-sensitized satire of commodity forms.

For the female artist, in contrast, subjectivity invariably meant dealing intimately with her own eroticized and even sexually objectified body, its shifting shape

63

13 *Sometimes I Feel Beautiful*, 2000
cibachrome print
123 x 84cm (48³/₈ x 33in)

and its objectification through morals, customs and rapidly changing sartorial fashions. When Edgar Degas depicted Mary Cassatt in the Louvre looking at paintings,[2] he spied on a creative process: the American painter contemplates the techniques and themes of the old masters. Yet at the same time Degas portrays an extremely fashionable woman, wearing a tailored wool suit trimmed with fur and resting nonchalantly on her parasol. The subjective, in this case anti-bohemian, trademark of knowing and carefully following contemporary fashion becomes her. The female painter is shown as inescapably 'fashionable', and it is not the artistic imagination of a fellow artist but her body that becomes the subject of Degas's work. Obviously, in her own work Cassatt chooses to portray herself somewhat differently. But again, in her various guises as mother or guardian who is cuddling babies or tending to children, what is integral to her subjectivity is her body and not the autonomous creation that led to the work of art in the first place. *In extremis*, for the modern female artist the *Kippfigur* of the *poncif* tilts away from the dialectics of trademark and pattern and establishes subjectivity as the pattern itself. The female subject is caught between articulating subjectivity as necessary for the creation of works of art and the anxiety of seeing such subjectivity consumed as a pattern that becomes representative for the work itself. Her work is commonly interpreted as dealing with the juxtaposition of being a (receptive) woman and a (creative) artist; it has to be seen to debate her body, her sexuality in particular; only then does it appear to become truly marketable and materially successful. Thereby it slips into the process that is commonplace in many parts of Western culture (from opera to Hollywood), where the female body is objectified for consumption and her subjectivity is reduced to emotive residue rather than maintained as a genuine structural force.

In April 2001 the British edition of *Vogue* opened a feature on Tracey Emin with a photograph of the artist in the bathroom of her East End studio. The space is easily identifiable as the artist's own because the bathtub in the background had featured prominently in Emin's photographic work *Sometimes I Feel Beautiful* (**13**) a year earlier – a photo of the artist in soapy water hanging her head over the edge of the bathtub. *Vogue* published this photograph a few pages into the article (also detailing the location of the artist's studio). What initially appears as an incidental observation

quickly shifts to become part of an extended artistic strategy that makes each public representation as subjective and personal as possible, homing in on the privacy of the artist and her immediate environment. The trademark is here 'made by Emin' as the spectator expects to be privy to the artist's most intimate surroundings and her exposure within it. Despite the emphasis on intimacy, however, the *Vogue* photo stops short of exposing Emin as a nude figure, in contrast to a number of her own works.[3] Rather, the magazine portrait, surely also for material rather than moral reasons, shows Emin sumptuously attired and looking critically into a mirror as if to gauge the best moment to press the shutter-release she is holding. We have here a Cindy Sherman-like gesture of controlling a (fictional) self-construction that contradicts the photo's by-line, which credits the image not to the artist but to a *Vogue* photographer.

The clothes in the image are chosen not merely for their appropriate 'chic' within a fashion magazine, but to complement Emin's establishment of a trademark-*poncif*. The artist is wearing a silk-brocade dress and high-heeled shoes by the British designer Vivienne Westwood. Professional make-up and hair-styling complement the fashionable representation in the portrait, while Emin's day-to-day attire of jeans and sweater is decoratively tossed at her feet and she hitches up the dress over her thigh as if to provide an erotic frisson reminiscent of the much more daring revelation of the female body in her artwork. The portrait is a careful construct of pictorial journalism and calculated artistic *poncif*. It functions not so much as a deliberate marketing strategy (she is selling neither the dress nor, directly, her art), but rather as a controlled self-image of the artist's trademark-*poncif*. One might casually assume that the choice of gown Emin wears is accidental, perhaps chosen by the art director or fashion editor of the magazine. However, since they are not listed in the by-lines of the piece one can assume that the outfit has perhaps been chosen by the artist herself and therefore constitutes an integral part of the creative strategy of the *poncif*, the cliché that renders the artist's subjective taste part of a recognizable commodity. Indeed, it could be argued that this is very much the case: Emin wears Westwood because her audience expects it. On a general level, this audience expects the now ubiquitous coupling of contemporary art and fashion, and

furthermore they expect the artist's choice of dress to reflect her own subjectivity. The media exposure that has been granted to artists and designers recently easily circumvents any actual presentation or discussion of their respective work and focuses now on the intimate details and personal circumstances of the creators. The consumer of popular, and indeed 'high', culture is now so accustomed to the practice as to expect such a shift. To successfully underscore her *poncif*, Emin wears Westwood: because Westwood is the Emin of the fashion industry, or perhaps because Emin is the Westwood of the art world. Both are seen as subjectively irrational, emotionally bare – and therefore very feminine – and each as the sexually liberated 'wild child' of their respective generations. Westwood tells the media that she accepted her MBE from the Queen *sans* underwear; Emin drunkenly interrupts a cultural debate on national television. Westwood is photographed in the nude with her much younger partner; Emin details anal intercourse in her monoprints. Westwood presents *trompe-l'oeil* nudes on the Parisian catwalk; Emin spends a fortnight naked under the public gaze in a Swedish gallery. Westwood cultivates her past as a punk and claims to be untrained as a fashion designer; Emin initially presented herself as the painfully naïve anti-painter who scribbled obscene slogans on T-shirts or embroidered tents. Both raise subjectivity to a highly sublimated and artistically relevant methodology, both create an instantly recognizable *poncif* of anarchic protest through thematizing their own bodies: Westwood in creating risqué female clothes which she wears herself, Emin by creating an infinite variation of revelatory self-portraits (**14**).

Such trademark-*poncifs*, however, would not be successful in today's commodity culture were they not to contain an element of commercial promotion. Thus, the connection between Emin and Westwood has significant material roots. Westwood supplies Emin with clothing for a *Vogue* photo shoot, Emin models for the designer's show; Westwood uses photographs by Emin's partner, the artist Mat Collishaw, in her advertising for spring/summer 2001 (also featuring Emin, superimposed by her tortured calligraphy)[4] and, most significantly perhaps, Emin has produced a series of twelve monoprints entitled 'Vivienne Westwood', of which two consist only of *faux-naïf* renderings of the designer's trademark (**15**). A sign of artistic congeniality, of

14 *Self Portrait Feeling beautiful*, 2000
monoprint
29.5 x 41.75cm (11^5/$_8$ x 16^7/$_{16}$in)

15 *Vivienne Westwood*, 2000
monoprint
29.5 x 41.75cm (11⅝ x 16⁷/₁₆in)

elective affinities in regard to self-image, or perhaps the direct extension of the *poncif* from clichéd subjectivity to commercial logo? As Baudelaire remarked, the *poncif* is necessary for success in contemporary culture because in its immediate access to the artist's subjectivity it proves the originality of his vision. Yet such originality is directly appropriated by the market, since the *poncif* in essence was original only in deliberately creating an artistic commodity – since the personal style of an artist had always existed. Walter Benjamin in his essay on Baudelaire accordingly judged that 'the milieu of the market... determined a mode of production and of living very different from that of earlier poets. It was necessary for Baudelaire to claim the dignity of a poet in a society no longer capable of conferring dignity.'[5] The cliché or trademark functioned as a protest against the commodification of art, ironically by advancing the very process of turning subjectivity and its relation to the artistic object into a commercial strategy.

Today such a process appears canonized, and only the most unworldly artist eschews any reaction to the operations of the market. If a writer like Fay Weldon can turn promotional material for a jeweller into literature, surely an artist like Tracey Emin can turn a fashion designer's pattern-*poncif* and logo into a series of drawings. Especially if, as in the case of Westwood, the designer's *poncif* itself is a consciously historiographic one that ceaselessly quotes from costume history, in particular from fashion at the time of Baudelaire with its sumptuous textures and grandiose underpinnings. But what do the monoprints reveal about Westwood's, or indeed Emin's, *poncif*? Is it that the pattern-*poncif* of the designer, the style of her commercial creations, becomes appropriated to the trademark-*poncif*, to the subjective worldview of the artist? The reclining woman in the 'Vivienne Westwood' series is clearly similar to the subjects of the monoprints Emin began around 1995 with *My beautiful legs 16/05/95* (**16**) and it seems virtually indistinguishable in style and subject matter from contemporary prints such as *A Cunt is a Rose is a Cunt*, 2000 (**17**). That some prints show a clothed woman, or one playing with her dress, gestures towards the rendition of fashion, but since the clothing is only roughly delineated and not detailed in the mode of *poncer un dessin*, the dress could be any dress, the still life of the shoes any type of footwear, whether designed or not. However, the fashion in the

16 *My beautiful legs 16/05/95*, 1995
monoprint
58 x 75cm (22³/₄ x 29¹/₂in)

17 *A Cunt is a Rose is a Cunt*, 2000
monoprint
58 x 81.5cm (22³/₄ x 32¹/₄in)

series actually requires no detailing at all since it is perfectly defined through the inclusion of the logo – the ultimate pattern-*poncif* – which occupies the entire pictorial frame of two prints. Even if the title of the series is unknown, the clothes in the monoprints are therefore clearly identified. Here the relation of Emin's drawings to Westwood's fashion is essentially semantic, but all the more effective for that, as in the contemporary profusion of designer fashions each season one dress resembles the other and is marked out chiefly by the written pattern-*poncif* of the designer's logo, a commodified name tag which is sewn into the clothes.[6] Not only by entitling the series 'Vivienne Westwood' but by repeating the logo, and also stating the designer's name four times within one separate print, the artist leaves the viewer in no doubt as to the origin and character of this particular *poncif*. In fact, the series as a whole could be read as a narrative that depicts a move from designer logo to artistic subjectivity, from one aspect of the *poncif* as *Kippfigur*, the commercial pattern, back to its other, the subjective trademark.

My reading of the syntax of the series is to a degree conjectural since the artist has not numbered the prints to indicate their arrangement, but the close proximity to the narrative character of a fashion editorial appears obvious. As such the central position of the figure, the pair of shoes and the logos are to be understood as following the conventions of the magazine editorial, where a story-line is constructed through a formal axis that provides the viewer with a visual pattern onto which the varying fashion is placed. In the case of Emin's twelve monoprints, the opener of the 'editorial' would thus be marked by either one of the images of Westwood's logo, which becomes disfigured in the playfully laboured attempt to render it part of the overall style of the series. Through adapting the typography of the designer's logo to the subjective, inverted handwriting of the artist – similar to the manner in which teenagers crudely personalize the name tag of their favourite pop group in copying them onto their rucksacks – it seems as if the commodifying force of the market is simultaneously celebrated and ridiculed. However, the Westwood logo can also be placed at the beginning of the series to establish a material context for the viewer regarding the objects that are subsequently presented in the series. The next four images depict the model in a dress, standing or reclining, to illustrate the interaction

73

of clothing and human body. The fact that these images depict expressively con-torted bodies and crossed out faces does not distract from their fashionable character since recent fashion photography has used the same ploys to inject social realism into fashion's artifice. Mat Collishaw's photos of Emin for Westwood's spring/summer 2001 campaign (1) cannot be fully appreciated by the casual reader of a fashion magazine without an awareness of the edgy realism portrayed by London-based fashion photographers such as Juergen Teller, Wolfgang Tillmans or Corinne Day (all of whom are now well represented in art galleries). Because the confines of the fashion image have changed over the last decade, the artwork can now be con-sumed in the manner of an illustration of contemporary fashion, the fear of touch between the two fields dissolved in the mutual assurance of its ephemeral signi-ficance. After the depiction of the dresses comes the act of undressing: two mono-prints deploy the familiar Emin figuring of the genital area as centre-point of the image (14), confronting the viewer like Gustave Courbet's *Origin of the World*, 1866.[7]

Within the editorial's narrative these images provide a link to a print which depicts a now entirely naked figure, turning her back to the viewer and gesturing with her (gloved?) arm towards her bare posterior. This too is a pictorial convention, borrowed this time not from a fashion editorial but from a pornographic magazine. This forthright image is then contrasted with the quiet complacency of a still life of shoes before the narrative proper concludes with a standing nude splitting the designer's name in two. Given the identification of the artist with the fashion designer, the next image in the series is particularly pertinent. The phrase 'Tracey Emin for Vivienne Westwood' is printed four times on the picture plane, echoing the tradition within the fashion industry where an established couture house hires a new stylist or designer to lend a contemporary cachet to the tradition of the house. (For example, 'Karl Lagerfeld pour Chanel' or, more recently, 'Tom Ford for Yves Saint Laurent'.) Here, the artist extends the fantasy of dressing up – as realized for the *Vogue* photo, of course – to imagining herself as the actual creator of fashion. 'Tracey Emin for Vivienne Westwood' hints at an ironic inversion of cultural hier-archies: instead of fashion designers wanting to be recognized as artists, artists now aim to become fashion designers.

More significant, however, is the manner in which the pattern-*poncif* of the Westwood logo migrates across the series to the standing nude which is commonly understood as a subjective trademark of the artist. Given the autobiographical references to her work that are underscored by Emin in her interviews, the female figure in the 'Westwood' series can be read as a variant of the artist. The nude becomes yet another element in the recurring theme of Emin's subjectivity as a bare, sexualized persona. Through the act of undressing the pattern-*poncif* is stripped of its commodity shell, turned into the sexualized self and regains the trademark-*poncif* of expressed subjectivity. The subsequent move from the nude figure back to the last two images of the by-line and the logo can be seen, in this context, as a resigned critique of the constant oscillation of the *Kippfigur* between the two readings of the *poncif.*

The original direction of the move within the series from brand name to artistic trademark, however, demonstrates the realization by the artist that the use of the *poncif* has to be underscored by artistic integrity of some sort. The straightforward adaptation of a logo might have worked for the iconic gestures of Pop art, but Emin's monoprints have little in common with 1960s silk-screens. For the contemporary artist, a conceptual switch occurs from the use of commodified images for fine art to positioning the fine artist as a commodifiable persona. In the monoprints, the trademark intimacy of the nude figure with open legs is more significant than the use of any logo, even if it is one representing a congenial designer like Westwood.

The line 'Tracey Emin for Vivienne Westwood' also implies that the artist is modelling for the designer, and that the monoprints are portraits of the self as a designed object, an ironic revelation of the fashion victim laid bare, stripped of her clothes and reduced from a figurative element to a semantic one. As such, the jeans and sweater at the feet of the Westwood-clad Emin in the *Vogue* photo can be seen as evidence of the everyday persona that is abandoned in favour of the public image, splendidly attired, in an avant-garde gown. But this process has to be shown as conscious. In the present cultural climate, redolent with unfettered artistic enthusiasm for brand names and logos, the artist can only share the success of her *poncif* if it appears as calculated, if the commodification of the self is knowingly tongue-in-cheek.[8] As we have seen, the double meaning of the *poncif* incorporates the cliché of

the artist's subjectivity and the pattern she constructs in her works in order for them to become recognizable as objects, and subsequently as commodities, in the art market. In Emin, one *poncif* is her depiction of the open legs which also occurs in the central part of the 'Westwood' monoprints. This motif – if one can reduce such a charged image to a formal element – is repeatedly figured throughout Emin's work. The pattern-*poncif* of the open legs is essentially Emin and can be varied, in a similar way to Offenbach's cancan sequences, according to the context in which it appears. In Emin's oeuvre, with its constantly changing media, the open legs can be seen in different material contexts and with different art-historical references: as a painted 'Erich Heckel' in her student work, a printed 'Paul Klee' in the monoprints, an engineered 'Bruce Nauman' in the neon wall pieces, an assembled 'Mike Kelley' in the ottoman box filled with underwear, or as a written 'Charles Bukowski' in the opening lines of a poem.[9] Once the *poncif*-pattern is repeated a certain number of times and becomes exposed in the media, an interpretive framework is established into which any subsequent artwork can neatly slip. This framing is a significant strategy for contemporary art because it permits a controlled reception of the work, in contrast to the exhaustive need for manifestoes, proclamations or performances to influence critics and audience, as was the case with the modernist avant-garde. An aesthetic logo, in Emin's case an image of female sexuality, is created which originates from the critical *poncif* of the artist's subjectivity. Of course, one must add that such a motif is Emin's very own *poncif* because the artist imbues it with a profound sensibility, notwithstanding its critical perception as merely feminine or outspokenly feminist. In this artistic pattern one part of the *poncif* glides into the other, the stylistic logo and conceptual trademark are almost indistinguishable, since the creation of a public reception, as well as commercial success, is built into the variants of the motif. The success of the recognizable pattern prompts the artist's repeated investigation over time in different media, in different contexts – similar in method, though not in inspiration, to Vivienne Westwood's use of Scottish plaid or the corset as recurrent elements in her collections from the mid-1980s onwards.

Superficially, Emin's use of a recognizable pattern does not differ from the personal style of any painter. But the fact that the pattern is intimately tied to the investigation

of the subjective self allows for significant novelty in the way in which both parts of the *poncif* converge within the *Kippfigur*. A painting by Courbet, for example, is recognized as such due to its painterly style and not because it is necessarily tied to his life story. Any painting is infused with biographical references to some extent, but subjectivity reveals itself principally in the handling of paint and not the detailing of personal experiences. Even in his paintings of the Paris Commune, the short-lived revolution in which Courbet participated in 1870–1, the forms on the canvas are designed to tell us about the historic event rather than the personal predilections of the painter. To take a more recent example from British art, Damien Hirst's oeuvre displays a recognizable pattern of elements (cows, cigarette butts, display cases) and techniques (dissection, anaesthetization, stupefaction) but is not designed to trace autobiographical events. The most recognizable – and most literal – pattern in Hirst, the dot painting, functions very much as an aestheticized logo but does not generate any reflection about the intimate personality of the painter. On the contrary, the glossy workshop manufacture is deliberately designed to create a pronounced distance between painterly surface and artistic subjectivity. In such works the *poncif* is a purely exterior one, the logo dominates over any trademark subjectivity and the oscillating *Kippfigur* is replaced by a solid artifice for the market. Baudelaire's exclamation about the necessity for a *poncif* is answered by an unabashed adherence to a cultural value-system dominated by branded commodities. Nonetheless, the artist becomes known first of all for the look of his work and not for his own appearance.

Emin's patterns, defined as they are, always reflect the subjectivity that is instrumental in creating them. They are also behavioural patterns of the artist and always refer back to her biography. The double meaning of the *poncif*, creating a typical body of work as well as marking out the artist as a recognizable character, is potently realized through Emin's use of intimate details in her art. There is, however, a problem with the use of trademark subjectivity as guiding form for an artistic oeuvre, especially when it borders on cliché. The near-absolute identification of the artist with her work raises the spectre of confessional and commonplace sentimentality. The distance required for autonomous creation is compromised by the proximity to the artist's body. Each work is read as autobiographical, each gesture seen as self-

referential, each sentence – language and writing are prominent in Emin's artworks – is regarded as a revelatory part of life's narrative. The established themes in art, especially those with feminist connotations, such as gender roles, sexual personae or socio-political critique, are veiled, even obscured, by the complete identification of the artist's private life with her public performance. Despite their at times common-place nature, her statements always claim to be first and foremost personal and remain therefore in danger of being dismissed as idiosyncrasies rather than com-ments, let alone protestations of a general validity.

The meditated composition of the artist's *poncif* in modernity was genuinely critical because it exposed the irrelevance of claiming an aestheticized independence from social reality and denounced the fear of the commonplace. Baudelaire under-stood the uselessness of remaining in the confines of the studio as analogous to remaining uninterested in the socio-political environment surrounding it. In Courbet's painting of his fictional studio, which depicted Baudelaire reading in one corner (suggesting that its confines could be expanded mentally as well as physically), the studio became the world; it expanded into a space without walls that let in everything from political demonstration to sexual liberation.[10] In the context of late modernism, Emin's fictionalized studio in Sweden was similarly public, with the quite significant exception that it again forswore grand schemes for private gestures: the clothing line with Burlington socks, the line 'I love you Sarah' on an unfinished canvas.

Subjectivity prevents the pattern or artistic logo from dominating the work, it focuses critical reception on the artist herself and therefore underscores the impor-tance of human values over market values. The revelation of intimate details shapes the *poncif* to refute the cliché or commonplace that Baudelaire observed in the suc-cessful art of his time. It tilts the *Kippfigur* to reveal its unconscious substructure rather than its commodified surface. In doing so, it perhaps reclaims some of the general validity that Emin loses through her insistence on a re-examination of her autobiography. As befits the contemporary artist, who grows up with the constant challenge to reflect on the art market itself, Emin's pattern of repeating painfully intimate details is indeed her trademark, a perfectly conceived *poncif* that shows commercial savvy and personal integrity alike.

HEART OF GLASS

Reflection, Reprise and Riposte in Self-Representation

CHRIS TOWNSEND

'The subject that acts is oneself; the object that retroacts is a... subject arising in the imagination. This is consequently an indirect method of acting upon oneself... and it is also, more directly, a tale.'

André Gide, *Journal*, 1893

Naked, save for a thin gold chain around her neck, constantly available for public scrutiny – at least during gallery opening hours – through sixteen fish-eye lenses set into the walls of the space she occupied, Tracey Emin spent three weeks of February 1996 cloistered within a studio-cum-living space at the Galeri Andreas Brändström in Stockholm. This performance piece, *Exorcism of the Last Painting I Ever Made*, resonant of those confinement projects so beloved of male artists such as Stuart Brisley and Vito Acconci during the 1970s, was documented in a series of photographs entitled *The Life Model Goes Mad*. Emin's exercise in self-display did not only appear to disclose the raw totality of her life as an artist: the piece also posed the making of art – its content premised upon the artist's intimate autobiographical disclosures – as itself performative, as much a spectacle of provisionality and production as the consumption of completed, authorized artworks. *The Life Model Goes Mad* inverted the economies of the studio: first by this disruption of the privacy of art's making and the established order of its reception, and second through the nomination of Emin's incarceration in the Brändström gallery. The performance of creating art was attributed not to 'the artist', but to the subordinate and marginal figure of the artist's model (a role by which the impoverished Emin had earned a living earlier in her career). Furthermore, this carnivalesque tumbling of the creative

hierarchy seemed to be a consequence of the model's madness. Insanity here could be understood as both an appeal to notions of psychic disturbance as opening otherwise sealed channels of creativity in the painter, and as metaphor for the world turned upside down.

One of the pictures which Emin painted during her incarceration was a female nude sprawled with her legs open, styled after a drawing by the Austrian painter Egon Schiele (1890–1918). Schiele is one of two painters often concerned with the expression of disturbed inner states, the other being Edvard Munch, whom Emin cites as influencing her work. However, far from offering a straightforward homage to a role model, Emin's painting, and the performance that framed it, can perhaps be better understood as an ethical riposte to Schiele's frequent depiction of the female model as lubricious – in the dual sense of the word as both unstable and lascivious – and to the artist's miming of particular tropes of sexualized and hysterical femininity within his self-portraiture in the period 1909–12. This painting not only reflects upon a practice within Emin's oeuvre whereby she mimes Schiele's distinctive mode of self-representation, its context of production suggests a meditated reversal of the values that inform Schiele's work. While *The Life Model Goes Mad* provides an isolated example of this strategy of ethical reflexivity within a stylistic appropriation, perhaps its most frequent and energetic manifestation is in the literal inversions of Emin's monoprints. In these rapidly executed images Emin provides a series of representations in which she reflects upon her own life – almost invariably depicting herself naked, her body convulsed into submissive postures of sexual presentation – with oblique and supplementary textual commentaries written alongside the image. However, not least in their proliferation, but primarily in their spontaneity and handling of the female body, Emin's monoprints offer striking parallels both with Schiele's drawings of young female models and his corresponding practice of self-portraiture.

The monoprint is one of the most basic and easily effected techniques of printmaking. There is a degree to which the method indeed contradicts the purpose of print-production: the image that it creates is unique and further copies cannot be reproduced using the same procedure. The monoprint is not a means of generating

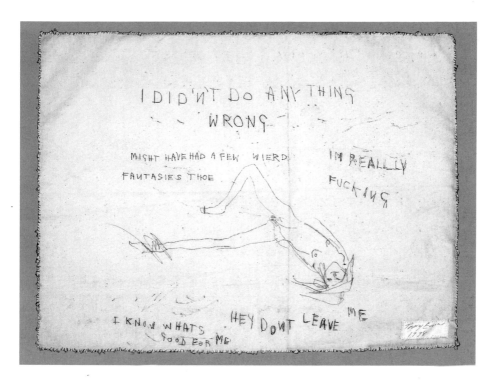

18 *I Didn't Do Anything Wrong*, 1998
monoprint on calico with stitching
38.1 x 55cm (15 x 19⁷/₈in)

serial imagery but rather a strategy of distantiation, of removing a certain immediacy and directness of gesture which might characterize the drawing. Made by coating a smooth impervious surface such as glass or stone with ink or, less commonly, gouache and other media, and placing on top of it a sheet of paper which is then worked by the end of a brush handle or similar inscriptive tool, the monoprint inverts the gestures traced on the paper: it is effectively a unique drawing or sketch that is only seen by the artist after its completion, when the paper is peeled back to reveal the inscribed image. Use of different colours on the printing surface, combined with accurate registration of the paper, can produce monoprints in which a greater degree of engagement by the artist is necessary, and in which the final image is formally complex. All of Emin's monoprints, however, are line drawings effected principally in black ink in a single registration, usually on paper, although some, such as *I Didn't Do Anything Wrong*, 1998 (**18**), are produced on other surfaces, in this case calico, which may be the subject of subsequent work by the artist, and she has used a wide variety of other colours of ink.

This simplicity – the absence of hatching, the single gesture of inscription, the use of a single colour – is complicated by Emin's recourse to text as an accompaniment to the image. Lettering on monoprints is rare, perhaps because it demands a particular skill in being able to write backwards at speed. Emin draws attention to this reversal through a 'failure' in her characteristic use of the reversed letters 'N' and 'Y' – that is, written in the normal manner on the original inscriptive surface – in the midst of coherently arranged and intimately expressive statements. The flipping of the character performs that inversion of incapacity or marginality into aesthetic lure, familiar to the avant-garde since the early years of modernism, which declares just sufficient difference to solicit identification or attention from the viewer. Since Emin also uses the reversed 'N' in some of her other written pieces, including appliqués such as *Love Poem*, 1996 (**33**), where the letter is carefully cut from fabric, we might understand that this inversion becomes a deliberate lapse which emphasizes the reflexive nature of the medium, and highlights the conflict between the apparent immediacy of the statement and the constraint of having to inscribe it in a medium that will record every mistake without the possibility of erasure. At the

19 *Walking drunk in high shoes*, 1998
monoprint
23 x 81cm (9 x 31⁷/₈in)

same time, however, the clumsy and inhibited script, which the process of reversed inscription produces, creates an effect which, if read simply as 'writing', seems to be the product of an artist writing hurriedly and perhaps incapable of forming neatly figured characters.

Many of the monoprints also contain textual commentaries in pencil – for example *Walking drunk in high shoes*, 1998 (**19**), where the pencilled statement is further emphasized by deletion, and *Inspired*, 1998 (**23**), where no text was inscribed during the making of the print. The writing style in these texts is similar to that registered in ink by the print. Both forms, however, contrast markedly with the smaller, rather demure letters which Emin uses when she subsequently adds a title and her signature to these works, also in pencil. The dominant, upper-case texts and the quick gestures of her line drawings, together with the slight smudging of the surface with a residue of ink, combine to give an effect of instantaneity to Emin's monoprints. We read these images as the unmediated residue of feral experience, unstructured by the constraints of medium, understand them as if they were draw-ings, and with equal potential for spontaneity, effected by someone barely capable of coherent writing, and therefore, we assume, barely capable of cogent thought.

84

A drawing such as *Wish You Were Here*, 1997, seems similarly to manifest imme-diacy and establish profound visual parallels with the monoprints. Emin made the drawing on the headed paper of the Soho Grand Hotel, as if, unprepared to make an image, she had reached, instinctively, for the first sheets at hand. The splayed legs of the frenziedly masturbating subject – we presume Emin, because of an accom-panying text addressed in the first person, also on Soho Grand paper – have been scribbled out and redrawn, as though the demand to complete the personal statement in *this* work overrode the expediency of drafting the image afresh. The exaggerated and hurried gestures of deletion become statements in their own right in this drawing; flame-like metonyms for the body burning with desire, and graph-like traces of the moving fingers that attempt desire's satisfaction. Female masturbation is a vital trope in Emin's drawings and monoprints – as it is central to Schiele's – the subject *inter alia* of *Thinking about you all the time*, 1996 (**20**), *I use to have a good imagination*, 1997 (**27**) and *Oh Oh Oh Oh Oh Yea CANADA*, 1997 (**21**).

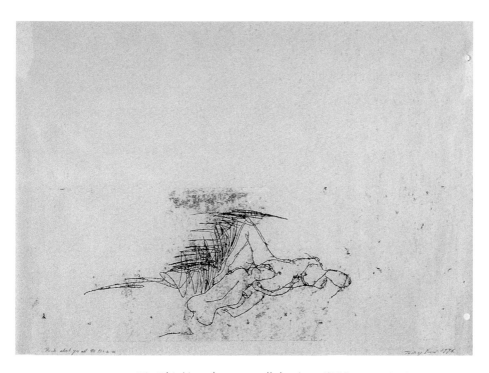

20 *Thinking about you all the time,* 1996
monoprint
58 x 81cm (22⁷/₈ x 31⁷/₈in)

The explicitness and gestural urgency of the latter is not only resonant of Schiele's drawings of masturbating women, its textual supplement – 'Oh Yeh' – parallels the 'Come On' of *Wish You Were Here*. If the sight of a woman pleasuring herself may be the source of a vicarious pleasure for the male spectator – as was almost certainly the case with some of Schiele's drawings, made for private consumption by a limited audience of collectors[1] – the text articulates the pleasure of the demeaned body of that spectacle, that of the female life model, who is here given both a voice and a corporeal delight which may exceed that of either the distanced male voyeur or immediately engaged male artist.

If the image and its text, however, imply immediacy (of such a degree that we might understand *Oh Oh Oh Oh Oh Yea CANADA* as a self-portrait drawn *from* as well as *on* a mirror), the medium of the monoprint and the textual supplement suggest a meditated approach by the artist which the urgency of figuring then occults. While *Wish You Were Here* has apparently been made with the first sheet of paper to hand, the production of a monoprint requires that the artist similarly have to hand a glass plate, ink and paper. A monoprint may be among the most rapidly produced of all printing media, but it nonetheless requires material and prior intentions that do not necessarily characterize the drawing. There is, therefore, both a distance between the apparent immediacy of expression that the work conveys, and the necessary preparation contingent on the medium that carries it. There are, furthermore, reasons why the image is rendered as a monoprint and not a drawing. The distance between moment of thought and moment of representation is further extended by Emin's use of text. Far from being a hurried scribble, the discipline of writing in reverse necessitates a studious concentration. Since Emin does not mark the reverse of the paper on which the monoprint is made, rather making the inscription with any suitable and convenient implement, an equivalent constraint governs the line drawing of figures in the work, since the most that may be seen of the mark as it is made is a faint trace through the recto of the sheet.

That a degree of meditation and sustained process informs the seemingly spontaneous provides fresh insights into the monoprints *Room Service* and *Room Service II*, 1997, made like *Wish You Were Here* on hotel notepaper. Emin clearly took

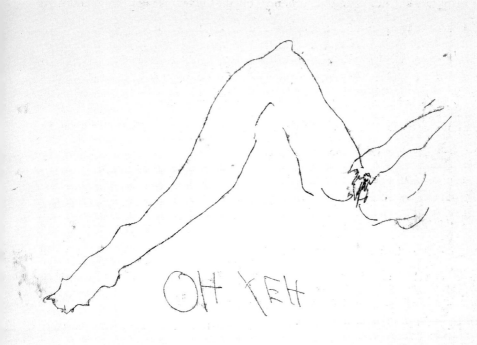

21 *Oh Oh Oh Oh Oh Yea CANADA,* 1997
monoprint
58 x 81cm (22^{7}/$_{8}$ x 31^{7}/$_{8}$in)

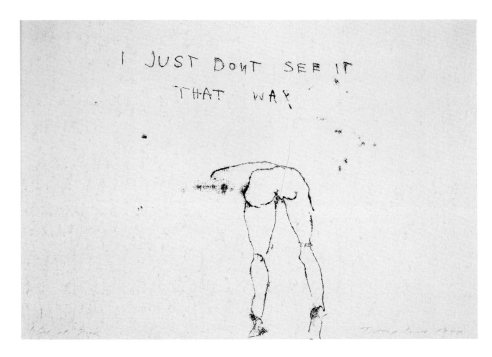

22 *I see it thoe*, 1998
monoprint
30 x 42cm (11¾ x 16½in)

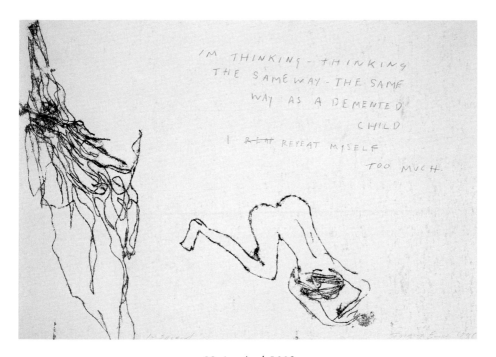

23 *Inspired*, 1998
monoprint
30 x 42cm (11³/₄ x 16¹/₂in)

the trouble to travel with the means of producing monoprints: did she then forget or run out of paper? Or did she resort to the hotel's paper both as an expression of particular sentiments – distance from home and the sexual partner whose genitals are figured in the lower right-hand corner of *Room Service II* – and because of a formal interest in its distinctive weave, which she emphasizes through extra and generalized pressure on certain areas of the print? The *Room Service* monoprints have implications for the perceived spontaneity of *Wish You Were Here*, and perhaps also for Emin's drawings in general. The recourse to hotel paper in meditated works suggests that *Wish You Were Here* may not be as frenziedly spontaneous as it first appears. Rather than being made with the only paper to hand, Emin's use of the Soho Grand's resources is perhaps a premeditated drawing of attention to separation, which the style of her drawing represents as urgent and immediate.

Emin's subject in her monoprints is almost invariably herself: but it is rarely, identifiably, the self as artist. Whereas a drawing such as *Wish You Were Here* seemingly reflects an immediate and unmeditated response to current loss and alienation, many, though not all, of the monoprints represent moments from Emin's history as sexually abused child, wanton teenager and isolated, often miserable figure in a dreary seaside town. The attention to history in these prints is frequently upon sexual experience – masturbation, anal and vaginal intercourse – or its inevitably catastrophic aftermath, a collapse into hysteria and emotional distress. A work such as *If I could just go back and start again*, 1995 (**24**), depicts 'I' as a narrow-hipped, small-breasted, disconsolate adolescent. The image is autobiographical, but it is not self-portraitive. The claim to self-representation emerges in the retrospective wish of the artist making the work in the present: it emerges not as image but in the relationship between image and text, where the drawn figure of the juvenile Emin suffuses the regret of lost origins with a generalized pathos. The statement in the present suggests that the artist believes her life has gone wrong: the image of the past, created quite literally as a reflection – a reflexive image not drawn from a mirror as a self-portrait might traditionally be, but inverted by the process of production nonetheless – is a recollection of innocence violated by subsequent experience.

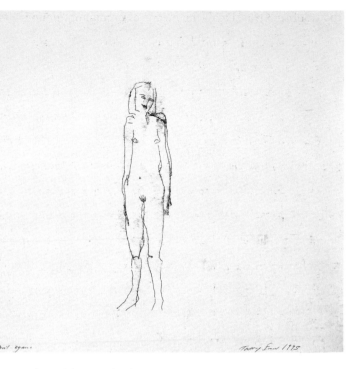

24 *If I could just go back and start again*, 1995
monoprint
65 x 81.5cm (25½ x 32in) framed

We might say that Emin's self-representation emerges not in image or text, but rather in a parsing of the relationship between them as differently tensed, but simultaneously articulated, recollections. Where conventional self-portraiture largely imagines its artist in the present, Emin's self-depiction is fixed in the trauma of memory, the space of history which representation in the present cannot alone bridge. If the self-portrait conventionally articulates 'who I am' (or at least 'who I imagine myself to be'), within her monoprints Emin's self-representation is concerned with the construction of the self through an interiorized difference – its transformation through history, rather than its apparent transcendence over history – and the impossibility of recovering what one once was. Emin's insistent recourse to the monoprint, with its hesitation and uncertainty of accurate reproduction to achieve this self-reflectiveness, might be understood as an artistic practice that includes the specific technical properties, and in particular the deficiencies, of the medium in the process of representation. The monoprints effect that strategy, described by André Gide as a *mise-en-abyme*, in which the work reflects, as it were, on its making; the medium discloses its own properties of mediation. 'In a work of art I like to find transposed, at the scale of the characters, the subject of that same work.'[2]

What Emin once was, at least in her imaginative reflections of the past, bears more than a passing resemblance to many of Schiele's models. If the painting made by Emin during *The Life Model Goes Mad* was a closely figured parody, effected by its erstwhile subject, a comparison of her monoprints with Schiele's drawings suggests both a stylistic influence and a thematic convergence which, crucially, manifests itself as an inversion of Schiele's values. This reversal is effected by the introduction of a self-conscious textual commentary – the model's voice – but it is emphasized by the dehiscence between recto and verso in the monoprint. Just as the process enacts a *mise-en-abyme* of reflectiveness, so Emin's choice of medium establishes a commentary upon both her engagement with Schiele's ethics and the reversal of the relationship between model and artist.

After 1909, as he moved away from working in the approved style of the Academy drawing class, Schiele increasingly focused upon the nude female body,

representing not the rounded, mature subjects of the school's life models, in whose depiction he had concentrated on shape and volume, the formal relationship of parts,[3] but rather on subjects who were sexually immature. Typical of this is the crayon and pencil drawing D.308, which illustrates a thin young woman seated in profile. The model's head is angled forward to be almost at ninety degrees to her back; her eyes are carefully modelled blanks, as if she were insensible and the eyeballs had rolled beneath their lids. Paralleling this development in Schiele's drawing of female subjects is a new emphasis in his self-portraiture upon a depiction of stilted and sometimes grotesque facial and corporeal gestures – for example, in D.347, where the left arm is raised above the head, canted strangely at the elbow, so that it forms an arch over the subject, and the artist's distorted, opened mouth is carefully high-lighted in red crayon, as if he were wearing lipstick or his mouth were bleeding.

In 1910 Schiele produced a number of drawings of pre-pubescent females, including the standing nude D.428, which, perhaps because of the simplicity of its pose, but perhaps also because of the sense of discomfiture that the naked figure conveys, bears a striking similarity to Emin's posture in *If I could just go back and start again*. Schiele in the same year produced an extraordinarily prolific corpus of nude studies of women, many of whom – in particular the subject of D.576–D.581 – were little older than the girl in D.428, and who were often represented in states of bodily contortion that suggest either sexual rapture or hysteric convulsion. These disposi-tions – for example, the gouache, watercolour and black crayon D.512 – not only mimic the artist's posturings in D.347, but parallel an increased emphasis on con-vulsion in the self-portraits of the same year. The attention to children will become increasingly prurient in Schiele's drawings of the following year: the gouache, water-colour and pencil study D.773 depicts bare only the girl's buttocks and labia, as, dress hoisted around her waist, she lies on her stomach with her legs parted, as if presenting herself for penetration from behind. Other drawings of 1911 such as D.966–D.968 depict teenage girls in lesbian couplings, while *Masturbating Woman*, D.800, is a pencil study of a model engaged in genital stimulation. The models for many of these distasteful works were, as recalled by Schiele's friend Albert Paris von Guttersloh, often teenage prostitutes 'solicited in... Schönbrunn Park'.[4]

Schiele's own postures in his self-portraits suggest a striking degree of convergence with his female subjects. In the frank pencil and watercolour *Self-portrait Masturbating*, 1911 (D.947), the artist's onanistic performance appropriates the stimulative gesture of female masturbation. This work suggests much more than an elision of masculine identity, and it does so not through the concealment of the genitals which the hand effects, but through the expression of the artist's authorial presence and agency in his hand.[5] Allesandra Comini remarks, apropos of the accentuated modelling of nipples and breasts, and the frequent elision of the penis in certain of the watercolour studies: 'In these most intimate of his drawings we see Schiele actually transformed into the object of his own desire.'[6] The complexity of this relationship between artist and subject is perhaps manifested best in a form of self-portrait, the pencil drawing of 1910 (D.737) known as *Self-portrait Drawing a Nude Model in Front of a Mirror* (**25**). In this study Schiele executes a self-portrait as he also draws an adolescent female model. The girl, with her back to Schiele, is then seen in a reflection which exposes her small pubic triangle and vestigial breasts. The model's mirrored body partially obscures the seated artist at work on the double portrait. *Self-portrait Drawing a Nude Model in Front of a Mirror* contains a complex set of looks at, and by, artist and model in which the artist comments on his alienated relationship with an ambiguous, adolescent, sexual materiality *as if it were his own*. The model adopts a coquettish pose redolent of Schiele's own 'feminine' stance in *Self-portrait in Street Clothes Gesturing*, 1910 (D.695). This equivalence of femininity renders ambivalent exactly what sort of an object the model is meant to constitute, and in what register of desire her body is objectified. The foregrounded presence in the drawing is not Schiele but this young girl, seen from the rear, and the artist reserves his most skilful modelling for the cleft of her posterior and her back. Like Emin's monoprints, this drawing is itself a *mise-en-abyme*: one that comments on the processes of self-portraiture and the relationship of model to artist.

Most self-portraits were, even well into the era of the mechanically reproduced photograph, effected through the use of a mirror. Schiele's drawing, in common with those portraits in which artists paint themselves painting, literalizes the relationship of artist to reflection as both material condition and inner state which may

94

25 Egon Schiele
Self-portrait Drawing a Nude Model in Front of a Mirror, D.737, 1910
pencil on paper
55.2 x 35.3cm (21³/₄ x 13⁹/₁₀in)

be conflated within representation. However, Schiele then positions the pubescent female model as an interruption of the linear relationship between artist and artistic self-disclosure. Significantly, Schiele disposes the girl in a posture which he himself has used – in a portrait which might itself be understood as a mimesis of the solicitations of the street-girls whom he has also recruited as models. In a dizzying convergence of roles the young model is simultaneously herself, 'performing' a role as prostitute which is itself an imposture designed to both attract attention and satisfy expectation, and a parody of Schiele's parody of that performance. The girl 'stands in' for Schiele, but she stands not only for that alter ego towards which Comini gestures, but for Schiele as controlling agency within the picture: as object of the artist's attention, perhaps as object of desire, but certainly of scrutiny and representation for an artist who is also present. Schiele's contribution to this series of reflexive exchanges is both to place himself inside them – as the model – and outside them as controlling, and self-representing, artist, immediately restoring the loss of masculine power and identity which his assumption of femininity might effect.

The contortions shared by Schiele and his models in studies in the period 1909–12 are perhaps a similar mapping of the male artist onto a feminine materiality, and indeed onto what was understood at the time, despite the imprecations of the field's medical practitioners and diagnosticians, to be a specifically feminine condition, that of hysteria. The convergence that is effected between hysteria as a woman's problem and sexuality resurfaces in the discourse that surrounds Tracey Emin. It manifests itself both in her autobiographical disclosures – for example, the video *Why I Never Became a Dancer*, 1995 (**5**), where Emin recalls fleeing a dancefloor to a chorus of 'Slag! Slag! Slag!' from a group of former sexual partners, and her ironic self-appellation in the textile work *Mad Tracey from Margate. Everyone's Been There*, 1997 (**50**) – and in the popular reception of her public behaviour as artist, including an overwrought departure from a live television debate on the 'death of painting'. Emin is depicted, both by herself and others, as a lewd, lubricious hysteric. Interestingly enough, this may have been what Schiele was trying to depict himself as in his self-portraits, whilst allowing himself critical distance elsewhere through the strategy of the *mise-en-abyme*.

The postures which Schiele adopts, and which he imposes on his models, bear striking similarities to those in publications of the late nineteenth and early twentieth century depicting the convulsions of incarcerated hysterics and epileptics. The artist's facial distortions are also remarkably similar to those photographed by, *inter alia*, Hugh Diamond in Britain and Régnard and Londe at the Salpêtrière hospital in Paris, where hysterics were under the supervision of the distinguished clinician Jean-Marie Charcot. A number of publications illustrating the Salpêtrière's inmates had a wide circulation in Europe, notably Charcot and Paul Richer's *Les démoniaques dans l'art* of 1887 and Richer's *Études cliniques sur l'Hystéro-Épilepsie* of 1881. Patrick Werkner has pointed to an acceptance within Viennese Expressionist circles at the *fin de siècle* of creativity as somehow resident within madness, and a corresponding belief in the convulsions of the hysteric as possessing an aesthetic quality, which was valorized by psychoanalysts, including Freud and Breuer, and artists alike, and manifested itself particularly in contemporary dance in the work of Rudolph Laban and his pupil Mary Wigman. 'The power of ecstasy that philologists imposed on their view of Dionysian cults – clearly in the tradition of Nietzschean thought – corresponded to the "beauty" of hysteric convulsions or hallucinations that psychoanalysts admired in their patients. Both concepts found their way onto the stage through Hofmannsthal and into art through Klimt – and later, implicitly, through the painters of Viennese Expressionism. Their mediator in Vienna was expressive free dance, which was supplied with its theoretic foundation by enthusiastic (male) critics.'[7]

Accompanying hysteria as a distinctively feminine condition, however, and often claimed simultaneously as both cause and consequence, was the ascription to the woman of an overheated and perverse sexuality. This conflation was especially manifested in the figure of the prostitute, and in particular, the child-prostitute. In a discussion of the cultural context of Freud's association of childhood and adult sexuality in the *Three Essays on Sexuality*, Sander Gilman defines the more general discourse. 'Freud's view concerning the prostitute did not coincide with public opinion of the latter nineteenth century, which isolated and distanced the prostitute by categorizing her as a congenital degenerate. That view is well represented in

Cesare Lombroso's classic study *The Delinquent Female: The Prostitute and the Normal Woman* (1893). Christian Ströhmberg, Lombroso's most vociferous German supporter, stated it quite baldly: "[The prostitute] fills her ranks from the degenerate females, who are clearly differentiated from the normal woman. Their abnormal predisposition can be seen in the gradations from occasional prostitution to moral insanity." The prostitute's future is predetermined both physically and psychologically from the moment of conception. Freud, by contrast, intimates that all women possess as a tendency the characteristics that prostitutes live out.'[8]

Freud's chief contribution to this discourse is to shift the emphasis of the psychopathology of prostitution from the class origins which Lombroso and others understand as its aetiology – working-class women are naturally disposed to prostitution because they are morally and psychically degenerate, both conditions also being conditions of entry to the working class and femininity – to a general claim for the disposition to perversity as 'a general and fundamental human characteristic'.[9] However, Freud's assertions that 'children behave in the same kind of way as an average uncultivated woman in whom the same polymorphous perverse disposition persists' and that 'Prostitutes exploit the same polymorphous, that is, infantile, disposition for the purposes of their profession'[10] conveniently conflate tropes of the woman as child, as wanton, as mentally unstable, which had been in circulation for much of the latter half of the nineteenth century, and do not necessarily portray these conditions as limited or exacerbated by class. In her analysis of the etymology of hysteria within medicine and literature in nineteenth-century France, Jacqueline Carroy comments of a contemporary study: 'Henceforth, in referring to the woman, one spoke not of "lewdness", in the old vocabulary of the priest, nor of "disposition", a common euphemism which had become rather antiquated, but appropriated a technical word from medicine.'[11] The technical term which came to stand in for 'woman' was 'hysteric'. Carroy argues for a discursive convulsion of 'hysteria' itself within literary and visual culture. '"Hysteric" became a portmanteau word which permitted the designation of characteristics that were unusual and contradictory. In the literature of the period "hysteria" became synonymous with coquettishness, capriciousness, malingering, lying, excess, drug addiction, perversion, nympho-

mania, frigidity, emotiveness, intellectualism.'[12] The problem in representing the hysteric is not simply one of depicting psychic reality through the self against romanticized representations of the other, as a number of commentators, seeking to recuperate Schiele's self-portraits, have suggested.[13] In performing 'hysteria', Schiele cannot escape a performance of gender contradictory to his biological materiality. Furthermore, embedded in that gendering are terms – 'coquettishness', 'perversion', 'nymphomania' – which continually return it to the notion of 'lewdness', even when the word that signifies such a concept has lost any discursive currency. The hysteric woman becomes a cultural rearticulation of attributes that have previously been marked as both feminine and sexually promiscuous through other terms. This suggests that Schiele's mimeses of the hysteric, despite the radical gesture of their articulation through the artist's own body, embody a set of conservative tropes already enclosing femininity.

For 'hysteria' we should then consider a definition that includes an absorption by sexual otherness which simultaneously fascinates and terrifies the male artist, and which may be contained by its assumption as both the subject of pathos and denigration. Simultaneously the male artist can demonstrate critical control over and exterior agency from that assumption through the figure of the *mise-en-abyme*, the distancing effect whose framing of the work within itself makes clear that the convergences of corpus and psyche are never more than recuperable fantasies. *Self-portrait Drawing a Nude Model in Front of a Mirror* is a singular example of this practice: we might understand the photographs commissioned by Schiele from Josef Anton Trčka in 1914 as a sustained programme of recuperation that plays between modes of representation to establish authority. If, in the more convulsive manifestations of his self-portraiture, Schiele was influenced, either directly or indirectly, by the documentation of female hysteria, or by a discourse of femininity *as* hysteria *as* promiscuity, in these studies he employs photographic representation as a fixing of the self outside the forms of his art, and as a conceptual medium by which this externally confirmed authority transcends the conditions of its fantasized abasement.

In one instance Schiele poses beside his still incomplete painting *Self-portrait with Saint*, 1913. This posturing contributes an additional 'self-portrait' which

doubles the presence of Schiele's painted figure. However, rather than being in the tradition of his earlier double self-portraits, the emphasis here is on the differences between the two subjects. It is the photographed figure of the artist that appears stable, corporeal and meditative, while the painted form seems provisional, spectral and perhaps fictional. There is a dehiscence between the subject of the painting and that of the photograph. Comini remarks of this photograph that 'the artist actually "completes" his painting'.[14] One is led to question what kind of 'completion' this might be, since there is a gap of both time and space between Schiele's composition of *Self-portrait with Saint* and Trčka's study. It is, perhaps, a second signature, an authorization. The photograph might be considered as an image of the real Schiele – the material artist who has undeniably been present in the time and space of the photograph – contemplating his fictional project. Both physically and conceptually the artist is outside his work. Eduardo Cadava contends that 'what structures the relationship between the photographic image and any particular referent, between the photograph and the photographed, is the absence of relation'.[15] One might suggest that a similar absence structures this image, despite its figural presences, and that the aetiology of this non-relation lies in the photograph's conscious display of different embodiments of the self at different times.

A similar relation is, as we have seen, both contained and displayed within Emin's monoprints. On the one hand they proclaim spontaneity and intimate disclosure of autobiography. The print promises authentic revelation of the traumatic life. But the monoprint contains both in its relationship of text to drawing, and within the print itself, its choice as medium, as well as in the subsequent relation of supplementary text, evidence of meditated composition which is occulted by its content. Just as Schiele can return to the frank immediacy of D.347 to highlight, and feminize, his lips, so Emin may return to the monoprint to rework textually her commentary on the past. Emin's use of the medium as *mise-en-abyme* seemingly resembles that of Schiele's: for both artists the mirroring of practice introduces, indeed metonymizes, artistic authority and distance. There, however, the parallel ends. For if Schiele requires figuring *en abyme* in order to recuperate, and stress the superiority of, his masculinity, Emin deploys it to articulate a parody of that which

Schiele both fantasizes and fears. She does not contradict, but rather appropriates and inverts the economies of pleasure in looking and representing. There is a meditated emphasis upon the very condition which Schiele, and the discourse in which he is embedded, denigrates. Emin performs as if she were one of Schiele's models, directed to be emotional, bawdy, sexually perverse, because that should be her true nature, but simultaneously she performs as Schiele, performing himself, as artist, performing femininity. This is a series of interlocked parodies at least as vertiginous in its effect as that performed by the model in *Self-portrait Drawing a Nude Model in Front of a Mirror*, but with an added effect: the model now assumes the role of artist, simultaneously engaged in self-elision and construction, as well. The life model, asked to be mad, takes over the role of the artist who feigns madness as token of authenticity and creativity. Within the same reflective figuration of self-representation and authority, the *mise-en-abyme*, Emin inverts the male artist's privileging over the woman of his identity, sexuality and historical arrogation, to draw attention to the aetiology of catastrophe in her biography. She suggests, perhaps, that there is no possibility of the transcendence over circumstance which the male artist so urgently seeks in his reclamation of masculinity, but rather that the subject, male or female, is continually transformed within history.

101

CHAPTER 5

THE EFFECT OF INTIMACY

Tracey Emin's Bad-Sex Aesthetics

JENNIFER DOYLE

'People like you need to fuck people like me.'

Tracey Emin

BAD SEX, AS AN ACADEMIC EXERCISE

In a delightful expression of the academy's ability to assimilate anything into critical
discourse (especially things that seem to echo the structure-of-feeling of the aca-
demy itself), several years ago I was asked by some feminist colleagues to participate
in a 'think-tank' about bad sex. The conversations we had that weekend never went
anywhere – the collective intellectual project, which I describe below, has since been
abandoned. I have, however, been thinking about some of the terms we kicked
around ever since, because that conversation gave me a vocabulary for representing
what I take to be one of the most interesting aspect of Tracey Emin's work: its partici-
pation in what I would like to call a 'bad-sex aesthetic'.

As feminists, our hope that weekend was to use the term 'bad sex' to drive a
wedge into discourses on women and sexual history in which negative, disabling,
unpleasurable, humiliating, abjecting sexual experiences might be projected into a
space not defined by a contractual, consent/non-consent model of sexual encounters.
This model offers women (and perhaps especially American women, who must wrangle
with a cultural imperative to psycho-sexual health) a choice between only two kinds of
sex – good/happy/fulfilling sex or assaultive sex.[1] It seemed to us that we could use more
room to acknowledge the importance of experiences of boring or non-orgasmic sex,
humiliation, even painful and traumatic (but entirely consensual) encounters as poten-
tially formative – as foundational, at the very least as experiences of what we do not want.

We wanted to claim this kind of sex (as something that happens) without enacting, around ourselves, a therapeutic discourse of victimization, confession and recovery.

We wanted, furthermore, to distinguish our interest in 'bad sex' from sex-policing (and its history within feminism), and from a redemptive project advocating one kind of encounter or another as 'good, healthy sex', as egalitarian in form and, therefore, as 'good for you'. States such as self-abandonment, submission, objectification – the experience of being made the object of another's pleasure – were not only exciting and fun, we all agreed, but very important, even necessary, to experiences of sexual pleasure. This is, in a sense, a reiteration of Leo Bersani's polemic against the 'pastoralization' of sex within feminist and anti-homophobic writing. In his essay 'Is the Rectum a Grave?' Bersani describes sex as structurally pivoting on a will to self-disintegration. It is not, as liberals such as Catharine MacKinnon and Andrea Dworkin would have it, an expression of 'tenderness and love' but, again, structurally 'anti-communal, anti-egalitarian, anti-nurturing, anti-loving' – unequal in its essence.[2] Bersani advocates a vision of 'the sexual as... moving between a hyperbolic sense of self and a loss of all consciousness of self'. He continues: 'It is primarily the degeneration of the sexual into a relationship that condemns sexuality to becoming a struggle for power. As soon as persons are posited, the war begins.'[3] What one proposes to do about this 'war' marks the difference between Bersani (who writes of the power dynamics in sex as 'our primary hygienic practice of nonviolence', as valuable for its disruption of the social, the communal) and MacKinnon (who, for nearly the same reasons, would reorganize the practice of sex in order to bring about women's social empowerment).

Candace Vogler (one of the participants in the bad-sex weekend retreat) neatly summarizes the attraction and the difficulty of Bersani's writing in her essay 'Sex and Talk'. 'If one hasn't the boundless self-assurance... required to find the pastoral vision of sex anything but decidedly un-sexy, alien, and faintly revolting, then one almost cannot not love [Bersani's] account of the sexual as sublime. The story is a delicious antidote to the widespread impulse to harness sexuality firmly to carts carrying happy selves towards egalitarian camaraderie. Nevertheless, it's worth resisting the impulse to sublime sex if only because... it's worth resisting the

impulse to sublime anything.'[4] Vogler argues that Bersani's 'account of the seesaw of me-not-me in sex... treats sexual excitement, not as a culturally imbricated destination for men with overly rigid senses of masculine self-hood seeking de-personalizing intimacy, but rather as the sublime footprint of human evolution.'[5] In doing so, it risks underrepresenting the degree to which the possibility of taking pleasure from being relieved of 'personhood' is deeply contingent and political, and naturalizing the designation of sex as the place in which this happens (and as an intersubjective space less social, less ideological than any other). One's access to the desire for this experience of self-dissolution may be a symptom of privilege – a hetero-sexual white man, for instance, might crave that experience more intensely for all the ways that he experiences his 'personhood' as a burden. The articulation, further-more, of social privilege around feminized, racialized, classed spectacles of sexual abjection is a definitive operation in the social practice of white bourgeois hetero-sexual masculinity.[6] People subjected to these dynamics outside the bedroom may yearn for the reiteration of those dynamics in the bedroom differently (more or less intensely, more or less modified).[7] This isn't to say that this social inequity isn't in and of itself useful as an erotic script to minority subjects male and female, merely that the ecstatic rehearsal of these scripts is, sometimes, all the more delicate for your resemblance to the part you play.

Bersani's polemic presumes, furthermore, that 'self-shattering and solipsistic jouissance' always 'drives [lovers] apart'.[8] What if it doesn't? What if, in fact, when everything goes well, sexual contact facilitates connection exactly insofar as it allows for a relief from the epistemic pressures of selfhood? Towards this effect, Vogler writes that 'the fact that some intimacies are not affairs of the self is what makes people want them', and, furthermore, want them with other people.[9] What if, return-ing to our initial subject, bad sex grows out of the failures of the mechanism that allows us to take pleasure in letting the body become a thing, a body 'subjected' to another's desires – the play with one's own 'thingness' being one condition of possibility for the ecstasy of being relieved, for a moment, of one's 'personhood'?

Vogler and Sharon Willis (another member of the bad-sex collective) described the unhappy experience of yourself as a 'subject' in sex as a 'failure in objecti-

fication'. This 'failure' may happen when, in sex, you see yourself – when the phone rings or someone knocks on the door. You catch an accidental glimpse of your own banality (à la Sartre) and the wind is sucked out of your sails. Or, worse, you discover that you've misread the moment, misread your desires, or theirs, and don't trust that you can 'go there' and come back intact. You might not be in the mood, you could be feeling too fragile to let your body go that way, or perhaps you misrecognized the context and find yourself giving your body over in a way you don't enjoy and to a person you don't trust. Maybe bad sex is sex you deeply regret, a continual source of shame – not because it was assaultive, but precisely because, out of curiosity, out of a desire to please, out of a fear of appearing prudish, you did ask for it. Bad sex, in this sense, may also happen around the production of one person's social privilege as the other's sexual abjection – and one's proximity to social, political abjection (via sex, sexuality, race, for instance) may make the process of self-abandonment more tricky, more risky, emotionally. Becoming an object may not be sexy (or may be differently exciting) if object-ness is always already thrust upon you. It may require feeling safe to go there.

As we talked about bad sex, I found myself increasingly preoccupied with certain kinds of objects – art objects which I had for years found compelling, for reasons I had not been able to explain. Vogler and Willis's phrase 'failure of objectification', and its sexual context, struck me as immediately useful for thinking about contemporary artists working the difference between the abject and the beautiful, enacting a violent seduction and rejection, fucking with our interest in art. These artists produce spectators who are, sometimes, physically repelled by the object, but that revulsion is precipitated only by an aggressive interest in, attraction to, the object's prettiness from a distance. Your attraction to it is what turns that object into something grotesque. This is, as it happens, how Chris Ofili's 'Virgin Mary' figures work: his painterly multimedia collages are, above all else, pretty, gorgeous. It is only as you draw close – solicited by its prettiness, and, perhaps, by the curiosity, as one nineteenth-century writer put it, of a colonialist hoping 'to discover some new race of Hottentot'[10] – that you notice she is surrounded by nasty asses, pussies and clumps of elephant shit.

This sort of work often produces affective states deeply inappropriate to (and yet already embedded in) the museum space – sexual interest, disgust, boredom or tears. That body, furthermore, is more likely to be that of the spectator than the artist: these artists trouble the category 'Art' by provoking physical and problematic responses, eliciting too much person, from an art audience.

IF THESE WALLS COULD TALK

If my vaginal ego could talk (to reference obliquely *The Vagina Monologues*) it would definitely disobey the two-word limit that Eve Ensler put on the participants in her project. It would prattle on, it would repeat itself, it would forget itself, embarrass itself, embarrass its audience, offering up instead a stinking, venomous, maudlin stream not altogether unlike the following:

> I know when the fighting starts I know that I have lost every hole in my body is bleeding my nose my cunt my eyes are red raw from all the tears I'm clutching my stomach, holding onto myself trying to stop my SHIT from spilling onto the floor I'm all wrapped up in my own pathetic loneliness desperate to feel loved again I can't eat I can't sleep my mind jumps from a grinding numbness to some crazy fucked up out of control DOG like hell That's how it is to live without LOVE

The words are Tracey Emin's, and I conjure them up as an elliptical response to Warhol's question 'Where is your rupture?' I've always liked Warhol's uncomfortable blend of a sexing question with a sexless body. *Where Is Your Rupture?*, 1960 (**26**), presumes that we all have ruptures, and that we love to talk about them. The body in this image, however, has none, merely arrows suggesting that if it did, we might find it somewhere between the heart and the crotch. In place of the kind of splitting I imagine in response to the question posed by the painting, Warhol offers us a neat tuck, a hospital-corner fold, a drag queen's crotch: sex as anywhere and everywhere but there.

26 Andy Warhol
Where Is Your Rupture?, 1960
casein on canvas
177 x 137cm (69³/₄ x 54in)

27 *I use to have a good imagination*, 1997
monoprint
59 x 73 cm (23¹/₄ x 28³/₄in)

The torso is blank. The vaguely medical, therapeutic caption implies a narrative that might sex the body, might locate the body in sex. The question 'Where is your rupture?' hopes to produce the breach it assumes. We could take this work as a somewhat flatfooted illustration of one of the principles of queer performativity – that the body, as we know it, is produced through narrative, that sexual difference is less discovered than produced by the question 'Boy or Girl?' Sexual difference as imagined in art, furthermore, is no more a record of the Real or the natural than the painting that depicts it, or the spectator's demand for it. 'Where is your rupture?' may be the first question you ask of an image of a sexless torso – forgetting Magritte's lesson. 'Ceci', after all, 'n'est pas une pipe.'[11]

My interest in this work is not as noble, however, as an academic's commitment to allegorical valuation: I like it because I think it is talking to me, I take it as being about me. It indulges my narcissism: 'Here! Here! My rupture is right here!' Being the Warhol fan that I am, furthermore, I imagine the artist himself asking me to tell him all about it (over the phone, each in our own bed, downing Valium and vitamins, gossiping, talking about sexual triumph, romantic abjection, abortions and colostomies). A fag-hag's fantasy of being a favoured hag to the ultimate fag.

Where Is Your Rupture? conjoins formula and sincerity – it cites, simultaneously, a story that is completely scripted and absolutely personal.[12] It implies that you can produce the most generic story about your 'rupture' with the utmost sincerity and eagerness of affect. If you are a person who has these kinds of ruptures, you tell your story again and again, forgetting who you've told what.

One could place Emin's monoprint, *I use to have a good imagination*, 1997 (**27**), alongside Warhol's painting, as one response to his question. It is a rough impression of a woman, legs splayed open on a couch, fingering herself. A strange object hovers in space behind her. A rifle? A broom? (Either way, it looks like an impending punishment.) This work equates a failure of imagination with masturbation, with the excesses of everyday desire. The woman in the picture seems like she might be bored. The picture seems drawn out of boredom – carelessly executed by a person without much of an attention span, tossed off. The light touch of Emin's line (partly an effect of the monoprint, which places the touch of the artist's hand at a remove

from the page) makes the work feel quick, executed without much of a plan, with a minimum of intention.

The sex recorded in Emin's work is aggressive, delirious and joyful, and loaded with fear, humiliation and anger. The romantic moments she describes are hopelessly melodramatic. Take, for instance, *Love Poem*, 1996 (**33**), a blanket embroidered with the following: 'EVERY PART OF MY BODY IS/ SCREAMING I'M LOST/ ABOUT TO BE SMASHED/ INTO A THOUSAND MILLION/ PIECES EACH PART FOR/ EVER BELONGING TO YOU'. Emin's drawings, monoprints and paintings in particular delineate a life ruled and often undermined by sexual desire – a will to fuck, no matter what the cost. 'If I have to be honest, I'd rather not be painting' captions a painting of a man and woman fucking; *No Clear Thoughts*, 1998 (**28**), repeats the ambivalent equation of sexual aggression with the failure of intellect in *I use to have a good imagination*. Emin frames naked women on hands and knees with the words 'I'm thinking the same way – the same way as a demented child I repeat myself too much' (*Inspired*, 1998 [**23**]) and a desperate plea (*Don't just leave me here*, 1997 [**29**]).[13] These works are acidic when compared with the folksy charm of a tent appliquéd with the names of everyone she's ever slept with (siblings, best friends, lovers, parents), or the defiantly happy stance of 'Mad Tracey from Margate' expressed in her literalized crazy quilts: gin-soaked observations stitched into colourful blankets ('LEAVE HIM TRACE', 'FUCK OFF BACK TO YOUR WEEK WORLD THAT YOU CAME FROM', 'I LOVE ALL MY FRIENDS'). Taken as a whole, the work testifies to the banality of pathos. The drawings and blankets produce extraordinary affect through an almost quotidian recital of romantic triumph and disaster.

The overwhelming consensus on Emin's art is that it is confessional, that it is personal and tautological ('she opens her heart and mind without seeking sympathy or forgiveness'; 'Emin's subject matter is herself'). She is her art and her art is her.[14] Adoring and circumspect critics alike worry (defensively or critically) that she'll run out of things to say and write about her antics with the failure of subtlety that's usually peculiar to discourse on former lovers and ex-wives. Neal Brown opens his catalogue essay with 'Tracey Emin has big tits' before launching into an effusive

NO CLEAR
THOUGTS

28 *No Clear Thoughts*, 1998
monoprint
23 x 81cm (9 x 31^{7}/$_{8}$ in)

explanation of why he loves her work. Matthew Collings begins his with: 'Tracey Emin is very striking. Jay Jopling once said she was all woman.' David Bowie, in his interview with her for *Modern Painters* (excerpted and reprinted in *Harper's Bazaar*), remarks: 'She shimmied like a disco-queen. If she wanted, she could travel the length and breadth of the land with me and my band. Everyone from stagehands to musicians would immediately fall in love with her.'[15] Her reception is littered with come-ons. Everyone is trying to 'pick up' Emin, as if her use of props from her everyday life (like her bed) and personal experiences (like pregnancy and abortion) constitutes an invitation to think about Emin the artist as an always-already available sexual object, as if these objects worked as metonyms for Emin the (injured) woman more powerfully than they do as metonyms for Emin the artist.

I am not exactly interested in contesting this aspect of her reception's history. The blurring of the boundary between Emin's person, her work and her public persona is an important effect of the work itself, and not simply because the work is so explicitly autobiographical. What makes Emin interesting, from my perspective, is not only the sensationalism of her self-presentation, and the way that her work seems to encourage suspicion about the originality of the gesture – as if the force of narratives of abuse, unwanted pregnancy, sexual conquest and humiliation was pinned entirely to their novelty, or even their veracity (it isn't).[16] The work is, on top of all these other things, melodramatic, and this trait is fundamentally intersubjective. Reviews almost invariably describe weeping young women who identify with Emin's narratives of abuse, humiliation, rebellion. These spectators are so moved because they feel the work is not so much about 'Trace' as it is about them.

I'm not convinced, in other words, that what makes Emin controversial or interesting is the deep narcissism described by her oeuvre, or an autobiographical practice that seems unchecked by a sense of decency or shame.[17] One could ascribe those same qualities to contemporary artists with extremely different styles – Mary Kelly, Jeff Koons, Robert Mapplethorpe. At first glance, it seemed to me that Emin's work fitted squarely within the major paradigms of feminist art-making: grounded in personal experience; explicitly critical, even accusatory in tone; her body offering itself up as a site of spectacular ambivalence; the citation of domesticity – a bed here

29 *Don't just leave me here,* 1997
monoprint
58 x 81cm (22⁷/₈ x 31¹⁵/₁₆in)

and there, a grandmother's chair, homemade blankets – objects that, however, invoke a kind of failed domesticity, the failure of a house to acquire fully the aspects of a 'proper home'. I can invoke a range of feminist art-historical contexts for Emin – artists like Carolee Schneeman, Cindy Sherman or Hannah Wilke who explore 'the paradox of being both artist and object at once';[18] Judy Chicago's recuperation of feminine modes of production; Ann Magnuson's and Annie Sprinkle's use of their own bodies in the performance of sexual scripts. But none of these artists produces work that is quite as maudlin, or that provokes such a particular response from spectators. Emin's work seems to offer itself up as an 'unedited' incorporation of the remains of a messy sex life, as a fantasy of a (nearly) unmediated encounter with the artist herself – again, less precisely as an 'artist' than as a woman. In doing so, however, it sets the stage for a fantasy encounter – between her, and you, and me.

Emin's work invites us to take it personally. I first saw *My Bed* (**36**), the monoprints and videotapes at Lehmann Maupin gallery in New York ('Every Part of Me's Bleeding', 1999), and, as jaded an art consumer as I am, I could not stop looking at works such as *No Clear Thoughts* (**28**) and *Terrebly wrong*, 1997 (**30**). The body in the latter leans so far back her head disappears – her legs are open and her body expels an abortive, squiggly pile of blood, shit or semen. It is a gynophobic poster; a record of sexual damage. The body ego limned by these drawings was familiar to me. I found myself interpolated by the work, as a spectator, in a manner that was both uncomfortable and exhilarating. I couldn't help but think: 'Isn't this how Judy Chicago and Georgia O'Keeffe are supposed to make me feel (but don't)?' This response, an intense identification with the affect of the work, is melodramatic – akin to the attraction to the gorgeous cinematic abjection of the last scene of *Stella Dallas*, with Barbara Stanwyck in a tacky dress, in the cold, crying, chewing on her handkerchief, outside, alone.

A set of problems has emerged as I try to represent my attachment to Emin's work to colleagues who are almost universally suspicious of it as 'too obvious' and 'not as good' as that of her contemporaries. ('Why don't you write about Sarah Lucas?') The unavoidably personal character of my response is a problem in criticism. I reveal too much about myself in laying claim to this response (a risk that does

30 *Terrebly wrong*, 1997
monoprint
58 x 81cm (22^{7}/$_{8}$ x 31^{7}/$_{8}$in)

not adhere to identification with Chicago's soft, slightly abstracted vaginal portraits). That the work feels like it is addressing me does not feel like a critical response at all (a failure of intellect to rise above emotion).

It is difficult to evacuate the personal, the intimate, from discussion of Emin's work. This makes it hard to defend the work's aesthetic value without engaging in an exercise in bad faith. It seems almost impossible to speak of the encounter with Emin's work as an 'aesthetic experience' unless we do so negatively, in as much as Emin's oeuvre is grounded firmly in all those things that the aesthetic, traditionally, cannot accommodate, such as semen and tears.

Think, for instance, of Michael Fried's famously anxious essay 'Art and Objecthood'. There he narrates his suspicion of the seductive powers of the art object that seems to anticipate the physical, sensual presence of the beholder, that appears to depend upon the desires of an audience (and therefore leans into theatricality, inducing, in his argument, a miscegenation of genre).[19] Fried's wariness, his ambivalence about the place of embodiment and feeling in art, interestingly, rhymes with a feminist (or anti-homophobic, or anti-racist) sense of the hazards of having a body – the kind of hazard Laura Mulvey delineates in her essay on the dependence of the pleasures of narrative cinema on the visual subjection (objectification) of women in representation, or even with a Foucauldian suspicion of the liberatory possibilities of making sex visible (as an object of study). Feminists are not necessarily, in other words, any less uneasy than the average conservative art historian about the appeal that static art objects and performances make to the senses (for all the ways that this seems to flirt with disaster).

This is to say that narratives of the relationship between the art object and the institutions of the art world have often been written from an abstracted place, in which the body represented in or by the work of art and consumed by the spectator/reader has no material specificity. Narratives of art and institution are frequently written from a place in which the most successful resistance to institutionalization, to commodification, to a conservative politics, is imagined as the resistance to materialization. This is figured powerfully in criticism either as a tendency favouring abstraction, or as a treatment of art objects as the mournful

remains of something lost. This kind of erasure, in which the problems that most drive our work as critics (questions about pleasure and the body, for example) are washed clean of all the organic materials that make those problems interesting (the material and political role of sex, gender, race or money in aesthetics), is almost impossible to sustain when writing, talking or thinking about the work of Tracey Emin.

My impulse to take my own response to Emin's work as its content, is no less scripted, no less banal than the stories and states that Emin depicts. I am compelled, somewhat counterintuitively, by Emin's work insofar as it enacts a series of immediately recognizable, clichéd performances of feminine sexual abjection. I recognize myself in those clichés. And, worse, I find myself caught in the cliché of a woman's response to a woman's work – in which I identify with it, in which I refuse emotional distance and linger in affective proximity.

We can think of Emin's solicitation of our desire and interest as an effect of intimacy. The effect of intimacy may be thought of as an analogue to Michael Fried's 'effect of realism'. Fried has powerfully displaced the critical treatment of painterly realism as 'the painter painting what he saw as he saw it'. In this view (and here I'm rehearsing a critical conversation I've had before), the realist text 'represents with something approaching total fidelity the painter's perception of an original, actual situation, from which the further conclusion is drawn that any features of the painting that are at all unusual have their rationale in the specifics of that situation and in the emphases and limitations inherent in the painter's point of view'. This approach, Fried argues, is built around a metalepsis – 'the confusion of effect with cause'. The only evidence we have of the original situation and determining point of view is the painting itself which therefore can't be taken to establish the priority of either. In this case, 'What are the sources for the painting?' becomes a less interesting question than 'What kind of effect does the painting create in the spectator?'

What if we approach the intimacy of Emin's work – its materialization of physical and emotional availability, its metonymic relation to the artist and her body, its invitation to melodramatic identification – as an effect, as an aesthetic strategy? This is to take availability itself as the subject of her work. If, as Gayatri Spivak writes,

'the discourse of man is the metaphor of woman', the allegorical force of Emin's self-portrait, before she sets pen to paper, has already been enlisted in the service of someone else.[20]

The work, in this sense, describes the ambivalence about objecthood shared by diverse writers (Bersani, Fried, Mulvey), albeit for different reasons. The visibility of public investment in Emin, as erotic object, should reveal the homosociality of art criticism which is all the time working itself up over the bravura, the wounded masculinity or the macho cool of characters such as Jackson Pollock, Julian Schnabel or Damien Hirst, without avowing the economies of erotic investment in them. It should render visible, furthermore, the odd place of women in art – walking wounded, *vagina dentata*, emptied-out sex pots, valuable only insofar as they are fungible, only insofar as their bodies have no intrinsic significance.

The necessity of what Amelia Jones has termed 'the embodiment of the interpretive act' to Emin's work places it at an uneasy remove from the aesthetic: there are too many people in the room, reciting too many scripts.[21] Here, Emin stages her work as a failure of objectification – framing her work (and herself) in such a way as to make the disinterested appropriation of it as 'art object' impossible without flirting with the very conservative models of artistic genius and expression that Emin lampoons, or acknowledging the disavowals of libidinal, economic, affective and emotional interest that underpin the business of art consumption.

CHAPTER 6

BEDTIME

MANDY MERCK

It wasn't possible to view the Tate Gallery's exhibition of artists nominated for the 1999 Turner Prize in whatever order you pleased. A strict traffic plan routed the throngs of spectators into a room of work by Tracey Emin, then past a second, darkened chamber screening her autobiographical video (packed with viewers watching the artist's tearful discussion of her abortion on my visits); on to a divided space on whose walls Jane and Louise Wilson's monumental videotapes of Las Vegas casinos were projected; then to a long, rectangular room where Steven Pippin's 'Laundromat-Locomotion' photographic reworking of Muybridge hung; and then to three smaller ones in which two films and a slidework by Steve McQueen looped continuously as the exit sign shone through the gloom. If the exhibition had been a dwelling, the bedroom was the brightly lit foyer, the first space you encountered, and the façade that kept falling on McQueen in his tribute to Buster Keaton, *Deadpan*, 1999, relocated deep in the darkened rear of the house. The literal foregrounding of sex which this exhibition accomplished is my starting point, its central and contro-versial object Emin's *My Bed*, 1998 (**31**), an installation including the artist's bed, soiled sheets, bloodied underwear, empty vodka bottles, discarded tissues, fag ends, used condoms and other post-coital detritus.

Born in 1963, Emin grew up in the coastal resort of Margate, where her Turkish-Cypriot father divided his time between two families and her English mother ran an eighty-room hotel. Abused from the age of eight, raped at thirteen, promiscuous in her early teens, derided as the town slag, she has subsequently made this biography (which also includes a suicide attempt and the decapitation of a favourite uncle in a car crash) the subject of her work. At present she is Britain's best-known artist, a celebrity inaugurated with the 'Britpop' explosion of young British artists, the

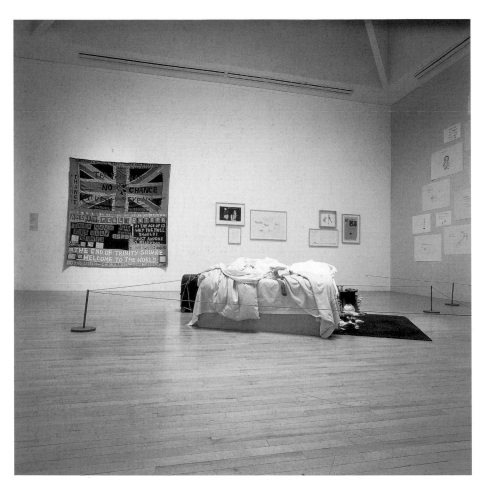

31 *My Bed*, 1998
mattress, linens, pillows, rope, various memorabilia
79 x 211 x 234cm (31 x 83 x 92in)
installation shot, Turner Prize Exhibition, Tate Gallery, London
20 October 1999–23 January 2000

massive publicity accorded to the 'Sensation' exhibition at the Royal Academy in 1997–8 and her penchant for self-promotion.

With *My Bed*, Emin became a prominent figure of personal sexual suffering and public exhibition (often compared to the copyright holder on that situation, Princess Diana) and critics have duly thematized the public and the private in response to her work. In Sarah Kent's account of Emin's childhood, it was an 'environment where public and private realms intertwined', where Tracey and her twin brother developed a secret language 'to gain privacy in the semi-public domain of the hotel', a privacy that nevertheless failed to protect her 'from the sexual advances of visitors nor... prevent her from spying on the guests and witnessing things normally reserved for adult eyes'.[1]

But one need not be aware of this biography to get the point when someone's dirty laundry is aired in the Tate. As the *Independent on Sunday* (24.10.1999) (**32**) immediately asked in response to the exhibition of *My Bed*: 'Would you show your bed to the public?' The answers that the newspaper printed revealed a surprisingly literal take on that question, perhaps because two of those asked worked for interior-decorating magazines. Thus, a designer for *Better Homes* declared that her 'worst nightmare would be putting my bed on display... I've moved house recently and I've no storage space yet in my bedroom so all my clothes are piled up on two chairs'; while a journalist for *Living Etc* enthused 'I always make my bed in the morning and I'd say it was pretty passable... I think people should be prepared to show their bedroom off at any time and always keep it tidy.' Two high-school students replied to the question with similar meditations on their personal cleanliness (or lack of it), going on to challenge the exhibition of Emin's bed in an art gallery: 'Putting your bed on display for "art's sake" is a waste of time and money. Art should evoke emotion or thought'; 'I wouldn't put my bed on display as a piece of art... I don't think there's anything artistic about being a messy person.'

This question wasn't confined to the *vox populi*. In the *Observer* (24.10.1999), critic Matthew Collings (the Ruskin of the yBas, famous for his *faux-naïf* evocations of the contemporary British scene) asked if anyone's bed could be a work of art. To determine this, he compared Emin's installation to three other beds: that of video

Would you show your bed to the public?

Last week Tracey Emin provoked controversy when her bedroom was exhibited as part of this year's Turner Prize

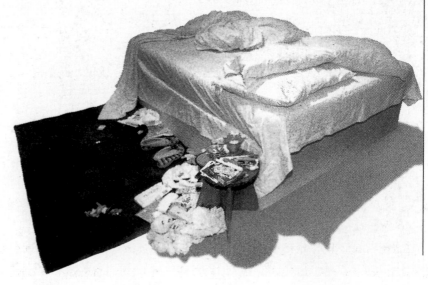

artist Gillian Wearing, winner of the 1997 Turner Prize; that of comedian and play-wright Arthur Smith, whose characters stay in bed onstage throughout his *Live Bed Show*; and his own. Comparing the formal values of *My Bed*'s rumpled white surface to the minimalism of Wearing's loft sleeping space, the boudoir fantasy conveyed by Smith's bedside oil of a female nude and the colour-field pulsations of his own red and green duvet, Collings accorded all four beds an aesthetic defence. (The degree to which this was parodic was never quite clear – thus his success as both critic and satirist.) The difference, he argued, is that 'there's a little culture of "Tracey Emin" that she's worked on over the years, and this is what makes it possible for her bed to make the leap from lifestyle into art'. In Collings's description, that culture consists of an unacknowledged economy of expression allied to Emin's 'emotional maximal-ism', 'cheap shock content' and 'torture and anguish'.

A typical example of these characteristics is Emin's *Love Poem*, 1996 (**33**), in which she turns to the textiles reworked by feminist artists since the 1970s and appliqués cloth letters to a sheet. The poem reads:

123

> YOU PUT YOUR HAND
>
> ACROSS MY MOUTH STILL
>
> THE NOISE CONTINUES
>
> EVERY PART OF MY BODY IS
>
> SCREAMING IM LOST
>
> ABOUT TO BE SMASHED
>
> INTO A THOUSAND MILLION
>
> PIECES EACH PART FOR
>
> EVER BELONGING TO YOU.

Such representations develop a continuing theme in Emin's work, where sex is not so much coupled with violence as equated with it. But if her own experience registered this equation as a biographical fact, it is also a familiar theme in many feminist critiques of heterosexuality as well as in psychoanalytic accounts of human sexuality in general. Freud claimed that children perceive intercourse as violence, a 'sadistic view of coition' in which the stronger parent is believed to be overwhelming the weaker, and that they experience 'obscure urges to do something violent' in early

33 *Love Poem*, 1996
appliqué blanket
243.8 x 243.8cm (96 x 96in)

sexual arousal.[2] These observations later developed into a metapsychology of sex as violence, in which the subject's earliest sexual excitations are said to be experienced not as pleasure but as pain, trauma, a breach of psychical defences. It is the elaboration of this theory, via the writings of Jean Laplanche, that leads Leo Bersani to postulate 'an identity between a sexualized consciousness and a destabilized, potentially shattered consciousness'.[3]

In a consideration of abject art, 'drawn to the broken boundaries of the violated body', Hal Foster considers the 1990s aesthetics of trauma, which he sees as a rebuke to the poststructuralist celebration of desire and subjective mobility in fantasy. Such art is read to register the despair generated by systemic poverty, disease, death and an abandoned social contract. But Foster is sceptical of the ascription of truth to abjection, noting that it relies on two incompatible presumptions: the psychoanalytic account of trauma as that which shatters subjectivity, and more popular views that grant the sufferer the authority of 'witness, testifier, survivor'. 'In trauma discourse,' he concludes, 'the subject is evacuated and elevated at once.'[4]

Tracey Emin's artistic career might have been invented to illustrate this paradox. If, as Foster says of Cindy Sherman's disaster images, her 'signifiers of menstrual blood and sexual discharge, vomit and shit... evoke the body turned inside out, the subject literally abjected', it is certainly possible to describe Emin's unmade bed, with its own residue of bodily effluents and the gashed pillow emitting its pubic stuffing, in this idiom. Indeed, the skidmarks so evident on her sheets bear testimony to an excremental tradition on which she may be knowingly calling, one that begins with Robert Rauschenberg's 1951–3 *Black Paintings*, canvases covered by newspaper dipped in glue and several coats of 'shit brown and black' paint, and continues with Rauschenberg's own *Bed*, 1955, its linen soiled with graphite scribbles and thick gobs of paint.

Like the stains on Emin's linen, these effluvial references can be taken as attempts to connect the artist's body with the artwork, a connection that Rauschenberg also rendered indexical in various works by applying paint to canvas directly with hands or by handpressing his collaged images into their glue. Helen Molesworth reads the resulting glue stains as tantamount to the bodily emanations

that dirty our surroundings: 'sweat, semen, mucus, the remains of sex on linen'.[5] Her inventory clearly anticipates the traces left on our aptly named artist's bedding. Moreover, from 1949, Rauschenberg collaborated with his soon-to-be-wife, Susan Weil, to give such psychical indices corporeal form by placing a model on light-sensitive paper in the *Blueprint* series. The best-known of these is the life-size figure of the artist's friend Pat Pearman in a bathing suit (*Female Figure [Blueprint]*, c. 1950). Rauschenberg himself posed on blueprint paper for the *Untitled* (c. 1950) work in the series and later had himself X-rayed for the 1967 composite print *Booster*, in which five skeletal sections of his body are juxtaposed with serigraphs of spinning rockets and a gravity-defying long jump. But where Rauschenberg's anatomical work, however indexical, withdraws into the deep space of diagram and dissection,[6] an ethos supporting a *recognizable* union of subject, object and – debatably – abject would be Emin's inheritance of the century's end. Thirty years after *Booster*, she performed the functions of artists and model during a fortnight's residence in a

windowed space in Stockholm's Galeri Andreas Brändström, where spectators viewed and photographed her painting, eating, sleeping and telephoning friends – nude. There Rauschenberg's excremental theme was reprised on a large canvas in which a roughly outlined female face smokes a cigarette in profile next to a painted caption reading:

> THE FIRST CIGARETTE OF
>
> THE DAY ALWAYS MAKES
>
> ME WANT TO SHIT
>
> THIS IS MY FIRST

To the right of the figure a series of vertical black brushstrokes coalesce to form a suitably shitty stain.

But as the photographs of Emin – toned, tanned, concentrating – in the Stockholm show suggest, the tenor of her work is not always that of abjection or agony. Indeed, her physical attractiveness, combined with her increasing fame, led to catwalk modelling for Vivienne Westwood, endorsements for Bombay Sapphire gin and Beck's beer, and celebrity appearances at the plethora of public events that marked the opening of exhibitions and galleries across Britain

at the beginning of the new millennium. In an interview for *Frieze* magazine Emin once argued that pain is just the part of her work 'people hook into' and declared her intention to continue mining all her own experiences. The interview is headlined 'The Story of I'.[7] As Turner Prize judge Sacha Craddock observed when naming Emin to the 1999 shortlist: 'There is a constancy of subject and we all know what that subject is: It's her.' Or, as Collings puts it: '"I really matter" is the message of her art.'

If the vandalism an artwork elicits can be said in some way to characterize it, what happened to *My Bed* seems consistent with these allegations of egotism in Emin's oeuvre. Where Damien Hirst's pickled lamb at the Serpentine Gallery and Marcus Harvey's portrait of child-killer Myra Hindley in 'Sensation' were doused in ink, visitors to the Turner Prize exhibition watched as two men leapt half-naked onto Emin's installation and staged a pillow-fight. ('Fan Hits Sheet', a tabloid headline announced the next day.) One of the men was reported to have shouted, 'This is art. I am art.' After their release from Belgravia police station, performance artists Xi Jianjun and Cai Yuan – whose previous interventions included scattering £1,200 in a London art college to highlight the greed of the art market and erecting mock street signs to confuse spectators at the Venice Biennale – explained that they were 'simply trying to react to the work and the self-promotion implicit in it'.[8]

'I am art.' In his discussion of personal pronouns the linguistic analyst Emile Benveniste reminds us that 'I' has only a momentary reference, to the act of individual discourse in which it is pronounced. But the short life of this 'shifter' belies its efficacy. In its utterance the speaker proclaims herself *as* a subject. To feminize Benveniste's formula, '"Ego" is [s]he who says "ego".'[9] Saying 'I' brings 'I' into being, makes 'I' really matter. Nevertheless, the denotative function of the personal pronouns and pronominal adjectives may be appropriated by any speaker. Hence the journalists' replies to *My Bed*: What about *his* bed? *Her* bed? What about *my* bed? Or, to move from the metaphor to the implicit meaning, what about my subjectivity? My body? My art? My suffering? Interestingly, Benveniste cites the verb 'suffer' for the way that a difference in person does not change its meaning. Unlike, in his example, 'swear', where the first-person utterance ('I swear') binds the speaker and the second-

and third-person usages merely describe such vows, the conjugation of 'suffer' does not vary the state described in regard to the speaker, the one spoken to or the one spoken of: 'I suffer, you suffer, [s]he suffers.' But Benveniste does not conjugate 'suffer' in the plural and neither, I would argue, does Emin's installation. Despite its public exhibition and discussion, despite the crowds that queued at the Tate, despite the universality ascribed to the artist's work by critics who read it as 'reflections on the crummy pathos of the human condition', it remains *My Bed*, not *Our Bed*.

In the world's wealthier cultures the bed is a commonplace figure for solitude. From crib to coffin we lie, for much of our existence, alone. Coming to terms with this is regarded as a sign of maturation in small children, and it's a lesson that adults must often relearn in later life. But the bed, particularly the unmade bed, also stands for what might seem the opposite of solitude – sex. On the one hand we have Walker Evans's 1930s photographs of lonely black bedsteads with cold white sheets, on the other, Delacroix's *Un lit défait*, 1824–6, and its dishevelled suggestions of a night of passion. But as Emin's installation, and much of her other work, insists, sex is not an antidote to singularity. Hers may be a double bed, the bed for the couple and coupling, but that only makes it a more potent figure of longing and abandonment. Moreover, its stained linen can be read to represent the dangers sex still represents for women – virginity undone, reputation lost, desire supplanted by disgust. At the very least, Emin's bloodied bed suggests a battlefield, the *amor militis* celebrated in the Renaissance. Looking at it, I was reminded of Don Paterson's poem 'Imperial', in which a man and a woman spar until finally one night they surrender to each other 'like prisoners over a bridge'. As the sun rises the next morning, it casts a reflected red globe on the white sheets of the post-coital, but even more antagonistic, couple. The narrator marvels:

> and no trade was ever so fair or so tender;
>
> so where was the flaw in the plan,
>
> the night we lay down on the flag of surrender
>
> and woke on the flag of Japan.[10]

Describing the contemporary epoch he calls supermodernity, the anthropologist Marc Augé observes that even as the forces for cultural homogenization, or

'globalization', accumulate, so do 'the factors of singularity... backed by a whole advertising apparatus (which talks of the body, the senses, the freshness of living) and a whole political language (hinged on the theme of individual freedoms)'. The paradoxical product of mass similitude is solitude, Augé argues, as collective identifications recede in the face of acculturated individualism and the ego 'makes a comeback'.[11] This comeback has been charted most devastatingly in Wendy Brown's warnings against the privatizing impetus of contemporary identity politics, including feminism. In a more detailed diagnosis of the public trauma described by Hal Foster, Brown identifies the expansion of capital and the bureaucratic state, increasing secularism, the distintegration of communal institutions and the increasing production of individuated identities by consumer capitalism and social regulation as forces that 'combine to produce an utterly unrelieved individual'.[12]

All too often the consequence of such suffering has been the political vindication of suffering itself – personal trauma as the source of superior knowledge and moral standing. But in a moral economy that so values suffering the subject must cling to her subjugation in order to be recognized as a subject, an 'I' steadfastly imagining itself to be cast out from the community of 'we'. This *ressentiment* was instantly ascribed to Emin's installation in the most severe criticism of *My Bed*, a review that stressed its complicity with a long tradition of confessional art in which women 'strip off and cry to get noticed'. The author, Natasha Walter, cited Germaine Greer's observation that female poets must choose between being 'happy and mute, or unhappy and articulate' and counselled Emin 'to make her bed and move on' from autobiographical expressionism to a more detached and analytical conceptualism.[13] But if the woman artist (and clearly not only the woman artist – read Martin Amis's *Experience*) can barter private grief for public notice, what does the spectator get?

In one of her best-known works before *My Bed*, *Everyone I Have Ever Slept With 1963–95*, 1995 (**6**), Emin appliquéd the inside of a tent with the names of all her bed partners, including her grandmother and her fraternal twin. In order to read them and the stories attached to the tent's sides, the spectator has to crawl inside the womb-like structure and lie on the message inscribed on the blanket covering the floor:

'With myself, always myself, never forgetting.' A critical celebration of this brief encounter with an artist who sleeps with herself argues that it affirms another self, that of the spectator, whose own sense of personal continuity is sustained in an experience of intimacy and separation she compares to 'sex with a stranger'.[14] As Emin's celebrant summarizes the lesson of her tent, sharing is inevitably short-lived, but the self survives. But such compensation only sustains the political momentum lamented by Augé, Brown and Foster, in which isolation is assuaged by narcissism and identity affirmed in lieu of the strategies or sustenance of collective existence.

POSTSCRIPT

In May 2000, I was asked to discuss Emin's bed at a conference called 'Remembering the 1990s'. Could her installation be said in some way to characterize the decade? Certainly the commentaries I've quoted here share an ambition to historicize the period, described by Augé in 1992 as 'supermodernity', by Brown in 1995 as 'late modernity', and (with a good deal of qualification) by Foster in 1996 as the 'postmodern'. Although none alludes to any of the others, their descriptions are strikingly similar, notwithstanding the variations in prefix. Moreover, each includes a sustained discussion of what Brown describes as 'the contemporary problem of history itself'.[15] Here again, they concur, claiming that history has become an intolerable weight (Brown citing Marx's *Eighteenth Brumaire*) or pressure (Foster citing Benjamin's *One-Way Street*) or excess (Augé citing François Furet's *Penser la Révolution*).

For Brown, the force of past events convinces the resentful contemporary subject of her (or his) impotence. For Foster, the wired-up immediacy of current events requires a rethinking of critical distance and analytical perspective. For Augé, the sheer number of events in our collective memory expands with increased life expectancy and the globalization of information. Far from defying significance, this excess of events incites interpretation, turns happenstance into history, as we demand 'meaningful' lives. 'Nowadays,' he writes in what might have been a warning to my confrères, 'the recent past – "the sixties," "the seventies," now "the eighties" – becomes history as soon as it has been lived. History is on our heels, following us like our shadows, like death.'[16]

In one of the many histories that followed on the heels of the 1990s, twenty-four-year-old novelist Zadie Smith cited Emin's career, and her own, as examples of the decade's acceleration of cultural celebrity and its assimilation of artistic experiment into advertising. Again, this was articulated as sexual violence. Looking at Emin (with an image of *My Bed* in the accompanying illustration) Smith declared 'how hard it is to be the feminine symbol in the twentieth and twenty-first centuries; how constantly it is like a rape and damage... She's not the artist; she's the art, at the moment.'[17] A subsequent article pointed out that Emin's Turner Prize exhibition included a framed newpaper interview of the artist and that her first notable work in 2000, for the opening of the new White Cube[2] gallery, was a urine-stained blanket titled *I Think it Must Have Been Fear*, 2000 (**34**). On it is written: 'The only reason I like printed stuff is to prove that I exist. My children could be a few boxes of clippings – the stains of life.' The article complains that very little in the five books of Emin press cuttings collected by her gallery over the last two years deals with her work.[18]

At the moment, nowadays, neither the transformation of the woman into spectacle nor the artist into art is a particularly surprising occurrence – whether or not one approves. Nor, since Warhol, can anyone find the acceleration of celebrity or the interfacing of art and advertising at all unusual. But even if, as the Institute of Contemporary Arts director Philip Dodd argued in his discussion with Zadie Smith, 'that doesn't mean that the art is poor, just that the critical language to make sense of it is exhausted', this still leaves the problem – and the problematic – of making sense. If the 1990s were noisy with demands that the decade make sense, be significant, become history, that history became a predictably tautological enterprise, in which Emin's art mattered because she suffered and she suffered because her art mattered.

POST-POSTSCRIPT

In July 2000 I came across a new article attempting to theorize the relationship of the historical and the contemporary in a volume dedicated to the work of Stuart Hall. Like my talk on *My Bed*, the piece straddled the supposed cusp of the millennium, having been written before it and published afterwards. This, and further develop-

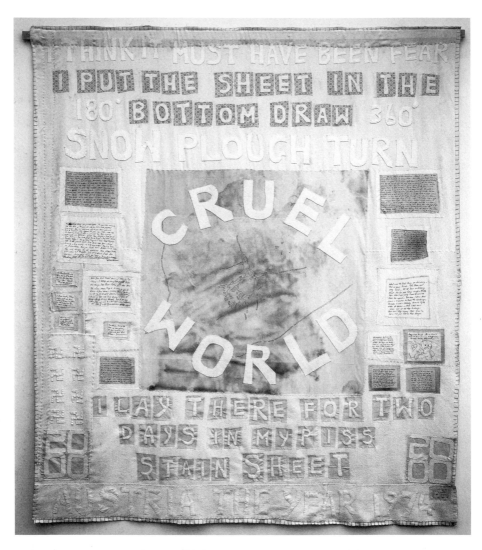

34 *I Think it Must Have Been Fear*, 2000
appliqué blanket
232 x 200cm (91⁵/₆ x 78³/₄in)

ments in the critical discourse on Emin, gave a certain salience to Lawrence Grossberg's thoughts on 'when the twentieth century is no longer contemporary'.[19] To make an admirably short summary shorter still, Grossberg takes up the argument that modernity has always understood itself as the present, that which is beyond history, contemporary by its very nature. (Here there could be no better example than the hugely successful Tate Modern, opened in spring 2000, with its thematically rather than chronologically organized exhibitions achieving a competitive contemporaneity over its parent museum, even though Tate Britain, as it is now known, continues to stage major shows of new work.) Conversely, Grossberg argues, the subject of modernity is still historical, reaping what she sows in a continual process of self-realization.

While I was reading Grossberg on the difficulties of historicizing the present, Tracey Emin was ascending from artworld celebrity to the celestial heights of pop stardom, compared to Posh Spice for her performance of herself, but without the usual pathos or condescension. If the lives of both were regarded as more 'compelling' than their work, this led neither to their condemnation nor to predictions of personal disaster.[20] The month before Victoria Beckham's new single entered the UK charts at number two, *My Bed* was purchased by Charles Saatchi for £150,000, reportedly some £130,000 more than the original price. As Emin observed to the London *Evening Standard*, the Turner nomination had considerably improved her sales, as well as securing her A-list status in the fashion world. 'I'm not an outsider at all,' the avatar of abandonment declared. 'I go to all the parties.' Popular, prosperous and – as it turned out – partnered since 1997 by artist Mat Collishaw, Emin had miraculously escaped from the suffering required for 1990s subjectivity, freed – according to her interviewer – by the very art that 'asks us to examine the messiness of her life': 'Tracey got up. As she did with the rest of her tousled life, she remade her bed and got rich, famous and happy, or happier, doing so.'[21] Perhaps the decade was over after all.

133

ON THE MOVE

My Bed, 1998 to 1999

DEBORAH CHERRY

A year before its 1999 showing in London, Tracey Emin's *My Bed* made its first appearance in Tokyo. Following its subsequent enthusiastic reception in New York, it became a sensation when it was included in the Turner Prize show at the end of the year. Marooned in the raging sea of a woman's tempestuous emotions, *My Bed* now circulated in an economy of excess. For her British critics it expressed Emin's sluttish personality and exemplified the detritus of a life quintessentially her own; it was, above all, confessional. Emin's art was Emin, no more and no less than a tormented life story writ large on the stage of the art museum. What happened to the work as it travelled from London to Tokyo and back again, re-routed through New York? Analysing the predicament of installation art in the globalized art world of the later twentieth century, Miwon Kwon has drawn attention to the necessary return of the author. As itinerant artists travel from one place to another, reprising work for disparate audiences in heterogeneous spaces, the artist has become, she contends, the sole guarantor for the artwork's 'verification, repetition and circulation'. In the ever expanding transnational networks of dealers, galleries and biennials, it is the figure of the artist who can carry and fix meaning, who can ensure the work's intelligibility from site to site. As she concludes, this renewed emphasis on the artist as narrator and chief protagonist has resulted in the 'hermetic implosion of (auto)biographical and subjectivist indulgences'.[1] Kwon's commentary is particularly apt, for although in crossing continents *My Bed* has been varyingly (re)assembled, its creator has been installed as both the source of its meaning and its explanation.

In what Kwon calls the 'intricate orchestration of literal and discursive sites', the figure of the artist arrests the possibility that the art will not signify or will be rejected

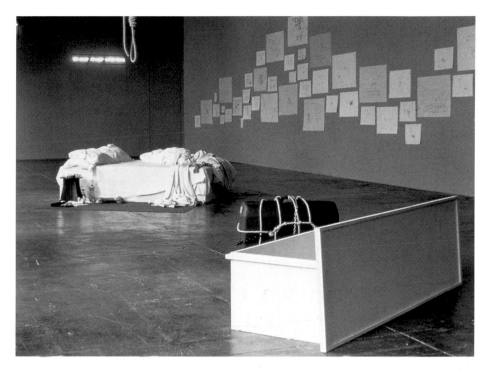

35 *Better to have a straight spine than a broken neck,* 1998
Mattress, linens, pillows, rope and various memorabilia
79 x 211 x 234cm (31 x 83 x 92in)
installation shot, Sagacho Exhibition Space, 1998

by new audiences. The art of the 'young British artists' is an art of late-twentieth-century Britain, often charged with specific cultural references which are not always comprehensible outside the island. This insularity has been emphasized by Kobena Mercer, who has characterized yBa art and its reception as 'defensive and, above all, regressive responses to the bewildering effects of globalisation'. Where Britain has attempted to come to terms, however uneasily, with multiculturalism and diversity, these artists have, he argues, traded relentlessly in stereotypes of Britishness.[2] Given this isolationism, it has been a deft move to put the artist, with a limited biography, up for global transfer, for this figure inhibits what Jacques Derrida has identified as *débordement*, the chaotic overflow of meanings into the unpredictability of difference and deferral. To map the movement of *My Bed* is to interrogate its *débordement*, its potential for meanings to overspill into the disjunctive yet overlapping contexts of sexual politics, homelessness and displacement at the end of the twentieth century. With their cartographies of diaspora and address to the unresolved longings of identity, the installations of *My Bed* touch on and point to some of the key concerns of a contemporary moment.

MAKING

For the Sagacho Exhibition Space, an alternative gallery on the international circuit, Emin created *Better to have a straight spine than a broken neck*. In an elongated space with windows ranged down one side, the bed was placed at an angle, a rope noose suspended from the ceiling, and juxtaposed to a wooden coffin box beside which were two bound suitcases (**35**). A collection of drawings was exhibited on the long wall and two white neon signs gleamed in the distance. To approach the bed was to pass the coffin box and the suitcases, moving deep into the space in which bed was theatrically staged. In a dramatic interplay of spatial geometries, emptiness counterpointed the cluttered wall, brilliant white contrasted with the dull surfaces of paper and the sheen of rumpled linen, flat horizontality was set against the strong vertical of the rope.

My Bed reappeared at Lehmann Maupin in New York (**36**) in the artist's solo show, 'Every Part of Me's Bleeding', in May and June 1999. Showcasing the many

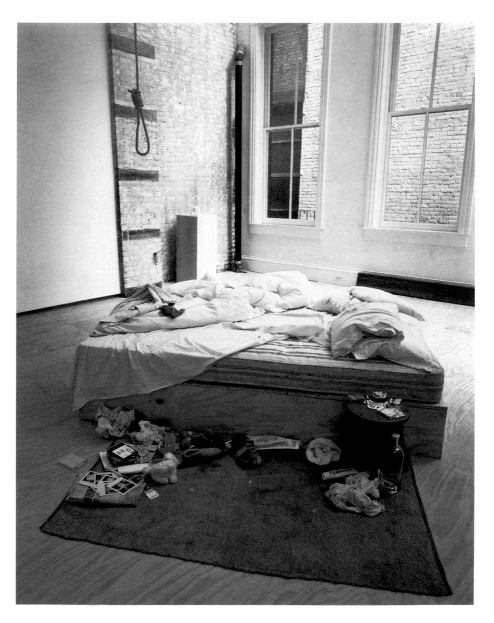

36 *My Bed,* 1998
Mattress, linens, pillows, rope, suitcases and various memorabilia
various dimensions
installation shot, Lehmann Maupin, New York, 1999

media in which Emin works, this exhibition included neons, drawings, video art, memorabilia, a textile work entitled *Pysco Slut*, 1999 (**39**), and a number of smaller installations: *Leaving Home*, 1999, which juxtaposed the bound suitcases with a metal tub part filled with gin, two keys and a spool of thread; *The History of Painting*, 1999 (**51**), and *The History of Painting Part 2*, 1999, fashioned with pregnancy-test kits, morning-after pills, used tampons, blood and tissue; and *The Interview*, in which two child-size chairs, slippers beside them, were arranged in front of portable television sets showing a video in which the artist, in different guises, confronted herself in a spiral of self-loathing. Adjacent to the bed were the two blue neons shown in Tokyo, *Sobasex*, 1999, and *My Cunt Is Wet with Fear*, 1998, and (seen beyond the bed in [**36**]) a small installation entitled *The first time I was pregnant I started to crochet the baby a shawl*, 1990–2000 (**38**). *The Hut*, 1999 (**40**), a reassembled beach hut from Whitstable once co-owned by the artist and Sarah Lucas, was displayed in the main gallery.[3] *My Bed* was approached through and seen between a maze of intersecting installations, still and moving images that, in the logic of supplementarity, added to and displaced it; seeing them at once distracted the gaze and intensified the viewing of *My Bed*, still positioned in a spatial narrative of distance and deferral and seen here after *The Hut*.

Shortlisted in summer 1999 for the Turner Prize, *My Bed* was installed without the rope noose or the theatricality of the Tokyo site; the two suitcases, separated from the coffin box (not exhibited) and removed from *Leaving Home*, were placed close up beside the bed, on the opposite side to the objects. The artist's space included a blue-painted wall showing her drawings and monoprints, the neon *Every Part of Me's Bleeding*, 1999 (**37**), a blanket work, *No Chance*, 1999 (visible in [**31**]), and, in a separate room, a changing selection of videos including *Why I Never Became a Dancer*, 1995 (**5**), and *Tracey Emin's CV. Cunt Vernacular*, 1997 (42).

While many of the elements were established in Tokyo, the repertory of objects that have made up the piece has been far from fixed. If some items remain consistent – sheets, pillows, towel and pantyhose on the bed, and beside it a small table, bottles, slippers, cigarette packs, condoms, contraceptives, Polaroid (self-)portraits – others change. And just as the components and their disposition have varied at each installation, so too have the pieces with which *My Bed* has been shown. What

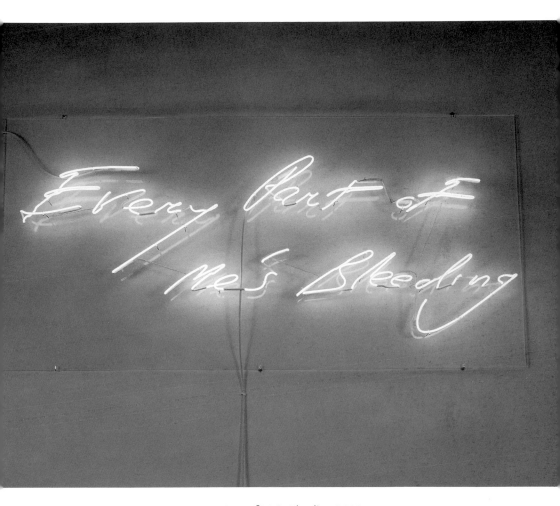

37 *Every Part of Me's Bleeding*, 1999
blue neon
100 x 200cm (39$\frac{1}{3}$ x 78$\frac{3}{4}$in)

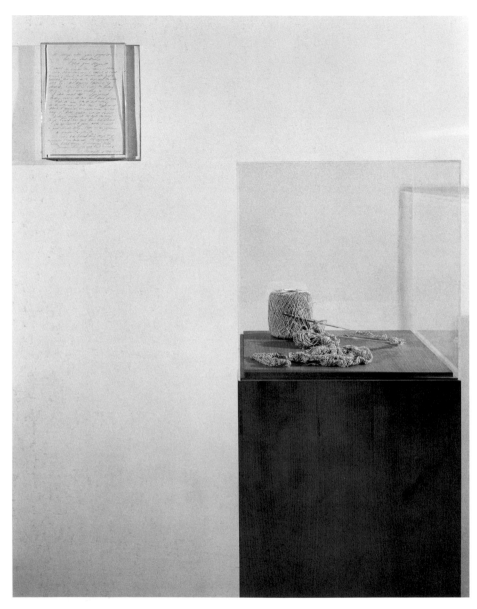

38 *The first time I was pregnant I started to crochet the baby a shawl,* 1990–2000
yarn needle, wood, text, Plexiglas
crochet piece: 141.5 x 40.6 x 40.6cm (55⁷/₁₀ x 16 x 16in)
text: 31.8 x 22.9cm (12¹/₂ x 9in)

constitutes *My Bed* is thus open to question. Is it a singular piece solely comprised of the bed base and its immediate objects or, as is suggested here, is it constituted by its exhibition locations, the assemblage taking part in installations which include other artworks with which it interacts?

Characteristic of the New York and London exhibitions in particular, and Emin's art in general, is an intermediality. It is not just that the artist experiments in and with diverse media, nor that her shows demonstrate an uncomplicated versatility; rather, her exhibitions stage juxtapositions, overlaps and layerings between works created in different media. The still, sculptural forms of *My Bed* are echoed in the moving images of *Tracey Emin's CV. Cunt Vernacular* filmed in her apartment near Waterloo station in London. Accompanied by voiceovers by the artist, a camera wanders through scenarios of clutter similar to that of *My Bed*, its slow-moving stealth bringing into view comparative disorder and identical objects. This visual and aural duplicity incites identification and prompts quests for recognition. Promising and refusing the repetition of the same, it tempts critics to ascribe a singular and stable referent, the artist herself.

141

FRAMING

American critics accepted, indeed promoted, Emin's art as open disclosure. They enjoyed what they saw as autobiographical revelation and 'controversial subjects, taken from her sordid life'.[4] On the whole, they were not hostile to or doubtful about these strategies. Christopher Bagley praised Emin for her 'profane, provocative, unflinchingly honest pieces shaped by the traumas of her childhood and adolescence'.[5] *The New York Times* celebrated an artist who, in a language akin to that of Jean Rhys and Jean Genet, 'tells all, all the truths, both awful and wonderful, but mostly awful, about her life'.[6] Her work was granted serious evaluation. A sympathetic and informed discussion over two pages in *Artforum* assessed her place in the history of twentieth-century art. Recognizing the plenitude of artistic citations, witty inversions and parodies in which her art delights, Jan Avgikos perceived her as reworking feminist traditions of textile art and as taking a critical stance in regard to major movements in modernism: 'You feel her wilful occupation of Conceptual art's formal turf

(think Bruce Nauman, Richard Serra, Joseph Kosuth) as well as her wicked put-down of its pompous austerity and authority.' To the New York art world Emin was new – *The New Yorker* hailed her 'promising début'. She offered self-exposure coupled with a provocative, even mischievous attitude to art of the recent past. Avgikos was not being ironic in suggesting that, in 'the land of CNN', Emin's art was 'perfectly suited' to a culture that delights in novelty and in the next big 'breaking story'.[7]

In London, however, *My Bed* met with controversy and notoriety. The extensive media coverage prompted the *Guardian* to proclaim 'the birth of a phenomenon', hailing Emin as 'a dedicated media tart and headline junkie'.[8] The *News of the World*, a Sunday tabloid devoted to sex scandals and celebrity gossip, told with relish how a 'furious housewife who attacked controversial artist Tracey Emin's bed' with a proprietary cleaner was pulled away in the nick of time.[9] Whereas Stuart Wavell's claims in the *Sunday Times* that 'at least the naughty schoolgirls liked it' traded on the appeal of transgression, a (tongue-in-cheek?) report in the *Sunday Mirror* noted that 'elderly readers have written in their thousands to grumble about the so-called art work'.[10]

The question that most preoccupied London critics was whether Tracey was telling the truth. If art is no more and no less than the artist's life, then authenticity becomes a key benchmark for a critical practice that judges the artist rather than the work. Whereas those who supported her argued for the unmediated translation of life into art, less enthusiastic reviewers questioned her genuineness. Richard Cork argued that 'nobody inside the show was fulminating about her unwashed knickers, or doubling up in satirical mirth at the revelations about her unbridled teenage libido and its disastrous consequences. Rather they were attending, quietly and seriously, to a young woman's frankness about the calamity and mess of her life so far.'[11] Writing in the *Financial Times*, Ralph Rugoff considered Emin's work to be candidly outspoken 'in the confessional register of our talk show, docusoap culture', dealing with 'teenage sex, bad relationships, self-destructive behaviour and emotional hangovers, with real-life hard-luck stories to which most of us can instantly respond, if not identify with'.[12] Others, however, were sceptical. Declining to view Emin's art as anything other than personal experience ('Emin brings life – in the forms of videos and things taken from the real world – into the art gallery and leaves

it there, more or less unchanged, like unprocessed sewage'), Richard Dorment in the *Daily Telegraph* expressed doubt and disbelief. Her biography, he assured his readers, was not only one of 'physical illness and emotional disorder' but character-ized by media celebrity and market success. *My Bed* was therefore '*supposedly* her own unmade bed' (my emphasis).[13] Suspicion that Emin was a media exhibitionist trading on stereotypes of dysfunctional femininity haunted feminist writing. Natasha Walter concluded that 'by making a parade of her suffering' the artist stands 'at the end of a long tradition of female artists who've gained esteem through public self-flagellation'.[14] The London *mise-en-scène*, with its misspelled jottings, declama-tory textile, screaming neon, memorabilia and 'home videos', encouraged elisions between life and art, indeed invited confusions between the two. It was all too easy to interpret her art as the outpourings of a tortured soul, to reduce it to a narrative of a singular self.

Emin's reputation in Britain has been built on a familiar strategy in art history and criticism: the reciprocity of art and life.[15] Critics, dealers, curators, collectors and even the artist herself insist that her work is produced out of and inescapably refers back to the events of her life. In place long before the Turner Prize nomination, the 'confessional' line came to prominence with the making of Tracey as a 'yBa'. 1997 saw her tent in 'Sensation', a solo show in London, and her inclusion in two accounts of recent British art: reviewers and commentators were singing from the same hymn sheet and media coverage escalated when she stormed out of a Channel Four discussion on the Turner Prize. In 'Sensation' Emin was presented as having 'fine-tuned the idea of self-portraiture and the cult of the artist by investing her objects... with an overwhelming amount of personal detail'.[16] The Jay Jopling publi-cation *I Need Art Like I Need God* confirmed this perspective, Sarah Kent asserting that 'Emin's subject matter is herself; her life story is the source of her pain and her pride. She mines this resource relentlessly.'[17] Although Julian Stallabrass, two years later, expressed concern about the asymmetry of life and art, characterizing Emin (with Damien Hirst and Gary Hume) as an artist whose fame was at risk of colliding with, even compromising, her art, generous quotations from her interviews assisted the conclusion that her art was 'confessional and self-exploratory'.[18] Nor did Matthew

Collings dissent from this opinion, confessing to his belief that her exhibited work 'told her life story in notes and diary and memorabilia form'.[19]

But the stories are not only or always Tracey Emin's. Critics and journalists have retold time and again the 'rags-to-riches' fairytale of a working-class girl growing up in a seedy seaside town who became a glitzy, funky artist in London. They have tirelessly repeated the view that hers is an art from the heart, wrought from personal experience. With its trials and tribulations, this life story, such as it is, makes excellent copy for a press that thrives on sensation and relishes a certain philistinism.[20] It comes as no surprise that censure of Emin's art is couched as satiety with these tales. *Guardian* critic Adrian Searle informed her that once he 'was touched by your stories. Now you are only a bore.'[21] Weariness with the artist may be no more than impatience with the refrain that Emin's art is no more than Tracey's life.

STINKING

Tracey Emin's reputation as the most notorious 'bad girl' of British art[22] was fuelled by the associations of *My Bed* with an aesthetics of dirt and disgust. Edgy stuff this woman artist playing dirty, provoking over-excited descriptions of 'urine-stained sheets', 'heavily soiled knickers' and 'used condoms'. Boyd Tonkin catechized 'Tracey Emin's notorious unmade bed, lapped with its scummy tide of soiled knickers, empty bottles, used condoms and discarded pharmaceuticals'.[23] Dalya Alberge's article for *The Times* was headlined 'It's Not a Dirty Bed, It's a Turner Prize Entry'. Devoting just twenty-six lines to the four contestants, the *Independent* mentioned 'soiled sheets' (twice), 'dirty knickers, cigarette butts and other debris'.[24] Savouring the scandal that 'Tate warns that soiled bed may offend', Nigel Reynolds in the *Daily Telegraph* delighted in describing 'several pairs of heavily soiled knickers', 'urine-stained sheets and torn pillows', 'smoked cigarettes, condoms, packets of contraceptive-pills, empty vodka bottles, a pregnancy testing kit, sanitary towels, nylons and three pairs of her dirty knickers'.[25]

Yet *My Bed* in all its variations is a thoughtful arrangement of items placed around a bed base. It invites ambivalent and contradictory responses. The linen is both disordered and smoothed, bright white and stained; beside the soiled items are pristine

objects such as the glistening clear glass of the vodka bottles. Encountered in daily life, all these items exude distinctive and powerful smells: sweaty feet, stinky ashtrays, stale bodily fluids. But *My Bed* emits no strong odour. Indeed, it does not smell at all. Nevertheless, a stink metaphor, already in circulation, drifted around *My Bed*. Neal Brown's earlier celebration of her art as an 'undeodorized song of poetic extremity' returned in the *Guardian*'s headline 'Clever Tracey! That bed causing a stink in the Tate has rocketed Tracey Emin from minor celebrity to mass notoriety', and in its declaration that Emin had 'tapped into a tradition of filth and got it dead right'.[26]

Comparisons to Mary Kelly (the nappy-liners of *Post-Partum Document*) and to Mike Kelley (besmirched toy animals and stained blankets), made by the *Guardian*, link Emin to what Mandy Merck in this volume rightly identifies as an 'excremental tradition' that metaphorically begins with Rauschenberg and is reprised in recent abject art with its signs and traces of menstrual blood, semen, vomit and shit.[27] Yet artistic and critical practices engaging with bodily emissions have been highly gendered and play into notions of Emin's transgressive femininity. If shit has been famously worked by male artists such as Piero Manzoni, Gilbert and George, and Chris Ofili (notably in 'Sensation' and his Turner Prize exhibition in 1998), menstrual blood, an exclusively female bodily discharge, was made visible in the politics of feminist art of the 1970s. The detritus beside the bed (soiled knickers and tampons) and the smaller installations in New York are pointers to and reminders of earlier feminist interventions, such as Judy Chicago's *Red Flag* and *Menstrual Bathroom* or Carolee Schneeman's *Interior Scroll*, 1975. The little texts that titled the small installations – *The History of Painting* – could point to the revivification of the medium among the yBas, subtly comment on one of the most intense disputes in feminist criticism, the possibilities of a feminist practice founded on the traditions of the old masters, and return to her 1996 performance documented in *The Life Model Goes Mad*.

JUMPING

The title of *My Bed* suggests ownership, someone to whom the bed belongs. For many viewers and most critics, it suggests that the owner is the artist herself. Jacques Derrida has indicated that the title of a work acts as a borderline, setting a boundary,

145

but not a conclusive limit, over which meaning can spill and proliferate in the movement of *débordement*. As he explains in 'Living On: Border Lines': 'If we are to approach a text, it must have an edge.'[28] Yet the title does not work all by itself. The 'edge' is given by the presentational matrix of title, signature and 'the unity of the corpus', or the notion that the works of the particular author have a special coherence. As Derrida has demonstrated on other occasions,[29] the signature connects work and author, art and artist; conjuring presence for absence, it comes to stand in for the person who signed and in so doing it acts as a guarantee – that this is the work of the named artist, and that what is on show is a work of art, not just anyone's unmade bed or pile of bricks. At the Turner Prize exhibition, Emin's signature was staged by the installation as a whole as well as by the gallery leaflet and information boards, critical reception and artist's statements, such as her claim that: 'It's a self-portrait, but not one that people would like to see.'[30] It was this 'intricate orchestration of literal and discursive sites', to reprise Miwon Kwon, which insistently returned the work to the artist, creating the absent artist as present in the gallery. Within this logic, the bed has a social life, its tousled state suggesting occupation by figures who have departed or disappeared, its objects the possessions of the artist or left with her by another missing person, perhaps the man who wore the underpants. Without it, possession might be transferred. This possibility was even allowed by the artist, recorded as saying after the sale of *My Bed*: 'I'm not putting my bed on display. Charles [Saatchi] is. It's his bed now. The bed's not mine.'

The Western metaphysics of presence and absence, and its preoccupation with origins, was called into question by the action of two male artists, Cai Yuan and Xi Jianjun, who removed some of their clothes, rushed onto the bed, shouting and jumping, and had a pillow fight. While for the media this was a fun event, for the artists it was one of a number of witty yet serious performances generated by an artistic, political and social activism. Intervening in galleries and exhibitions, they see themselves as 'artistic space invaders, using London as their exhibition space'. While their playful piece of self-publicity at the Tate was undertaken in order to call attention to Chinese artists in the UK and to refute Western desires for authenticity in their art, more generally their interventions are also designed to question the politics of art in

the West.[31] 'We are not trying to shock, we just want to show how spontaneous art is superior to the institutionalized art which dominates the Turner Prize.'[32] While the Turner Prize has frequently drawn similar criticism, the two artists also voiced an anxiety shared by many, that in moving from the margins to the centre, from radical alternative to mainstream, installation has become the most spectacular form of contemporary art.[33] Although the title of Cai Yuan and Xi Jianjun's performance, *Two Naked Men Jump on Tracey's Bed*, still attributes the bed to Emin, the bed was for a time no longer hers and actual possession was temporarily transferred. Their action transformed *My Bed* materially and semiotically, spilling its meanings over the borderline of confessional art and personal experience.

LISTENING

At all three sites of its exhibition, *My Bed* was surrounded by declamations in cool blue neon and hectically patterned textiles. *Pysco Slut* (**39**), the textile work exhibited in New York, includes statements which directly address a second person, suggest-ing a dialogue: 'I didn't know I had to ask to share your life', 'You see I'm one of the best', 'You know how much I love you'. By contrast, more open-ended interrogation and assertion characterize the textile piece selected for London, *No Chance*: 'some times nothing seems to make sense and everything seems so far away'; 'they were the ugly cunts'; 'at the age of 13 why the hell should I trust anyone'; 'no fucking way, I said no'. Sarah Kent has suggested that its Union Jack flag refers to 1977, the year of the Queen's Silver Jubilee and the rise of punk rock, the year when Emin was raped at thirteen years of age and dropped out of school.[34] 'No chance' is richly ambivalent: a cry of despair about the lack of opportunity in a decaying seaside town, a gesture of defiance and rebellion, a direct refusal of a request or demand. The pieces selected to accompany the bed in London created a cacophony of voices oscillating indeterminately from women's to men's, from feminine to masculine, from voices in the head to voices in the street, from past to present, from private pain to public recrimination, from immediate response to later recollection. And they were uttered not one by one, but all at once. Listening, the bed became a stage for occasions and events: sexual abuse and rejection, distrust and intimacy, fear and

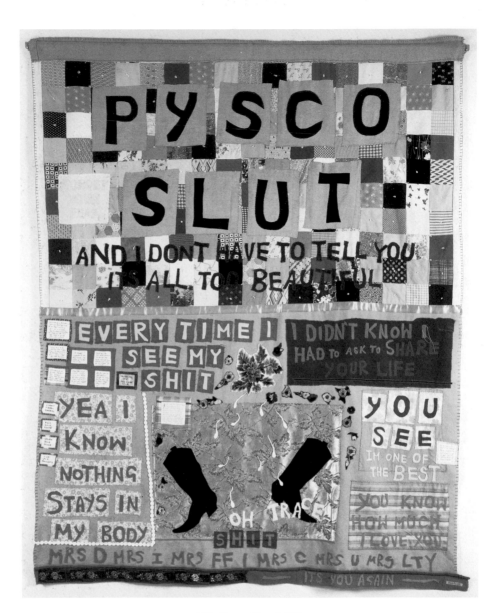

39 *Pysco Slut*, 1999
appliqué blanket
244 x 193cm (96 x 76in)

desire; it was encircled by speaking, screaming, whispering, muttering – about love, abuse, sex, abortion, desertion, promiscuity. The voices were conflicting, contradictory, varied in tone and emotional range, addressed as much to the speaker herself as to unseen figures from the artist's life who may or may not have been listening, or the audience, no longer just observers but, enveloped by silent/silenced speech, potentially complicit. Voices swirled around the bed, disarming the quiet domesticity of the cosy slippers and cuddly toy. Charging the linen and adult clothing with memories of childhood and adolescence and remembrances of rites of passage, they were lightning-strike reminders that the intimate spaces of home can be dangerous places. As Emin suggested: 'It looks like the scene of a crime, as if someone has just died or been fucked to death.' An emphasis on aurality – and theatricality – was heightened at Sagacho, where a long blue curtain screened the installation from view; visitors pausing at the entrance might hear the sound of a scream on the soundtrack of the videos.[35]

149

BEDDING

One of Sarah Lucas's most complex pieces about sexuality and sexual difference is *Au Naturel*, 1994,[36] in which a sagging, stained mattress is propped against a wall. Impossible to sleep or rest upon, its surface is interrupted by the objects placed on it: a bucket and two melons on one side, a cucumber and two oranges on the other. So long a stage for the performance of the female nude, upturned the mattress becomes the site for the incitation and play of fantasies and cultural representations as the artist trades with her audiences some of the crude sexual stereotypes in circulation in contemporary culture.

My Bed also offers markers of sexual difference, such as the men's and women's underwear. The scattered objects point to encounters in heterosexual sex; the Polaroids signal pleasures once taken, perhaps to be resumed. Numerous little indicators register the passage of time: cigarette butts, empty bottles, the depletion of the candle. In Tokyo and New York a rope noose was suspended from the ceiling; in Tokyo dollar bills were placed beside the bed and the piece installed adjacent to a wooden coffin box. These equivocal signs and spatial juxtapositions promise the pleasures and

terrors of sado-masochistic sex and auto-eroticism, sex tourism and prostitution, portend violent abuse and death, recall a children's game and suggest a means of execution or suicide. The inclusion in the Sagacho brochure of a photograph intensified these possibilities. Indicating the performance of an artistic subjectivity visually invested with traces of Cindy Sherman's 'Untitled Film Stills', it also conjured that tradition of the representation of the female body in Western culture which negotiates its pleasures between high culture and pornography. Wearing black underwear, a female figure, modelled by the artist, is sprawled across a low bed and the floor, ropes secured around each ankle and a noose encircling her neck. She is suspended between repose, sleep, unconsciousness, dying and death, between a youthful vulnerability and a certain maturity. Photographed by Eugene Doyenne, this *Portrait of the Artist Age 18*, 1983, is accompanied by the plea: 'Dont make me bleed – Dont make me cry... Its just the Lack of Love/ that killed me./ X/ My Cunt is wet with Fear.'

In an era of disturbing anxieties about life and death and the boundaries between them, in the century of AIDS which has also seen the return of tuberculosis and the persistence of malaria, in a period in Britain in which access to life-saving treatment can be a lottery and a hospital visit hazardous, even fatal, the bed, the mortuary slab and operating table slide into one another in the work of several contemporary artists. Rachel Whiteread's numerous bed pieces, inviting yet denying rest, inaccessible cots by Permindar Kaur or Mona Hatoum, Richard Hamilton's brutal *Treatment Room* of 1984[37] or Bill Viola's *Science of the Heart*, 1983, play on/prey on the oscillations between life and death, presence and absence. None has the comforts usually associated with the bed in the consumer culture of the 1980s and 1990s with its boom in home decoration and plethora of styles from the minimalist to the ornate. Conspicuous signs of a surfeited consumer culture, mattresses litter the urban landscape, evacuated from a room which has migrated from one of the most private spaces of home to one of the most public, to be pitched against walls, tossed into vacant lots and alleyways. At the same time mattress and bed pieces have been produced in, and reflect upon, two decades in which homelessness has become a major social concern. While politicians and agencies argue over whether the numbers of homeless people have risen and the effectiveness of different

approaches, one form of homelessness, sleeping rough, has become increasingly visible in Britain's major cities. Huddled figures sleep, by day and night, in doorways and underpasses, on pavements and waste ground. It is at this moment of profound change in the configurations of social exclusion that the bed and the mattress come to have a new significance, referring as much to lack as to consumer plenitude. While *My Bed* may have been prompted by personal trauma, it also speaks of and points to larger social themes of transit and displacement. In these broader narratives of home and homelessness, *My Bed* becomes as much a temporary halt en route in which the discarded objects point to the transience of a zone in space as much as a lost moment in time.

MOVING

My Bed was made and exhibited during the passage of the Immigration and Asylum Act of 1999, the most recent piece of a substantial raft of legislation designed to harmonize policies across the member states of the European Union. From the publication of the White Paper of 1998 to the bill becoming law in the following year, apocalyptic visions of waves of immigrants pouring into Britain were partnered by warnings of illegal entry. Fears of bogus claims on housing provision and the benefits system ran beside worsening conditions for many asylum-seekers, who by now, as several agencies testified, comprised a critical category in Britain's homeless population. About more than access to accommodation, homelessness has become entangled in debates about migration and diaspora, the forced and voluntary movement of peoples across national borders.[38]

In its showings in Tokyo, New York and London, Emin's bed was accompanied by two suitcases, bound together. One Emin had used, leaving home at 18; the other was a blue Samsonite. Like many of the items in *My Bed* they participate in an aesthetic that recycles and reuses: they carry traces of past movement and prefigure that which is to come. Part of a distinct installation piece in New York, whose title, *Leaving Home*, purposefully points to departure, in London, placed close beside the bed, they spoke of a life lived out of suitcases, recasting the objects as ephemeral, sentimental possessions that could be harboured in transit, packed up and unpacked again elsewhere, or even abandoned.

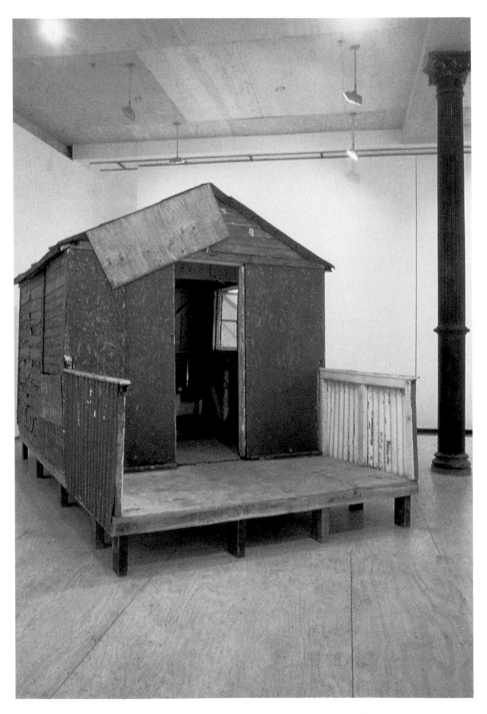

40 *The Last Thing I Said To You Is Don't Leave Me Here (The Hut)*, 1999
Mixed media
292 x 447 x 244cm (115 x 176 x 96in)

This sense of movement and transitoriness was heightened in New York by the juxtaposition at the same gallery but in distinct rooms of *My Bed* and *The Hut* (**40**). Whereas the precariousness of Thomas Hirschhorn's temporary constructions is augmented by their urban settings, beach structures are at risk from their borderline location at the water's edge where land washes into sea and sea laps onto the shore, a holiday site which is often a national frontier, an entry point and a barrier, a gateway and limit.[39] This fragile multiplicity is emphasized by the painter Lubaina Himid. In a poetic essay on her series of monumental paintings of beach houses from Santa Monica in the USA to Dieppe in France and Beit el Ras in Zanzibar, Himid places the beach house on the edge of space and time. From shacks to forts, huts to little dwelling-places, beach houses are, she reflects, havens of pleasure, sites that witnessed slavery and colonization, caches of memory, dream spaces and idylls of escape. 'The beach house stands on shifting sand constantly visited by shadows, winds and waves... The beach house is a site of conflict. Invasion and departure... The beach house as a place of refuge.'[40] If in New York Emin's hut could signify something of the picturesque quaintness of British culture, its ambivalence – at once temporary and enduring – enhanced the sense of transit and transience surrounding *My Bed*.

153

For her London showing, and only for her London showing, Emin created a space that spanned the borders of Europe, from its western edge to its eastern border, mapping a dynamic site of interaction and confrontation. The child of a Turkish-Cypriot father, Emin grew up in the Hotel International (run by her mother in Margate), having spent part of her early life in Turkey. Her sojourns in Turkey, the memories of her experiences there, sea-bathing with her father – on another shore line – were brought into the circuits of its viewing and revisited in the screenings of her videos. At this venue she elected to show not *Pysco Slut* but *No Chance* with its tattered Union Jack from the Queen's Silver Jubilee. Even if it holds autobiographical significance for the artist, this national symbol inevitably carries supplementary meanings. As much as it summoned, even insisted on, national identity, this overwritten, overstitched and reconfigured textile work called into question the imagined community of the nation and New Labour's promotion of 'Cool Britannia' in a museum that was preparing to take up a new and difficult identity as Tate Britain.

While Emin's diasporic family may well have prompted this cultural mapping of Turkey, Cyprus and Britain, it also took place within a wider context of international relations. Analysts of the 'new Europe' of the 1990s have argued that, in the attempts to reconcile divergences between member states and to promote a shared European culture while allowing for distinct national identities, internal inclusion was accompanied by an intense policing of the boundaries, both physical and cultural, and most evident in the exclusionary policies and legislation on asylum and immigration. Phil Marfleet maintains that moves towards inward coherence in the European Union have been founded on a culture of exclusion, and Sarah Collinson indicates that in response to anxieties about security, threats to democracy and fears of insurgency, the Mediterranean – from the straits of Gibraltar to the Bosphorus – has been defined as the key border and subjected to heightened surveillance.[41] This reconfiguration of the edges of Europe drew a line at Turkey, a country enjoyed as a holiday destination by many Europeans but currently excluded from membership of the European Union. Emin's exhibition space in London thus brought together two countries on the edge, one within, one without the European Union, tracing diasporic paths and movements between the two and mapping connections and disjunctions shaped by family, culture and ethnicity.

CONCLUDING

To situate *My Bed* within some of the concerns of the moment in which it was made and exhibited is to suggest a range of potential meanings conjured by the distinct installations in Tokyo, New York and London. This is not to say that *My Bed* expresses these historical moments, any more than it expresses the artist. It is seductively simple to see Emin's art as the confessional outpourings of a tortured soul and much harder to take it as serious, troubling work about migration, diaspora and sexual difference. To view *My Bed* through the frames of dysfunctional femininity and young British art of the 1990s is to miss the point and the charge of an extraordinary and awkward work.

WE LOVE YOU, TRACEY

Pop-Cultural Strategies in Tracey Emin's Videos

LORNA HEALY

'I met tracey in salzburg, all in vivienne westwood… and I knew I met a woman. Maybe one of the last who dares. human beings change. the end of romantic love is definite. she represents the struggle, the anger, the fear, the fury and the necessity. my vision: tracey emin and madonna… performing on a stage in Salzburg.'

'Tracey I love you, I love you cos, you're inside out, Inside out makes art, Love John.'

'y love you tracey emin
ez ji te pir hez dikim tracey emin…
I am kurdish artist.'

These protestations of love were mailed to the 'What People Are Saying about Tracey Emin' site, a part of Emin's unofficial homepage at Modern Culture.[1] There are a great many messages like this. There are also compliments on her sunglasses, her eyebrows, her skin and her appearance ('gorgeous') on the TV quiz show 'Have I Got News for You'; and there are statements from people who say that they have been through the same kinds of experiences, and that Emin's example has helped them to reconcile themselves with their own lives. After Emin had been interviewed at a live event early in 2001, her fans queued for autographs until security men cleared the auditorium. One group of girls had come from her old school in Margate. Emin has fans who seemingly want to possess her sexually or romantically, or be like her. Others have a desire to share the artist's space and thus her aura. 'Greetings to

Tracey, I have to say that i am astounded by the sheer presence of Tracey Emin. I went to hear her talk in London a week ago, and I just can't forget the experience. I managed to meet her thanks to a fire alarm, and miss my train back to taunton because my tutor and I were quite simply intoxicated by her. We were on such a high from listening and meeting this person who has such an incredible aura!... She is real... Tracey if you are reading this, then I'm the person you bumped into, walking out of the Tate. I glad that i did, but i was all over the place... i love you and your work!'

It is evident that Emin evokes powerful emotional responses in many people, and that these responses, intense feelings of affection and empathy, are unusual within the domain of contemporary gallery art. The essential fan's statement is: 'I love you, Tracey.' People cry 'I love you, Madonna' maybe, or express similar emotions to other pop stars and celebrities, but nobody, at gallery openings, shouts to Auerbach or Craig-Martin 'I love you, Frank', 'I love you, Michael'. Something about Emin – perhaps her work, perhaps the mediation of her persona – intensifies her appeal and encourages, even demands in some cases, identification by others and the desire to participate in her life. Perhaps it is that mixture of vulnerability and assertiveness, and also the powerful narratives that the works convey. People want to occupy Emin's subject position (or at least get somewhere near it) and empathize with her experiences as a strikingly different, half-Turkish-Cypriot woman. It is also clear that no distinction between the woman and the work figures here.

It would be a serious mistake either to see all this as a failure to adopt an attitude proper to the condition of Emin's artworks or as the misguided confusion of a real person with a character appearing in those works. These emotions, these kinds of affects, are not extrinsic to Emin's art. They are central to it. In relation to Emin's work (and I am going to focus especially on the films and videos), the statement 'I love you, Tracey' is the appropriate aesthetic judgment. It is motivated by what the work is and does. Emin's aesthetic is entirely of her time. It is made possible by at least three things: the death of 1980s Neo-Expressionist painting, and the space which that demise leaves open for remaking something like 'Expressionism'; the space created by feminism for the communication of (traumatic) personal stories; and above all perhaps by the development within popular culture, mainly music,

of the kind of personal commitment to the 'star' experienced by fans. The artistic achievement and the potential political radicalism of Emin's practice lies in the willingness she engenders, on the part of the viewer, to look, listen and empathize with her unorthodox and untheorized experiences. But I would also suggest that the way in which Emin and others legitimate her practice within art history blocks any effective understanding of what her work does. Never mind the Expressionist ideology, she should strategically embrace the pop aesthetic and her role as art star. Emin's power lies with her fans.

In Emin's videos we can apprehend the qualities that generate commitment. I want to explore these qualities, the affect that they create, and the kind of subject that is produced. The body of work to which I am referring comprises eighteen pieces shot either on Super 8 film and transferred to video, or made directly on video, between 1995 and 2001. These pieces were either shot by Emin herself or feature her and were shot by Sebastian Sharples.[2] Emin's films and videos are often testimonies to personal growth and self-development. Producing narratives of the self in this way organizes chaotic everyday experience within certain conventions to produce a sense of identity. The very act of narration, often used in therapy, contributes to the performance and thus the confirmation of individuality. The story tells the self. This use of personal testimony is, of course, always open to the criticism that it focuses exclusively on everyday creativity rather than on broader social structures.

In the first part of *Why I Never Became a Dancer*, 1995 (**5**), Emin's disembodied voice recounts experiences of adolescence in the Kentish seaside town of Margate. The voice is juxtaposed with over-exposed footage of the rather tawdry resort. Editing creates conspicuous correspondences between narration and imagery. When she describes grabbing men's balls, we see teddies being picked up in the 'Big Dipper' machine in an arcade. The narrator talks about how she disliked school, hung out in cafés and began having sex with male partners often much older than herself. We learn how her entry in a dancing competition at the local disco was sabotaged at the point of victory when some local men, most of whom had been casual sexual partners, started shouting 'Slag! Slag!' The narrator tells how she fled crying from the dancefloor, her hopes of winning dashed, vowing that she would 'escape this

place'. However, in the second part of the video, she – for we now see Emin, gyrating jubilantly to Sylvester's 'You Make Me Feel (Mighty Real)' in a beautifully lit space with a view not over the eastern reaches of the Thames Estuary or Margate's grubby beaches, but over central London – gets her retribution by naming and shaming the boys within a video which has been shown in museums and galleries around the world. 'This one's for you,' announces Emin, no longer a humiliated teenager, desperately seeking a route out of 'the coastal town that they forgot to close down',[3] but a mature woman and successful artist, as she demonstrates to the men, to Margate, not only that she made it (in so many ways), but that she still knows all the moves. If Gillian Wearing showed us 'Dancing in Peckham', Emin shows us 'Dancing in Triumph' – the ultimate 'fuck-you' gesture to a milieu that so casually belittled her creative energy and ambition.

Riding for a Fall, 1999 (41), realizes a homecoming fantasy and sees Emin return-ing to Margate resplendently sexual on horseback. In this three-and-a-half-minute piece, long shots of the equestrienne Emin on Margate beach are juxtaposed with close-ups of her turning the horse in slow motion to meet the viewer's gaze, with a look that is at once seductive and confrontational. Wearing a cowboy hat, black bras-sière and open shirt, Emin embodies the brazen hussy returning from exile. Her pose suggests 'that's the prodigal daughter riding home you see'.[4] Her gaze seems to be saying 'you thought I was heading for real trouble, but now look at me'. As a seaside resort Margate is noted for pony and donkey rides on the beach: Emin, riding a full-sized horse, contrasts this diminution of experience with her ability to handle a life beyond that which her home town can provide. As in Why I Never Became a Dancer, however, the message is ambivalent. There is the mainstream appeal of the trium-phant survivor, alongside the more subversive story of the bad girl who gets away with it. But the posture of her body remains vulnerable, she sits slightly slumped on the horse, her cowboy hat askew. Take a second look and there is also something, perhaps deliberately, absurd about the scene. Margate is, after all, no Wild West. But no one here is leading Emin; she is an independent, sexually potent woman.

Emin tells a great story in these two pieces. How many of us suffered misunder-standing, injustice and repression in our hometown, left for the big city, and how

41 *Riding for a Fall*, 1999
single-screen projection and sound, shot on Mini-DV
duration: 3 mins, 30 secs

many of us still entertain fantasies about returning to show them all one day how successful we've been and how small-scale 'they' really are? These two films also offer poignant narratives for anyone whose sexuality was policed, by parents or local culture, as a teenager. The mainstream appeal of the homecoming is combined with powerful testimony, and resistance, to the kind of sexual regulation that many young women (and gay men) have experienced, and still do experience, in provincial areas. Emin's story is one of personal victory against overwhelming odds. At the most obvious level, these narratives commit spectators to identification because their dramatic content concerns a struggle between desire and regulation, and this is something that figures, in however displaced a fashion, in the lives of many of us. And it is an authentic story. That, perhaps, is the key to the appeal for those who feel it, and respond with 'love': '[She] has such an incredible aura!'; 'Emin is real.' The aura is a function not only of her story's content but also of the presentation of its intimate disclosure.

Viewed cumulatively, this body of video work offers a strangely traditional narrative form, which is at odds with the more innovative uses of the medium, even by those contemporary practitioners such as Eija-Liisa Ahtila and Pierre Huyghe who have turned to increasingly cinematic and televisual production values, and to the TV soap-opera and mainstream film as points of cultural and narrative reference. There are three stages in the narrative trajectories of Emin's videos. The hometown is a point of equilibrium: Emin had a lot of freedom and early sex, was enchanted by the romance of a seedy town and the sea, but was also constrained and repressed. The second stage is a rupture of this stasis, effected by her move to London and the disruptive traumas of abortions and breakdowns. Eventually, there is a restoration of equilibrium, but not a reversion to the opening point of the narrative, now that Emin is a successful artist. A synopsis of this classic equilibrium-disruption-equilibrium structure appears in *Tracey Emin's CV. Cunt Vernacular*, 1997 (**42**). It is the narrative structure we know from classic Hollywood movies and pop songs, with the modification of the ending (stasis but not recuperation) that characterizes the coming-of-age story.

Emin's films and videos, however, are not solely concerned with narrative and content. There is a third element to take into account: the formal quality of the work. Here again a pop aesthetic is at work. The authenticity – or, rather, the authenticity-

42 *Tracey Emin's CV. Cunt Vernacular*, 1997
single-screen projection and sound, shot on Mini-DV
duration: 10 mins

affect – of Emin's persona is a function of what Roland Barthes called 'the grain of the voice'. The separation of voice and image in *Why I Never Became a Dancer* enhances our attention to the texture and timbre of the narrator's voice. Emin's work is not a matter of words and visual signs that simply communicate symbolic content. Julian Stallabrass is right (up to a point) when he writes that 'Her authenticity lies at the level of diction, not of discourse, in how she speaks rather than what she says.'[5] It can be literally the voice that conveys authenticity, perhaps through its human imperfections, rather than what it tells us about. There is Emin's sibilation: for example, the way that the rhythm of her voice gains momentum as a story climaxes; and there is her vernacular and idiomatic vocabulary ('shaggin'') and grammar ('the more better I get'). But the 'grain of the voice' needs to be understood in a more general sense as an attunement to the idiosyncrasies of the performer's body. These unique characteristics can include aspects of movement, posture and gait. The grain of the voice is 'the materiality of the body speaking its mother tongue... It is the body in the voice as it sings, the hand as it writes, the limb as it performs.'[6] In contrast to some of her photographs, which capture a fixed and often more typically 'beautiful' image, the vulnerability within Emin's filmed (or live) performances offers a more powerful sense of authenticity. The viewer glimpses, but cannot meditate for long upon, the imperfections of the body: a profoundly human and flawed presence revealed through a flash of the artist's crooked teeth, her slumped horse-riding posture or her awkward stilettoed scramble across the scrub. The authenticity-affect can also be displaced onto objects. In *Tracey Emin's CV. Cunt Vernacular* we view an apartment that is very much lived in: the bath is running, the phone charging and the disco ball spinning. Our sense of Emin's authenticity is often linked to the emotional subject matter, including sex, abortion and rape, but it requires technological mediation. While being filmed in *How It Feels*, 1996 (**45**), Emin asks Sharples to stop the camera when she becomes overcome by emotion. The break in the narration is both effective and affective strategy. It also recalls those moments in Warhol's films – of which Emin is clearly aware – where individuals ask either if they've finished yet (Ondine in *Chelsea Girls*) or plead, off-camera, for the filming of out-of-hand improvisation to stop (Ronald Tavel in *Horse*). The technology facilitates

the direct expression of Emin's emotion here, enhancing her aura, but it also rup-
tures the naturalness of the medium by drawing attention to its presence. Obviously
videos, like all artworks, are produced by a network of people (cameraman, producer,
editor, etc) but this collaborative practice does not seem to work against a sense of the
artist's authenticity. Emin's aura doesn't depend on technical control: it depends on
image control. Her deliberately sloppy aesthetic is a vital element in all of this.
Emin's work is effective precisely because she uses an apparently unskilled, naïve
aesthetic. The sloppiness appears in long and repetitive video works, full of
'mistakes', such as *Conversation With My Mum*, 2001. It manifests itself in the shaky
camera and lack of technical finesse or smooth editing (an exception is *Sometimes the
Dress is Worth More Money Than the Money*, 2001 [**12**]). In many of these pieces, the
work seems spontaneous, like a home video, when it is, of course, and cannot be
other than, a meditated and 'made' work of art.

A link between the creation of authentic aura and the perceptible grain or
materiality of the performer's body is familiar to us from our experience of popular
music. More specifically, it comes from analysing how consumers of popular music
engage with the music, rather than foreclosing the subjective space that the consu-
mer establishes by dismissing the process as the pursuit of pleasure enacted in bad
faith. (Significantly, Emin's videos and films should perhaps be viewed as interactive
performances where the meaning the viewer brings to the piece is crucial to its iden-
tity.) Perhaps the main criterion that we can borrow here from the critical discourse
that now surrounds popular music is the notion of a technologically mediated
authenticity. Despite pop's use of new recording technologies, enabling mass pro-
duction and pastiche through digital samples, the listener continues to be offered
and to demand the imperfections that sustain or, rather, create the impression of the
unmediated reality.[7] It is the search for the original that continues to drive fans
beyond the recorded work, towards the live concert, the 'unplugged', and the auto-
graph (and it drives Tracey's fans beyond the videos to the live, non-art interviews),
that is, towards the performer's body. It might be that the pop audience refuses to
view self-consciously, wanting its stars clad in denim or leather rather than quotation
marks. What is essential, however, is that authenticity is an effect of recording.

Recording, filming or other technological reproduction do not counteract the affect of authentic aura. It is its condition.

Emin's films and videos operate in much the same way, as does her recourse to music. It is worth noting that five of the film and video pieces have musical elements with narrative, and that three feature music only. Some of Emin's more lyrical pieces depend on the mood and temperament created by the grain of the voice in a similar way to music, for example *I Don't Think So*, 2000 (**43**), whose only soundtrack is a crying baby. There is also a connection between some of Emin's films and the music video. *Riding for a Fall* uses as soundtrack the often-covered Ska song of the same title by the Tams. The film is the same length as a music video, with the images cut to suit the music rather than the other way around: it is set by the sea, a typical music-video location; it uses some of the music video's conventions – slow motion, the lingering close-up, and the fetishized repetition of a key sequence of movements (the artist turning the horse around and gazing seductively at the viewer). From this perspective, 'Burning Up' – the track Emin recorded with Boy George for the Ambassadors' *We Love You* CD – starts to seem like a key work in the oeuvre. House music provides a regular and monotonous backdrop which highlights the stars' voices. The lyrics of 'Burning Up' were written by Emin, and the song contains some of her trademark lines such as 'my cunt is wet with fear'. The chorus she repeats most is 'Can you hear me? Can you hear me? I never stopped loving you, I think about fucking you, fucking you naked.' The song's main theme is sexual fantasy, which, if it is a staple of popular music, is also central to Emin's concerns throughout her art. Emin sings/speaks in three different timbres: drawling/arrogant, intense/demanding and sweet/childish. She repeatedly truncates words and modifies the 'th' sound, talking about a 'life widdin a life'.[8] The song's melody is superficially appealing, but it is a heady mixture of star status and grain of voice, of authenticity and glamour, that makes it work. David Bowie got it right when he remarked that Emin is like 'William Blake as a woman written by Mike Leigh': edgy, poetic, somewhere between high and low culture. Her fans want her clad in Vivienne Westwood and not quotation marks, and that is how they get her.

43 *I Don't Think So,* 2000
single-screen projection and sound, shot on Mini-DV
duration: 7 mins, 44 secs

If spectators consume Emin's videos, and Emin herself (for no distinction between the person and the persona is necessary or effective in this subjective apprehension), in the way in which they engage with popular music and musicians, then we need to rethink the relation – and there palpably is one – between Emin and Expressionism. Among other places, Emin pays her respects to the movement in the video *Homage to Edvard Munch and all My Dead Children*, 1998 (**44**). The grain of the artist's voice is particularly noticeable here. Shot on Super 8, and subsequently transferred to video, the work shows the artist, naked and curled in a foetal position on a Norwegian pier, turned away from the camera. As the camera settles on the sunlit water, reflections flaring on the lens, we hear Emin's terrified and frantic scream lasting for almost a minute. Then it stops, peace returns and the camera pans back to her body, which seems to have shifted in angle slightly as its shadow falls in a different place on the quay. The scream is commonly understood as the essential Expressionist gesture: the barely articulate, violent externalization of psychic pain. *Homage to Edvard Munch* is a statement of allegiance to an established art tradition. Locating Emin, and Emin locating herself, in this tradition is problematic. It is a trap that prevents us understanding what her artworks do, and it stops us taking seriously (as we ought) the aesthetic-affect experienced by her fans. Also, I suggest, it stops us seeing what is actually or potentially radical about her work. For several decades, Expressionism has been criticized for its primitivizing of women and non-Westerners, for its ideologically conservative character as a symptom rather than a critique of modern alienation (particularly in the case of its early twentieth-century German manifestations), and its denial of its own linguistic status. Emin might be understood as doing herself no favours by an attachment to this tradition, even if much popular music, particularly certain rock genres, is itself profoundly expressionistic. It might have contributed to building her career, situating her within a traditional art-historical discourse, but it has no relationship with what makes audiences love her and her art. To understand the emergence of this effectiveness from an apparently negative aesthetic framing, we need to set our sense of Emin's pop aesthetic against a background of a particular feminist thinking of desire and narration.

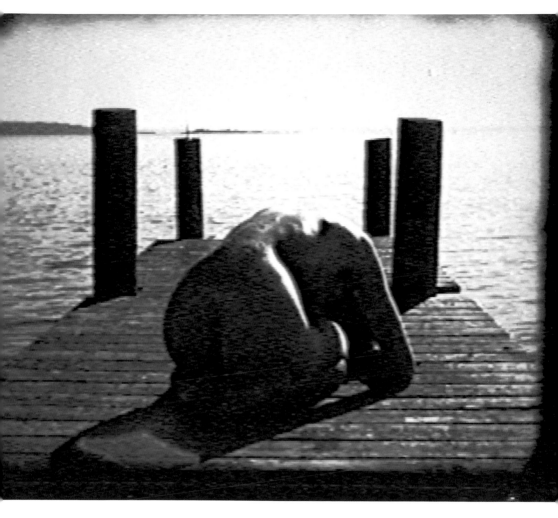

44 *Homage to Edvard Munch and all My Dead Children,* 1998
single-screen projection and sound, shot on Super 8
duration: 1 min, looped

45 *How It Feels*, 1996
single-screen projection and sound, shot on Hi-8
duration: 24 mins

Teresa de Lauretis has discussed the failure of avant-garde – that is to say, non-narrative – feminist film practices to engender desire, defending instead the tactical use of narrative, which contains desire in its very movement.[9] The attraction of this concept of narrative for feminist filmmakers is that it offers the possibility of making up one's own story. De Lauretis recognizes, however, the problem that the feminist maker of narrative film faces in adopting what is understood as a dominantly masculine mode of representation. Successful feminist filmmaking overcomes this difficulty by incorporating the contradiction in the work. Despite her interest in Warhol's work, Emin's film and video work betrays no pretensions to being 'avant-garde'. It engages with the viewer in an accessible way by using elements familiar from popular music and by offering narratives drawn from a mainstream imaginary. It is hard to think of Emin's work as feminist, but it could be said that she effects the kind of overcoming that, for de Lauretis, characterizes some of the most successful feminist film-making. The contradiction of narrative, feminist film is incorporated in the work as the tension – sometimes violent or disturbing or bizarre – between the form of the work and its content. This is particularly the case with Emin's films about abortion.

In *How It Feels* (**45**) and *I Don't Think So* (**43**) Emin deals with her subject in two very different ways: in the first film through personal testimony, and in the latter in a more distanced, poetic fashion. Perhaps all Emin's film and video works can be characterized according to these two approaches. The testimonial form is the more naturalistic of the two. Emin recounts events in her life to a camera whose presence is acknowledged. The poetic approach is more ambiguous. In some of these cases, the artist role-plays a character such as a cowgirl or bailiff. Sometimes, these films are technically complicated pieces where she acts out two roles simultaneously. But in most pieces, as in her magazine or auditorium interviews, Emin flips between modes. *How It Feels* takes the viewer documentary-style through the details of her first abortion. We follow her on a trail around London as she goes from a spot outside her doctor's surgery, to a park, then to outside the abortion clinic. There are a number of intense sequences featuring Emin's face in close-up telling us how she felt and feels. At times she threatens to alienate the viewer by overdramatizing an element of the story. There are also moments of extreme poignancy. For example, Emin

169

denounces the doctor who wouldn't sign the abortion papers, and discusses her decision not to say yes to abortion but to say yes to life. She explains how this event became the spur to change her art into a vital practice that engaged with everyday experience. Emin's story climaxes when she vividly describes how the foetus slid down her leg days after surgery. It is at this point that the content of the story and the narrative form collide.

I Don't Think So was made four years later. This short black and white film uses a static camera throughout its eight minutes, showing Emin tossing and turning in her bed. (Beyond the static camera and unusual recourse to monochrome footage, we might see, once again, a Warholian reference here: to the early film *Sleep*, 1963, in which the poet John Giorno slumbers through a full five hours.) Emin's bed here is similar to that featured in the installation *My Bed* (**31**), but it is not surrounded by any of the clutter that was an integral part of that work. The bedroom is spacious and dream-like, everything is white and curtains blow gently in the background. There is

an ambiguous dark shape on the left-hand side of the screen, which could be read as another person asleep in bed. The silence is broken intermittently by the sound of a baby crying. The crying could be a haunting, dreamt reminder of her unborn babies which disturbs Emin even as she sleeps. However, as the title of the piece suggests, it could also be a confirmation of her decision not to have children. Emin could be reaffirming her refusal ever to have to jump to the attention of a crying infant instead of having a lie-in. In contrast to *How It Feels*, this piece does not demand the same concentrated attention from the viewer to the voice, so there is more breathing space in which to speculate about the meaning. There is a spectral quality to the film that may be disturbing but it is in no way as emotionally draining as Emin's earlier testimony. Its focus is different, however, as it is giving form to an interior life of dreams and memories rather than describing events. The film testifies to the way in which major life decisions around sex, life and death stay with us long after the moment of choice. We might see *I Don't Think So* as an important film in Emin's maturation as a video artist as she condenses the implications of her fraught decision to 'say yes to life' into one trope – the sound of a baby crying. That is more art and less documentary, a more spacious and playful second stage that perhaps can only take place after

the important work of the testimony has been done. *I Don't Think So* is a cooler piece than Emin's previous works, where the artist's ego is sublimated. It does not offer much that we would understand as 'Emin-ness', nor a linear narrative. As a consequence the viewer's identifications are less intense.

It is in her treatment of abortion that Emin's potential radicalism is most apparent. The work is highly political in the way that it puts untheorized experience onto the cultural agenda. From my Irish perspective, which is very aware of the denial and repression of abortion and thinking about abortion in Ireland, the importance of Emin's testimony is clear. She breaks a code of silence, letting her story enter the sterile white space of the gallery. It is not just about abortion, of course. Emin covers many other areas around desire and relationships that 1970s feminists such as Hannah Wilke also treated. In each instance, there is a joy of recognition. The repressed meanings around abortion, fear and fantasy of violation and illicit sexual pleasure take their place in the public space.

But if these things were treated in the 1970s, why is Emin's work – if it is more than pastiche – still necessary? It is necessary strategically because she has managed to bring these subjects into the mainstream, and perhaps necessary at a more specific level because the radical programme of first-generation feminists, and the art associated with it, failed fully to satisfy its objectives. However, this entry into the mainstream has only been possible, or at least effective, because of the formal conservatism of her work. Emin allows the viewer the conventional pleasures of narrative, star aura and individualistic expression. She reconciles herself with mainstream art history. She denies political affiliations, which ensures that the work is not relegated to a sub-category of identity politics – she belongs to a privileged generation that can make work about menstruation without it necessarily being understood as concerning 'women's issues'. Emin's work can be political without her having any political programme. It can be aesthetically effective, at the same time, without needing to mobilize traditional art devices like those of Expressionism, except through the strategies of popular culture. As familiar subjective spaces, the devices of pop culture are, in any case, often more powerfully effective and liberating for her – mostly loving – fans.

CHAPTER 9

ANOTHER DIMENSION

Tracey Emin's Interest in Mysticism

RENÉE VARA

'The only thing I am really well read in... is mysticism: moving into other dimensions through the understanding of time and space, whether it's levitation or astral projection. It's the only thing I have ever studied with any interest.'

Tracey Emin, 1997[1]

She is the messenger and her medium is herself: the biographical details of her working-class background, her experiences as a sickly child, suffering from whooping cough, measles and German measles, her fear of ghosts, her musings over love and her triumph as one of the most recognized artists in England. Tracey Emin's celebrity now reaches outside the inbred world of the young British artist phenomenon. Since being shortlisted for the 1999 Turner Prize, Emin has found an audience that transcends artworld boundaries. Even as she utilizes the highly personal and private voice of a contemporary female artist in much of her work, Emin elsewhere appropriates the decidedly feminine performance strategies of the Victorian clairvoyant, who was permitted to transgress the gendered and class-strictured boundaries of English society by 'being a lady'.

Being a lady included the creation of a persona characterized by denatured sexuality, personal passivity and formalized rituals of personal decorum. Performing this role, Emin is able to 'channel' the power of a female voice to create a unified oeuvre, using her interest in late nineteenth- and early twentieth-century manifestations of the paranormal to define a universal, and genderless, soul. Emin's performance of esoteric rituals, and their incorporation into a complex media matrix,

reflects the philosophical theories and thoughts historically associated with mysticism. Mysticism informs Emin's aesthetic, signifying a strategy of resistance, whether intentional or not, to the canon of the spiritual in modern art that has been predominantly defined by male artists such as Wassily Kandinsky and Piet Mondrian.[2]

Critics have commented on the widely variable elements in Emin's work, which ranges from crafty appliquéd blankets to textual works of written confession. Among these voices is that of Roberta Smith, who suggests that 'stylistically, it ricochets between various Post-Minimalist conventions, early feminist art and installation art'.[3] If superficially Emin's work fails to adhere to expectations of a uniform style, it does exhibit amazing consistency in its exploration of mysticism. Emin has given 'testimonials' in many interviews, between 1995 and her most recent show at White Cube[2] in 2001, narrating a childhood in a family psychically connected to, and with a solid faith in, the powers of the paranormal. To Emin's frustration, such spiritualism, however, has not been the subject of critical or popular attention, as she noted in a recent interview. 'Everyone focuses on the sexuality of my work. Why doesn't anyone ask me about my thoughts on God?'[4] From her earliest years, Emin was imbued with an empirical understanding of the otherworld as she was frequently included in traditional spiritualist practices ordained by female role models. Her mother is reported to have conducted séances regularly in her home. During these sessions the teenage Emin took shelter from unsavoury spirits under a Formica table.[5] In a recent interview, Emin initiates the unknowing reader into the world beyond. 'People imagine that they see the dead because they really want to, but it isn't quite like that. You miss people, you have to see them, and you are desperate to know what happened. So sometimes you feel them or imagine that they're sitting there. You see it, you sense it and then it's gone.'[6] Emin remarked in an interview with Miranda Sawyer that her twin brother, Paul, is so close to her that the two have 'an almost telepathic relationship.'[7]

Psychic connections extend outside Emin's immediate family and manifest themselves in several of her works. Her uncle Colin, who was said also to have possessed psychic powers, was decapitated while holding a pack of cigarettes when his Jaguar crashed. The assemblage *Uncle Colin*, 1963–93 (**46**), first installed on the

46 *Uncle Colin*, 1963–93
six framed memorabilia
dimensions variable

Jay Jopling stand at the Köln Art Fair, in 1993, is a type of *memento mori* in which Emin preserves his memory, with a golden Benson and Hedges packet displayed alongside a photograph of her uncle smiling proudly, standing next his to car. What is not immediately evident is that the work also represents an act of spiritual trans-mutation. Emin intended it to be a 'conscious' engagement with alchemical ideas: the ancient practice of transforming base elements into precious metal, or trans-forming 'the individual into spiritual gold – to achieve salvation, perfection, longevity, or immortality'.[8] Thus, at the moment of impact, as Uncle Colin's cigarette packet was transformed into the material properties of gold – 'like real gold', as Emin says – his body transmuted into the immaterial properties of the immortal soul.[9] Emin's decision to include this work in a major exhibition rested upon her confirmed belief in spirituality as necessary to art. *Uncle Colin* therefore becomes more than a ceremo-nial object. Emin endows the everyday materials of her uncle's existence – the commodified cigarette packet and the photograph – with the aura of high art by placing them within the sanctity of an art gallery. A more recent video work, *Reading Keys*, 1999 (**47**), which she recorded in and around her East End studio with her partner Mat Collishaw, suggests that initiates do not have to be blood rela-tives, just believers. In the six-minute video Emin 'reads' Collishaw's door keys, which he promptly gets 'recut' to fit their relationship.

175

Although some critics have intimated how mysticism and the esoteric fit into Emin's art, many have disregarded its consistent presence in her oeuvre. Susan Corrigan noted that the central subject of the exhibition 'I Need Art Like I Need God' 'draws on ideas inspired by fantasy – Ouija boards, imaginary conversa-tions with Kurt Cobain, star crushes'.[10] Yet Corrigan failed to recognize that, even if it is pure fantasy, Emin consciously pursues it with the devotion demanded by religion. Her involvement began to extend beyond her family when she first became identified with the emerging group of British artists in the early 1990s that became known as the yBas. In 1993, after several years of disillusion with making art, Emin opened 'The Shop' in Bethnal Green Road with her friend Sarah Lucas. As the well-rehearsed story of Emin's early career has it, both artists sold goods, including T-shirts, badges and other souvenirs, that artworld cognoscenti took

47 *Reading Keys,* 1999
single-screen projection and sound, shot on Mini-DV
duration: 6 mins, 5 secs

home from their East End pilgrimages. During those formative years, Lucas shared a book with Emin which featured, among other esoteric teachings, 'descriptions of heaven from people who have died and come back in séances to tell us what it's like'.[11] It seems likely that this book was the popular *Doors to Other Worlds*, 1993, by the Spiritualist Raymond Buchland. It recounts the history of the Spiritualist movement, supported by scientific evidence concerning such subjects as Hélène Smith, whose powers were studied by Charcot at the Salpêtrière hospital after his appointment there in 1862.[12] Through its simple explanations, pragmatic organization and low-key packaging, the book demystifies the occult for the everyday reader, reflecting the pluralistic nature of the Spiritualist movement in its attempt to appeal to a broader audience.[13] Buchland seeks to clarify a common misconception regarding psychic practices, reminding his readers that 'medium-ship is not the same thing as possession', because it corresponds to a voluntary rather than an involuntary act and therefore does not require the intervention of outside parties.[14]

177

The book did not influence Emin directly.[15] The significance of Buchland's work in any consideration of Emin's engagement with spirituality lies in its explanation of Spiritualism's relevance to Anglophone culture.[15] Buchland verified the continuity of a significant cultural movement, in both America and England, which reached its apogee during the early twentieth century, by illuminating its contemporary interpretation and popularity within popular culture.[16] While 'The Shop' was experiencing a flurry of activity, Emin befriended one of its many patrons, the precocious Joshua Compston. Compston felt the British art world was in dire need of aesthetic rejuvenation, and shortly after graduating from the Courtauld Institute opened his gallery, Factual Nonsense, nearby, as an alternative venue for emerging artists.[17] Later, Compston was inspired to organize the now mythologized street festival in Shoreditch, the ironically titled 'Fête Worse than Death'. The fair, which included Emin among its regular participants in its different incarnations, was held annually in the heartland of the yBa community, only ceasing after Compston's death in 1996 with a tribute organized by Gavin Turk. Compston solicited artists to rent stalls for small sums, complementing their presence with street performers,

musicians and any others willing to participate in a magnificently baroque display of the yBa spirit. In 1993, Emin's first-year contribution featured a table for 'Essential Readings'. Emin offered free readings to any souls willing to face their fate as revealed by simply opening their palm.[18] In Emin's performance as 'clairvoyant', she was dressed in a second-hand jacket, poised behind a makeshift table draped in fabric, relaying messages to her sitters, her mystique enhanced by the burning flames from flanking incense torchères.

A year after the closure of 'The Shop', Emin continued to explore esoteric practices through rituals held at her public space, the Tracey Emin Museum. In an unpublished interview, Emin reveals how she would get drunk at night, blindfold herself and allow images and text to come to her, recording these impressions on paper without interfering with the automatic process she employed. Though we have no images from this period, the process was responsible for her twilight vision of her friend Suleyman (who had been dead for three years), which Emin recorded in scrawled handwriting and published completely unedited at the back of the catalogue for 'I Need Art Like I Need God'. Emin described to me another ritual where she would get drunk and 'imagine' the faces of all the dead people she had known, blindly drawing her mental images and sometimes even 'feeling someone hold her hand'. These drawings reveal a process analogous to the automatic writings and spirit drawings commonly made by mediums during the 1850s and 1860s while in a state of trance or sleep, induced through voluntary hypnosis. Such evidence was often shown to visitors and sitters at a medium's home in order to demonstrate psychic abilities. Some of these drawings were regarded by Victorian critics as being 'high art', particularly those made during the 1860s and 1870s by Georgiana Houghton. As medium-cum-artist, Houghton, the 'Holy Symbolist', gained a degree of notoriety for her abstract images which in 1865 were accepted at the Royal Academy and then exhibited in 1871 at the New British Gallery in Old Bond Street.[19] However, Houghton's public recognition proved short-lived, prompting several historians to argue that her images have been denied their historical position in the canon of transcendental art, and suggest that they may have informed the work of Kandinsky, Mondrian and Frantisek Kupka.

Tom Gibbons has established that Houghton's 1871 exhibition is mentioned in Madame Blavatsky's *Isis Unveiled* of 1888, the seminal text that explained the theories of the Theosophy movement. Furthermore, Gibbons argues, Houghton's abstract images may have been the models for John Varley Jr, who illustrated *Thought Forms*, 1905, by Annie Besant and Charles W. Leadbeater, the second-generation leaders of Theosophy. The abstract images contained in the book are widely accepted to have been formative for Kandinsky's and Mondrian's theories and spiritual abstractions.[20]

These performative 'acts' of clairvoyance and works involving psychic processes in Emin's early oeuvre may appear inconsequential, or merely an ironic, postmodern play on ideas of the occult, but there is significant evidence to counter such scepticism. Although in contemporary culture mysticism has become equated with the occult and the esoteric, for some it remains an area of formal philosophical and historical inquiry, as it was in the late nineteenth and early twentieth centuries. It is the latter that finds specific expression in Emin's work. The historian of comparative religion Hal Bridges defines mysticism as the 'selfless, direct, transcendent, unitive experience of God or ultimate reality, and the experient's interpretation of the experience'.[21] In an interview with Mark Gisborne, Emin answered his question of why her works do not 'look' religious thus: 'I am not religious in terms of being christened or whatever; I don't believe in that kind of thing... I like the idea of all things connecting.' 'Pantheism?' Gisborne asked. 'Yes... So when you think about the world and its structure and everything, all things connect.'[22] The pantheist experient, often discussed in the mystical writings of the German Romantics and Symbolists, is someone who 'regards the oneness that characterizes mystical experience as the ultimate reality', and that 'ultimate reality may be denoted as God, the One, Brahma, nirvana', depending on the mystic's specific culture.[23]

After Emin's second abortion, in 1992, she destroyed all the work she had made at the Royal College of Art, dismissing the importance of making art through a monumental acknowledgment that her creative ability died with the loss of her foetus. Instead of pursuing her artistic career, Emin took a job as a tutor of young

adults with Southwark Council. It was then, as she subsequently noted in an interview, that she attended a philosophy course at Birkbeck College. 'And suddenly my brain, it was like doing exercises in a gym and your muscles waking up. It was brilliant.'[24] However, it took a while for such brilliance to ferment and materialize, as Emin made no art that embodied these philosophical concerns until after she had opened 'The Shop' with Lucas in 1993. Emin's enlarged philosophical preoccupations were nicely summarized in a joint installation made with Lucas, *From Army to Armani*, 1993, shown at the Galerie Analix in Geneva. This ephemeral work featured two director-style chairs around a table covered by a coloured umbrella, their backs draped with black T-shirts stencilled in white 'God is Dad' and 'Nietzsche is Dead'. Two large-scale photographs showing Emin and Lucas standing in front of their shop were mounted on the wall behind the installation, providing evidence to confirm that, yes, it was at this site where they, the 'experients', contemplated the metaphysical and interpreted their existential experience.[25] Although it conceals her renewed concern with the spiritual beneath a glib surface, *From Army to Armani* attests to the importance of Emin's philosophical studies, including her interest in the writings of Spinoza, the Dutch philosopher whose theories questioned the Calvinist notion of God's materiality. Central to the formulation of Romantic pantheistic thought, Spinoza's ideas were recognized by Nietzsche as being fundamental in the formation of his own notions of the self. Thus, the installation not only examines the history of questions concerning the eternal spirit, it also makes a larger statement about the commodification of spirituality. In the century after Nietzsche's death, the development of a capitalistic culture could make art act as a commodity. Moreover, with God being present in all creation – even Dad – the backs of souvenir T-shirts could act as pulpits for a pantheistic belief through mass-marketed slogans.

These seemingly disparate interests in mysticism and Spinoza's treatises are clarified in pieces Emin made during her first tour of America with the curator Carl Freedman. Works included a photographic essay made by Freedman of Emin reading her treatise *Exploration of the Soul*, 1994, in seven different locations from San Francisco to New York. The number seven is significant in mystical

teachings, including Theosophy, Spiritualism and numerology, representing the seven stages of evolution of the consciousness to reach eternal enlightenment. The photographic series *Journey across America*, 1994, narrates the journey of both Emin's body and soul; it travels through time from her birth as a twin up to the present. These photographs reveal that Emin's readings were ritualistically made from her talismanic 'Grandmum's chair', which featured in *There's Alot of Money in Chairs*, 1994 (**48**). The upholstered armchair, appliquéd with pithy sayings from her beloved grandparent, serves as a 'message' from her relative. Emin inherits the psychometrically endowed seat from a line of three generations of female visionaries empowered with wisdom from worlds beyond. Emin's message is supported by nature as she sits under the infinite expanse of the North American sky. In the role of the itinerant clairvoyant, Emin 'caravaned' across the country, stopping at various galleries with her 'psychometric' chair – a performance that symbolized an endeavour to save the lost soul of the art world. Ironically, the chair, while it remained a locus of this performance, assumed its own talismanic properties for Emin's career. Sustaining the family tradition, her grandmother's chair not only made Emin some money from her 'readings', but most significantly it indicated a fast-growing status with the art world with its arrival at White Cube as installed object for her first solo exhibition in London, 'My Major Retrospective'. This form of readymade was followed three years later by another work, a Ouija board table with assembled chairs, entitled *Tacimin – Can You Hear Me?*, 1997 (**49**). In its first incarnation this work used a card table which had been given to Emin by her grandmother. Knowing this, we might speculate that *Tacimin* reinforces the notion that psychic ability is often a gift or talent bestowed from birth and that there is a matriarchal genealogy of clairvoyance.

There's Alot of Money in Chairs marks a significant point in Emin's career where her physical presence within the work expands her philosophical discourse on the nature of the self according to mystical precepts. Perhaps no work so capitalizes on the notion of ritual as circumscribed by presence as *Everyone I Have Ever Slept With 1963–1995*, 1995 (**6**). A modified blue camping tent for two, it featured 103 names of all the people Emin had slept with, including her aborted children, her brother and

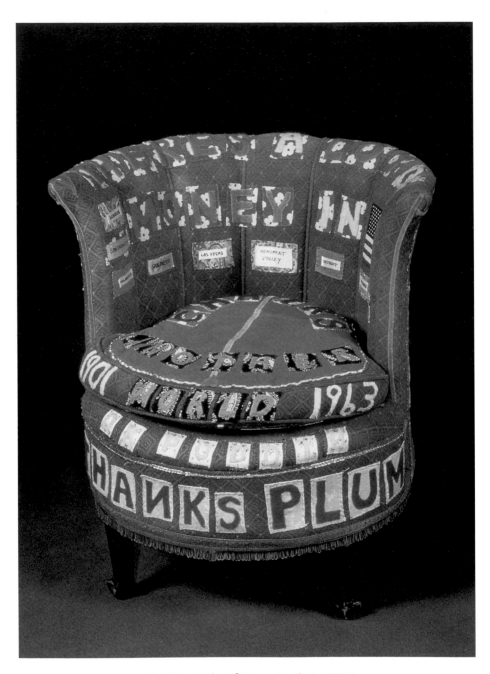

48 *There's Alot of Money in Chairs*, 1994
Appliqué armchair
69 x 53.5 x 49.5cm (27$\frac{1}{8}$ x 21 x 19$\frac{1}{2}$in)

49 *Tacimin – Can You Hear Me?*, 1997
table and chairs
dimensions variable

the poet Billy Childish, appliquéd within the interior. Considered by many as her breakthrough work, it was first exhibited in 1995 at the South London Gallery in 'Minky Manky', a show which featured among others Damien Hirst, Mat Collishaw, Sarah Lucas and Gary Hume. In the catalogue, Carl Freedman critically framed the yBa circle of significance: '"Minky Manky" is about life, both in the profound sense in that it deals with fundamental questions of existence... Indirectly, it is also an investigation into the phenomena of the artist, and presents the artist as an expressing subject, which rejects the idea of the death of the author.'[26]

Everyone I Have Ever Slept With, which lists Emin's sexual partners as if on a scorecard, is usually interpreted as a work that plays into a culture of public confession and voyeurism. However, such a view ignores the names of the platonic partners that appear, which suggest that there are elements of the work that examine the complex nature of intimacy associated with the ritual of sharing a bed. One issue overlooked in the prevailing interpretation is the work's spirituality, which was obviously missed by curators when it was reinstalled in America in 1995 for the 'Brilliant: New Art from London' exhibition at the Walker Art Center in Minneapolis. Emin noted: 'My requirements for the tent were that it be installed in a place where there was no sound, because it is a quiet, contemplative piece. They installed it in between two sound pieces. I thought if this is the way Americans are, I don't want to be here.'[27] By disregarding her directions, the museum curators prioritized the loud confessional aspects over the work's solitary qualities – a privatized site for contemplation.[28] This curatorial decision also ignored the historical precedents that informed the work's form and function. As Emin has repeatedly stated, her idea was derived from a Tibetan tent she had seen at an exhibition while working in her own 'museum', located near the Imperial War Museum.[29] The Tibetan tent is a site of ritualistic and contemplative action, where nomadic Buddhists seek solitude for meditative thought. Emin's tent was also to be a travelling shelter for her performances and, mirroring its Tibetan model's use, was supposed to roam to different galleries, reinforcing concepts first introduced by her grandmother's chair.

To understand the issues of sexuality within the tent requires more than just

reading the 'writing on the wall' by a 'bad girl': it involves an engagement with a complex philosophy concerning the nature of sex. *Everyone I Have Ever Slept With* is not just a site denoting orgasms scored but also one in which one travels to another place in time through the experience of sex. Emin's tent reflects a common belief within contemporary mystical thought that ascribes to sexual relations a meaning of cosmic proportions. Mystical thinkers and pantheists alike consider sex a perfect moment of unity, suspended outside of time and space, and think of it as a means of exploring the fourth dimension. The significance of the act lies outside the materiality of bodies and the physical pleasure of sex.[30]

Linda Dalrymple Henderson suggests that the notion of another dimension was first introduced in 1904 by Claude Bragdon in discussing the works of the Belgian Symbolist Maurice Maeterlinck, and 'put in motion certain mystical themes that became central to early twentieth-century discussions of a fourth dimension'.[31] If we recognize Emin's concern with sexuality as invoking a pantheistic experience of the fourth dimension, one can further understand her adoption of the guise of the Symbolist artist. Given Emin's interests in mysticism, it is unsurprising that she was attracted to the works of Edvard Munch from a very young age, acknowledging him as one of her most important aesthetic influences.[32] Munch was exposed to mysticism when he moved to Berlin in 1892, hopeful of finding international recognition and instead finding himself amid some of the most influential European thinkers of the time. As Carla Lathe has noted, Munch's opening exhibition at the Verein Berliner Kunstler in September 1892 caused a scandal, and his work was embraced by a group of radical literati and dissident artists who debated and wrote on topics such as Satanism, Spiritualism and Theosophy.[33] August Strindberg and other avant-garde writers, such as the Swedish critic Ola Hansson, the German critic Franz Servaes and Stanislaw Pryzbyszewski, frequently met to discuss their interests in mysticism, the occult and Nietzschian philosophy at the bar Zum Schwarzen Ferkel, and became Munch's closest friends in Berlin until his departure in 1903. Pryzbyszewski, a medical student at the time, formulated his own theories regarding 'synaesthesia', hypothesizing that brain vibrations could create projections between two minds. 'Thought waves' could create invisible bridges between two people, he

proposed.[34] Ola Hansson introduced Munch to Nietzsche's writing, emphasizing his call for an art that would produce a 'Rausch'[35] or frenzy, and eventually Munch became an admirer of the philosopher as well as a beneficiary of Elisabeth Forster-Nietzsche's patronage.[36] In addition, Munch accepted Emanuel Swedenborg's theories regarding auras, which he believed could be seen around people, and re-affirmed such ideas by reading related texts, including *Spiritualism and Animism*, 1890, by Aleksandr Aksakov.[37] So closely aligned was Munch with these mystical thinkers that he is known to have exhibited several paintings, including *The Kiss* and *The Scream*, at the studio of Hilma af Klint. A Swedish portrait painter who discovered abstraction through the writings of Blavatsky, Besant and Leadbeater, Klint established a female Spiritualist group. Under the direction of spirit guides and with the aid of a psychographic recorder, the women experimented with auto-matic drawing as a means of artistic expression.[38] As Bernard Smith notes, Theosophy, Spiritualism and anthroposophy were integral to the formulation of the modernist aesthetic during the early twentieth century, especially in Germany, Russia and Vienna.[39]

186

During this time, although Munch was associated with a bohemian, atheist milieu, some scholars have argued that he never completely denied his religious upbringing, trying to balance the claims of faith and freedom in his life and art. Munch was a known pantheist, a belief that he would often express in his writings. 'Everything is movement and light. God is in us and we are in God, God is in everything. In us are whole worlds.'[40] The lithograph *Madonna*, 1895, assimilates these ideals: it depicts a female figure raising her arms above her head in an ecstatic gesture, while a decorative border of swimming sperm surrounds her. In a colour woodcut, *Encounter in Space*, 1899, a red man and green woman meld together and float on an undefined, abstracted black background where large spermatozoa swim around their unified forms.[41] As Pat Berman has argued, these images show a 'merging of sacred and sexual themes', which was of central concern to Munch during the 1890s as he examined 'sexual love' as a cosmic act in another dimension that he believed linked 'thousands of generations' of human procreation.[42]

There are several ways in which Emin's writings, reputation and public image mirror Munch's, including her intimate sibling relationship, her descriptions of childhood as defined by illness, and a highly personalized art enacted through techniques of seemingly 'authentic' confessional expression. The introspective Munch turned to diaries for their almost 'therapeutic function', then published them later in life as the means by which others could decipher 'the meaning' of his paintings.[43] His published writings contain passages that seem to have influenced Emin's writings, especially in *Exploration of the Soul*. Reflecting on the importance of his painting *Dance of Life*, 1899, from Copenhagen in 1908 after his nervous breakdown, Munch remarked, 'I who came into the World sick/ into a sick environment/ whose Youth was a hospital room'[44] and later, in the romanticized style that was fashionable in Symbolist circles, that 'Sickness, insanity, and death were the malevolent angels that... have followed me through my life ever since.'[45] This exemplifies what Berman has identified as a common literary trope in the wake of Baudelaire and Nietzsche's *Birth of Tragedy*, 1872, where sickness of body and mind was made emblematic of artistic genius. In *Exploration of the Soul*, Emin utilizes similar tropes as she recalls her life as shaped by childhood sickness, as plagued by what the artist describes as 'neurotic ramblings'. She starts her narrative with the beginnings of her and her brother's lives in hospital, writing that 'When I was born – they thought I was dead', and therefore 'They put me into a little glass box.' Later she confesses that 'As a baby I wanted to die... my soul had been floating along when somehow a giant hook – had pulled me down from the sky – one moment free – the next – a creature of this world.'[46]

The most obvious means by which Emin fashions herself and her work in the tradition of male modernist artists such as Munch is by creating an oeuvre of personal confession, situating her life and body as its source, its corpus. Munch's work is often discussed in terms of his biography, especially his magnum opus *The Frieze of Life*, an installation that included *The Voice*, 1893, *The Vampire*, 1893, *The Scream*, 1893, and other paintings, which he first showed in 1893 and exhibited in various arrangements until the late 1920s. This work in particular has been subject to interpretation as a reflection of Munch's struggles with the deaths of his

mother and favourite sister while a teenager, the trauma associated with unrequited love affairs, his 'madman' reputation within conservative art circles, and his struggle with alcoholism. Arne Eggum romanticizes Munch's persona by claiming that, of all the modernist artists, 'none developed such a unique "private" symbolism with a deliberative use of their own traumatic experiences as Munch did. He had the courage to soberly display his own life for observation, renouncing all self-pity, a display of temperament that, profoundly speaking, became his life philosophy.'[47] As Sander Gilman has argued, Munch consciously created connections between his life, creativity and wayward social image in his diaries and literary notebooks, some of which were explicitly intended for public consumption.[47] Eggum's appraisal of Munch is not so remote from the headlines that surrounded Emin's initial success. She has titled herself 'Mad Tracey from Margate', her experiences appliquéd into history by her own hand in the blanket *Mad Tracey from Margate. Everyone's Been There*, 1997 (**50**). Critics have even speculated that Emin staged her drunken exit from a live television discussion between leading critics during a Turner Prize Award show in 1997. Emin clearly takes a cue from Munch's tumultuous life, making the 'story' of her life into a narrative art of which the tabloids cannot get enough, and which Emin continues to exploit through her advertising appearances. In a video entitled *Tracey Emin's CV. Cunt Vernacular*, 1997 (**42**), Emin visually catalogues every detail of her apartment while reciting her entire life story in the manner of a résumé. The viewer is exposed to all the particulars of Emin's life, from the intimacies of her rumpled bed to the trash in her bathroom, becoming a voyeuristic witness of the stuff of her life, which is paramount to her art. Where Emin carefully manipulates Munch's art of personal confession is in her inversion of its gender. For the life of the male 'genius' she substitutes the experiences of a woman artist, her successful career regaled in a first-person female voice.

Emin not only redefines Munch's public persona, rhetoric and confessional style, she also redraws his aesthetic, which vacillated from Romantic Symbolism to raw Expressionism. Munch's early style was nurtured by the radical Hans Jaeger. Munch's attachment to Jaeger is cited by Övind Storm Bjerke as a rebellion against his father's rigid thinking and proscriptive lifestyle.[49] Jaeger demanded that

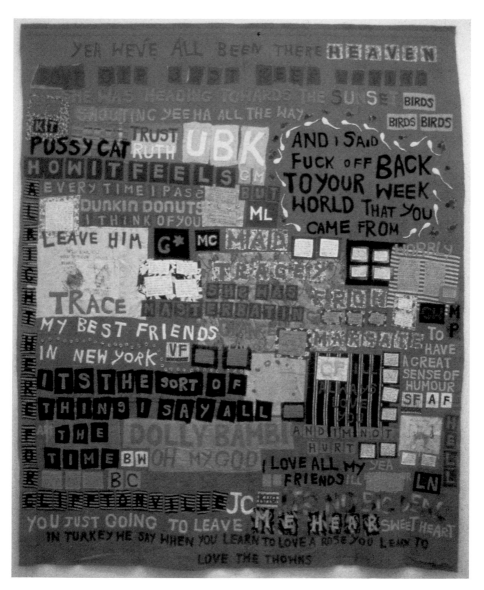

50 *Mad Tracey from Margate. Everyone's Been There*, 1997
appliqué blanket fabric from clothing provided by friends
215 x 267cm (84½ x 105⅛in)

intellectuals and artists break away from bourgeois ideas by abandoning their genteel lives, denying their roots and rewriting their lives, which were to end in suicide, the ultimate denial. Jaeger called for an aesthetic that used naturalism not to reproduce or imitate nature, but to portray human reality by adapting one's personal experience to it. Thus, one's private life was the raw material from which an artist was to create, which convinced Munch that 'All art, literature and music must be brought forth with your heart's blood. Art is your heart's blood.'[50] As a consequence, both Munch's literary and artistic creations emphasized the importance of expression through a symbolic incorporation of blood in the colour red and images of death. Munch maintained this aesthetic ideal throughout his life and cogently demonstrated it in *Self-portrait*, 1898, a woodcut he made for the German periodical *Quickborn* to be published with an image of Strindberg. Munch depicts himself as the suffering artist, with one arm above his head in a grand gesture of anguish while his other hand grabs at his heart, blood pouring forth to nourish a flower in the ground. Gerd Woll has remarked that Munch often compared himself to a woman, who through her ability to conceive and create a child plays a central role in the cycle of both life and the universe.[51]

Emin situates herself within this discourse of creativity, birth and sacrifice in numerous works and performative statements. Certainly the way she talks about the ceremonial destruction of all of the works she made between 1990 and 1992, following an abortion, echoes with a similar sentiment. In one interview, she stated: 'I couldn't go on doing art unless it meant something to me emotionally... so I began making things out of bits of me.'[52] Her 1999 exhibition at Lehmann Maupin, entitled 'Every Part of Me's Bleeding', is a monumental statement to this effect. The complete installation was focused upon her now infamous *My Bed*, 1998 (**36**), and included watercolours, videos, neon-scripted statements, cloth appliqués and blankets, monoprints and readymades, which formulated a unified statement looking backwards to Munch's discourse on creative powers. Hung on the wall was one of her signature appliqué blankets. Entitled *Psyco Slut*, 1999 (**39**), it employed what might be understood as Munch's cosmic sperm swimming next to the cut-out statement 'Oh TRACE', echoing the orgasmic moan of a lover. Other works, such as

51 *The History of Painting*, 1999
mixed media
dimensions variable
Galerie Gebauer, Berlin, 2000

The first time I was pregnant I started to crochet the baby a shawl, 1990–2000 (**38**) (an unfinished baby's shawl encased in Plexiglas), and *The History of Painting*, 1999 (**51**), in which a tableau of three pregnancy-test kits, morning-after pills and used tampons was assembled in five cases, allowed Emin to reassert her own ability to create an art more authentic than Munch's painting. Thus, her own blood replaces Munch's pigment, and endows it with reality rather than symbolic value. Emin trumps the ideals of modern aesthetics as defined by the male artist. Moreover, blood held magical properties within the discourse of Theosophy. In *Isis Unveiled* Blavatsky claims that blood is the first incarnation of the universal fluid and 'contains all the mysterious secrets of existence'.[53] With this installation, Emin not only reclaimed procreative power from the male modernist artist, she also relocated its discourse from one historically defined by Munch's male literary circle to the female psychic circle of Theosophy.

Two of the video works featured on a continuous loop during 'Every Part of Me's Bleeding' further support Emin's strategy of reconfiguring modernism's imagination as a pantheistic site of creativity. *How It Feels*, 1996 (**45**), is a twenty-four-minute recording of Emin, dressed in a dark suit, answering a litany of questions posed off-camera. The film opens on the steps of a church. A sign behind Emin's head ironically assures us that 'Art Is Therapy', as she gives her interpretation of the way in which her first abortion was mishandled by medical practitioners. At first she was denied permission for the procedure, delaying it for six weeks, after which doctors ineffectively terminated the foetus. Emin admits to the interviewer that, in having an abortion, she also lost control over her own procreative rights and thus 'the essence of creativity'. Her ability to make this experience of loss into a material work displayed in the confines of a New York gallery is the means by which she inverts metaphor. No longer concerned with symbolic gestures based on intellectual principles, Emin emphasizes the empirical weight of authentic experience and rewrites Munch's notion of articulating personal history within Expressionist painting.

Perhaps no work acknowledges Emin's conscious debt to Munch's mystical works and ideals more profoundly than her one-minute video work *Homage to*

Edvard Munch and all My Dead Children, 1998 (**44**). Filmed in Norway on the docks near Munch's studio, it served as the finale to a continuous loop of videos at Lehmann Maupin. Often mislabelled *The Scream*, after Munch's canonical painting, the video captures Emin curled face-down, lit from above.[54] The camera tilts down the side of the dock, recording light reflecting off the water's surface, twinkling in a random pattern, while the viewer's equanimity is broken by Emin's scream. The wailing continues as the camera tilts upwards to the dark sky, the glimmering water evanescing into a blinding oval in the shape of a distorted sunspot. The video ends with a full-screen shot of the sun, an image reminiscent of those in Leadbeater and Besant's *Thought Forms*. The pain of Munch's scream, its expression no longer limited to the silence of pigment and colour, is rendered real, its veracity confirmed through Emin's personal experience. Furthermore, Emin makes esoteric Theo-sophist teachings visible by recording the transformation of matter. In *The Ancient Wisdom*, 1897, Besant charts the transformation of the basic chemical elements through 'etheric stages', which begins with the most solid form – physical matter – and ends in the fourth form – an image of oval energy.[55] Allegorically, Emin's video charts the journey of the universal soul from the material depths of the woman's womb to the metaphysical heights of the sky.

193

Though some critics, as well as Emin herself, might question this rewriting of Munch's spiritualism as not purely feminist, Emin's work is neither fixedly polemi-cal nor simply 'pure'.[56] However, as Alex Owen has shown, Victorian women who participated in Spiritualism were not consciously enacting a feminist programme; their agreement to 'play' the role of the medium, whether authentic or fraudulent, was voluntary and, more importantly, resisted dominant constructions of femin-inity.[57] A similar strategy of resistance consistently manifests itself in Emin's work from her early career to the present, finding its expression in a wide variety of media. With Emin's rearticulation of the visual and rhetorical techniques of Edvard Munch through her own soul and body, his avant-garde spiritual works and principles that were representative of modernist intellectual thought are recast. Art history is Emin's portal to aesthetic power and her vessel is the modernist artist. What better medium to actualize her voice than by adopting the style of Munch's Expressionism?

By bringing into her possession this modernist idiom, Emin reclaims the voice of Victorian parlour culture, largely articulated by the female mystic for her own exploration, and thereby elevates it to the centre of postmodern aesthetics.

INTERVIEW WITH TRACEY EMIN

JEAN WAINWRIGHT

J W At Maidstone College of Art you studied for your BA in printmaking. You've spoken in the past about being in love with that prolific printmaker Edward Munch and many of the other Expressionists. You talked almost in religious terms of touching Munch's bed and the presence of the artist. What was it about Munch that engaged you?

T E There were two things going on there. I wasn't very well grounded in art history, I had very little understanding of it. I don't even think that I really knew what the Renaissance was until after I had finished my degree. I was quite blink-ered and not very interested in very much that was 'art' – but I was interested in things that would connect to me. Of course, the Expressionists in a certain way were almost naïve, guttural workers. They thought with their stomach basically. So I could relate to that, because everything was just so obvious, it was easy to under-stand. But the thing with Munch, though – there were a lot of artists that I liked at that time, and copied for want of a better word – I still carried on liking his work. If I had a Munch painting I would still want it on my wall. I wouldn't look back at it and think 'that was what I used to like when I was twenty'. I think that Munch was sophisticated because he used emotion in art, but not in an illustrative way. In *The Scream* he is actually painting sound and this is quite a radical idea for that time, quite a conceptual idea and also to actually paint jealousy is a completely different way of understanding art. My engagement with Munch was about where he took his influences from, ancient Egypt or mummified bodies. There is more to it than just the obvious connections.

J W Another artist you have mentioned in relation to your work is Egon Schiele.

T E Yeah, I really like his drawings, he is brilliant at drawing, fantastic. Not so good

195

at painting – illustrative when it comes to paint. He was only twenty-eight when he died and it would have been interesting to have seen what would have happened if he had carried on. He was incredibly influenced by other people, especially Klimt, but then he was really young.

J W In some of his drawings such as *Self-portrait Masturbating*, 1911, don't you think there are sexual references that link to your work?

T E In that work Schiele looks like an embarrassing mime artist. Expressionism as a whole is slightly embarrassing, isn't it? It is about putting your heart on your sleeve. Some of the works are really bad and really awful and really naïve and the worst elements of painting, but some are incredibly sophisticated. Much depends on the individual artists.

J W Are there other artists that have influenced you or you feel that are powerful or provoke you?

T E Loads – like Bruce Nauman, Frida Kahlo, Van Eyck, Vermeer and Jackson Pollock. There are a couple of Rothkos that I wouldn't mind owning. It's a really mixed-up, diverse taste, it's not what people would naturally think it was. I think all the artists I have mentioned are quite sexy.

J W Are you connecting with that sexuality?

T E No, the energy maybe.

J W And the angst in the work. But not in Vermeer, though?

T E Vermeer is really fantastic because of the way he uses narrative. I would like to turn a Vermeer painting into a film, it would make a really brilliant film, and it's just so obvious. It speaks lots, it talks. Vermeer paintings actually talk. It's not like Symbolism: you can imagine what happened afterwards and what happened just before, and when you look at the painting you wonder what is going to happen next.

J W I want to press you about your homages to particular artists. When you made your Stockholm work in 1996, you credited Carl Freedman with saying 'paint what you would like to own'.

T E That really got me thinking. I did a Schiele, I did a Picasso and three versions of *The Scream*. When I did the Picasso though, it was quite funny, I realized how much I resented and didn't like Picasso. It was only after I had done the painting

that I realized that. As I did the paintings it made me think about the artists and how they lived and worked. I thought that Picasso was this great genius, this great artist and great man, yet he treated women disgustingly. And I realized how easy it is to get somewhere in life if you decide just to dismiss half of humankind. You just dismiss women and treat them like objects and use them at your disposal, like a Mormon polygamist.

J W What was the artistic revelation?

T E I started off really thinking 'Picasso, a really good painter' but I was having dialogues with myself the whole time that I was doing the paintings. So, for example, when I was doing the Yves Kleins – which were great fun and I think everyone should do them – I thought Yves Klein was a really cool person, fantastically cool, sexy, brilliant, tragedy that he died so young, so wonderful, but when I actually completed an Yves Klein, after I'd rolled across the canvas, standing up I thought, 'I wish Yves Klein was here to tell me what to do next.'

J W You wanted him there in his role as artistic director?

T E Because he was the director, and as I rolled I realized that the bodies in his paintings leave a fantastic shape, but mine looked as if I had been shot up the arse or something. It was just so comical.

J W That's interesting because you were in the position of reliving the experience of being Klein's model without his presence.

T E You might think that Klein was being sexist by using those models like that, but actually it was something remarkable. Those women were not 'muses', they were dancers, and he was like a choreographer and there was a fantastic skill involved. Whereas Picasso, you have a sixteen-year-old girl, you sit her down, you paint her, you shag her, then on with the next one. It's fodder, fodder. He apparently had great relationships with his muses, so we read in history, but no thank you.

J W When you made the Yves Klein it was a very physical process, but how did you create the aesthetic with Picasso?

T E I ended up painting the whole canvas black apart from the vagina, this pink vagina, and I wrote something on the back of it like 'Fuck off, Picasso'. But I still enjoyed the process of working and thinking with him. Picasso's works are

fantastic, but I suddenly realized what a sexist he was. Like Matisse, of course he painted beautiful pictures, but what the fuck else did he do in his life?

J W You didn't think about doing a de Kooning woman?

T E Who should I have done that I didn't do? I didn't do a Jackson Pollock actually, but the room was in enough of a mess as it was! If I had done Jackson Pollock it would have been like... I was sleeping in there. It would have been out of order.

J W You said that you found your time in Stockholm quite cathartic, both by being the artist creating but also because of the voyeuristic nature of the gallery space, the dialogue you were having with the artist and the model.

T E It was a very clever set-up and I never got proper credit for it. The photos were called *The Life Model Goes Mad*.

J W Were you conscious of people looking at you, inside the panopticon of the portholes? Did you feel you had to perform?

T E I was just me, Tracey. I had to do the work. I knew when I was doing the Yves Klein and they [the audience] didn't know I was going to do it. I heard a stampede across the gallery and 'she's doing an Yves Klein!' – all these people fighting to get at the portholes, it was funny. I was so stupid. I could have done that piece in America or in Germany or London, and I was so worthy. Oh no, I did not want it to be sensational at all. I wanted this to be about the 'project' and being naked wouldn't be a big deal in Scandinavia. It did get on the television and in the papers and on the radio. But if I had done it in England it would have been in the *Sun* and the *Mirror* and the queues would have been going round the block. I should have done it with Jay [Jopling] or with a proper project space. But thinking it through now I didn't want people I knew looking through the holes, because I would have been performing then, wouldn't I? It was about being stripped and it could have been about being vulnerable but actually it wasn't, it became about the ego and about the strength of the ego. The strength of my failures are all amalgamated together. It was called *Exorcism of the Last Painting I Ever Made* because it was for me to get rid of them, plus the fact that painting for me was completely moribund: it was completely bound up with failure. Failure – painting, painting – failure: two things joined together which I wanted to separate, because I quite liked painting.

I'm not a good painter, but I knew that if I felt like doing some paintings, I should do them and not hold myself back and say, 'I can't paint' or something like that. My Nan had just died as well, so I was very upset and I needed to sort that out in my head, and I was afraid of the dark and I also detested my body, so there were quite a few things that I wanted to get out of the way.

J W What was it like being in the empty gallery at night?

T E I am petrified of the dark and also I am petrified of sleeping alone, that kind of thing, so yeah, I was in this big building on my own, it was weird. I was locked in and I had a key to go out onto the landing to where the toilets were and my biggest fear was locking myself out of the gallery. Also it was fifteen degrees below freezing outside so it was really cold. I just wish I hadn't done it with that gallery and done it with people with some balls, who could have appreciated how brilliant it was. There it was a mistake.

J W Maybe it could be revisited in a different way.

T E I would just do paintings now; I've done that bit now, haven't I?

199

J W You have cited other works as being equally cathartic for you. I'm thinking of *Why I Never Became a Dancer*, 1995 (**5**), where you were revealing your personal history and *Tracey Emin's CV. Cunt Vernacular*, 1997 (**42**).

T E When I get asked what my favourite piece of work is I often say *Why I Never Became a Dancer*, because it is a nifty little film, although it is about things that are pretty awful. But I like it, it's good, it's pretty, and it makes Margate look really good as well.

J W You often say that when you present Margate it is through your memory as a child and the bleached-out postcard.

T E Yes, that bleached-out look. I think I had my camera on the wrong light setting but it really works. With my *Tracey Emin's CV. Cunt Vernacular*, I'd like to re-edit that now but I can't because it's sold to the Tate. I'd like to get rid of some of the images and swap them over for others because some look more meaningful than they should be. It's because the camera has dwelled on them for too long. It's a bit like my tent, though [*Everyone I Have Ever Slept With 1963–1995*, 1995 (**6**)]. Oh god, I'd like to get rid of some of the names in that tent.

J W The videos you have made are consistently personal, even something like *I Don't Think So*, 2000 (**43**).

T E Some people don't get that film at all.

J W It's quite painful and I guess that the sense of loss that pervades the film can't be treated as ironic in any way.

T E I don't think I will be having a baby, but if I did I don't think I would be lying there letting it cry, so it is this mad mixture.

J W It's raw like one of your prints.

T E I think it looks like a painting. I've done a couple of films which I think look like paintings. The one where I am talking to my mum [*Conversation With My Mum*, 2001] is like a Vermeer painting, it is set up like that, two women having a dialogue at a table, but then it's like my paintings at the Royal College, bad paintings as they were.

J W Printmaking has been a consistent medium for you since Maidstone.

T E I started with monoprints, also woodcuts and screenprints. It was much more expressionist then. I love the magic of doing everything in reverse, and the viscosity of the ink, getting it right and the fact that it takes me two minutes to do a drawing. It's exciting, it's not laboured and I never know what it's going to look like until I turn the page over. What people don't understand is that I have to do the writing backwards.

J W Because people say that you must be profoundly dyslexic?

T E And people say that it is very pretentious – 'her dyslexia' – but I am actually writing very quickly backwards. That is why I might get a D back to front.

J W Your mistakes often are very provocative such as 'Fuck off back to your week world you came from' [a panel in *Mad Tracey from Margate. Everyone's Been There*, 1997 (**50**)].

T E It's good because I did spell 'weak' wrong, so it's 'go back to your tiny world' and something comes out automatically when I have spelled it that way. Sometimes with my work it's like 'hasn't she learnt to spell by now?' Well, I didn't know how to spell before. I'm not dyslexic, I just never learned to spell. It is not a pretentious thing. What is pretentious is I did this blanket [*Garden of Horror*, 1998 (**52**)] and I

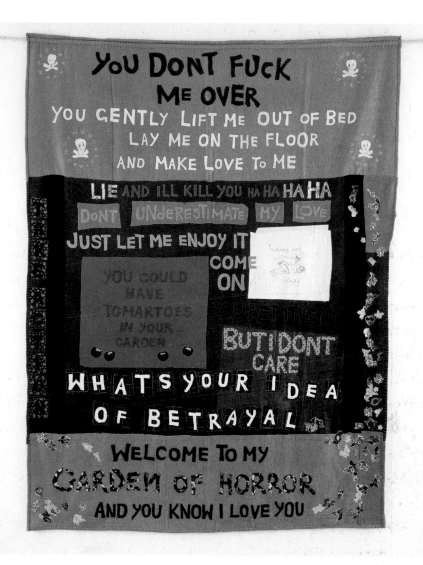

52 *Garden of Horror*, 1998
appliqué blanket
264 x 195.6cm (103¹⁵/₁₆ x 77in)

spelt tomatoes wrong as 'tomartoes'. I had this blanket on the floor of my museum, and I was working on it and people would point at the spelling, and I corrected it and it didn't look good. It threw the whole sentence out of balance. Another one was *Pysco Slut*, 1999 (**39**). I spelled it 'Pysco' and I had no idea I had written it wrongly, and of course I didn't do it on purpose. I try to put the right word down, but if I don't know it I don't care.

J W You often cross things out and re-edit your work.

T E Crossing things out, especially with the blankets, is visually satisfying, and also I might have sewn all the letters on and then change my mind, and if you unpick them all it's time-consuming. It's much better to cross it out for people to see what was there before.

J W You seem quite happy to work with various different media, swapping between them and understanding the physical nature of the approaches.

T E Lots of artists can't do it, they can be a brilliant painter but they go to make a film and they can't, or they could be really good with concrete and they work with wood and it's awful. It's lucky for me. Anything I want to work in, I just go off and do it.

J W I wanted to talk about your latest concerns with sculpture including *Self-portrait*, 2001 (**frontispiece**), the work you produced for your recent White Cube[2] exhibition and your references to Tatlin's *Model for the Monument to the Third International*, 1919.

T E I think with the 'helter-skelter' that there is not much to say. It's just so obvious and the more people talk about it the less it becomes. I think that in twenty years' time people will think that was quite good.

J W There was also your sculpture *Poor Thing (Sarah and Tracey)*, 2001.

T E That was quite complicated. That was for me and Sarah [Lucas] because it was for two women, but originally I thought about calling it mother and daughter. Then I thought that was too much, especially as my mum was really ill. I knew I wanted the Evian bottle, and I thought about me and Sarah and all our drinking and then it reminded me of a piece of Sarah's work. Me and Sarah worked together for six months, and you know how you get inside someone's head. I was really pleased with that work. There was also a drawing in the White Cube[2] show called *Poor Love* [1999] (**53**),

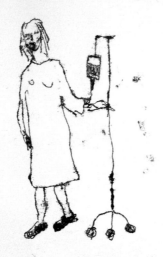

53 *Poor Love*, 1999
monoprint
29.7 x 42cm (11^{11}/$_{16}$ x 16^{1}/$_{2}$in)

where you have the hospital drip – that comes from one of my abortions. It went wrong, I had to have a scrape. I was in a ward with lots of old ladies for some bizarre reason, who had all had hysterectomies and when I got up to have breakfast I was still attached to a drip. I was walking past the long thin breakfast table and they were all eating boiled eggs, and they all went, 'Oh, poor love.' I thought they meant because I had the drip, but it was because the back of my gown was completely saturated with blood and I didn't know, I had no idea. I used a real hospital gown for the *Poor Thing* sculpture, which is what I wore in hospital when I had a really bad kidney infection, I nicked it from the hospital. The other object was the straitjacket. I sewed it by hand. The idea of making your own straitjacket is quite funny and it actually does work. I put it on and Mat [Collishaw] tied me up in it, and I couldn't get out. I thought of making a film of busting my way out of this straitjacket, but I had sewed it so much you couldn't escape.

J W So you were working on both the experience and the restriction. Was that a metaphor for how you felt?

T E Well, at certain times in my life I have felt that I should be restricted, I'm 'dangerous', and it was to do with that. The water bottle was to do with cleansing and not drinking spirits. I have to be really careful not to make work that looked like Louise Bourgeois's, because it would be just so easy for me. But also I have to remember that Louise Bourgeois does not have carte blanche on dangly, hanging, sewn things.

J W What is the difference for you working with sculpture from your work with the appliquéd blankets?

T E Well, I think that after I have done ten more sculptures then people will get the hang of it. When I first did the neon work people said, 'How can she go from sewing? We want a blanket, not a neon.' Now they are going, 'We want a neon', and there aren't any more neons, I am not making any more for a while – and it's like, I don't do many photographs but when I do people say, 'I didn't want a photograph', they wanted something sewn, and now they go, 'Oh, there are no photographs.' But it will catch up. I personally see no difference in it. I would like to spend more time sewing the blankets. I find it hard – it's so time-consuming it does my head in.

I would like to spend more time doing things myself. I would like to be more hands-on. I'd love to say to people that I am going to be away for a month, tell everyone I've gone away and I'd be here working. But even when I have gone away I still need to get to a fax machine and email and a telephone, so it still makes no difference.

J W The way that you have always worked is to take materials that you have had around you, letters, ephemera, and physically turned them into work. One object that was very personal was the white blanket that you urinated on [*I Think it Must Have Been Fear*, 2000 (**34**)].

T E That was my favourite blanket. When the White Cube² show was opening, I wanted to go away to LA for a month, for personal reasons, and I was still physically having to take the bad taste from the Turner Prize. I wanted to make a piece of work but I thought, 'They are all going to jump on me and slag me off again', and I thought, 'I don't want to be there, I don't want that kind of attention.' But the white blanket was something that I was already working on and the point was it didn't photograph well. When I wandered into White Cube² and I didn't have my glasses on, it just looked like a white wall to me, totally white, and also with that show some space was needed. I didn't just use white fabric, I reversed things and turned them inside out, and when you look at it closely there are lots of different colours in it. Because I didn't think that I was going to show it, I worked on it slowly, and then I had to finish it in two weeks from ten in the morning to five in the morning and I don't know how I did it. I just worked on it solidly and that is why part of it is slightly mad.

205

J W It also engages with other artists who have worked with urine, but yours is very female, the little girl wetting the bed.

T E It was really stupid things, like I always wanted to make a film of having a shit, I wanted to be walking along a beach and then do a poo and bury it. I have never done it and I never will, it's just an idea, you don't have to do it. Like using bodily fluids, you have to draw a line between what works as a metaphor and what doesn't, what is actually real and what isn't, and it is important. Telling the story of making the film is much better than making the film.

J W Some of the blankets have so much detail in them. I'm thinking, for example, of *Mad Tracey from Margate. Everyone's Been There*, 1997 (**50**), which was made from clothing provided by your friends.

T E These blankets excite me, but they are weaker graphically. The one I did in the church [for Art in Sacred Spaces, 2000] was scruffy and mad. I was using eight-year-old kids and they didn't know how to sew, because when do kids have time to be taught that kind of thing, and we had to sew it on by machine.

J W Telling stories, as you did with *Exploration of the Soul*, has also been an important part of your work.

T E I don't do that anymore. I did the thing at the British Museum ['An Evening with Tracey Emin', May 2001] and I was really ill and Gemma, my assistant, came round with Night Nurse, Day Nurse, and my tan was peeling and I was rubbing all this oil in and suddenly my voice was better, and then I went on stage and I was fine.

J W You seemed very at ease making work on stage.

T E I had thought about it a lot and I knew I had to entertain people for two hours and it is my favourite of all the talks I have ever done. The reason I don't do actual readings any more or performance like that, is that I got really drunk and did one at Camberwell art week. It was terrible and I was really pissed, and I don't know why I did it. I did it for the wrong reasons because I didn't want to be a cow. It was horrible and I resented it badly. It's too much work, and I'm not appreciated and I've done that now. It's like I did 'The Shop' with Sarah, I've just done all that now. The British Museum was different, it was talking about Cleopatra and it was funny.

J W Of course, there is the whole discussion of being Tracey Emin and waking up and being a celebrity.

T E Well, I was going to sell my house and I thought, 'Oh, fucking hell, I don't want people walking round my house, and if they say, "Can we take some photos?" I am going to have to say no.' I needed a plumber the other week, and I thought I don't know if I want someone I don't know in my house, that whole thing.

J W So when you wake up in the morning now...

T E I have to remember, I don't think any differently, and also I have to remember

that when I am on the Tube that a complete stranger will come up to me and start talking about my work and that this is going to happen nearly every Tube journey. Or if I'm in a restaurant someone will want to come up and shake my hand. I mustn't think it is not going to happen because it does.

JW I wanted to talk about the cult of personality and your interest in Warhol's films and superstars such as Edie Sedgwick.

TE The Warhol films of Edie are really hardcore, frighteningly real. They are shocking because they are so real. It's like the Big Brother house, what Warhol was doing, playing people off against each other. When I was fourteen or fifteen I wanted to go on a cruise ship and go to New York and get off and be met by Andy Warhol. I knew very little about Warhol or art but I thought it would be a good thing to do. You know when you have daydreams, don't ask me why.

JW You have never had any urge to work in the way that Warhol did with his films?

TE I wouldn't use other people in that way, but what he does is very different.

JW Perhaps the nearest you came to Warhol in terms of a filmic performance was the Channel Four discussion 'Is Painting Dead?' where you walked off the programme.

TE I couldn't watch it for six months and yet what I was saying was profound: 'Are people really watching this?'

JW I'm not sure who was. You cut though the whole tired critique in that programme.

TE I didn't know I had done it, I was off my face. I was too drunk. I told Channel Four I was too drunk, and the next thing I knew I was at the Atlantic with my friends. I got to the party in short time because there was a limo waiting for me. I was only on the show for about fifteen minutes before I left.

JW What about your fashion connection with Vivienne Westwood? You became a model for her.

TE I like the association. It's sexy, it's cool... Well, it is not cool. Actually Vivienne is not cool, it's good. I did the advertising campaign for Westwood, and if I am charging around in Westwood clothes it is because they suit me. Westwood also used my drawings for some of their advertising campaigns, it's a symbiotic thing.

J W Has it made you regard yourself differently, Tracey Emin as a celebrity?

T E Only in England really, though. I went to Paris last week and it doesn't happen there. But as soon as I'm in a Eurostar queue it starts happening.

J W Do you find that strange, the whole notion of celebrity and aura and how it translates?

T E Well, I went to a massive art dinner in Paris and we arrived really late and we were put on any old table, and we noticed the people at our table were press people with big cameras. Previously to that they had been stalking people they wanted to photograph, and we were sitting there the whole time. In London it would be unbearable.

J W Your family has been used in your work, in your tent for example, and you have said that because of your fame you are really aware of the implications of using them.

T E In the video of my mother she was totally aware that she was being filmed for an artwork and she says, 'You're not going to put that in, are you?'

J W You have also worked with your father. There is the moment in *Emin & Emin*, 1997, where you say, 'I love you, daddy.' It is very poignant.

T E I made that film in 1996. My dad is eighty so he is going to die soon, and I am going to have all these films of him. People often don't make art of things that they want themselves. They sit around and think, 'What can I do as an art ideal for a film?' My film in Monument Valley is bit like a photobooth machine where you can have whatever you want in the background. With that photo of me reading my book [*Outside Myself (Monument Valley)*, 1994 (3)], I've got Monument Valley in the background, it's what I would like to have. It's the same with the films of my dad, I would like to keep these and preserve them. At the moment I would like to really spend some concentrated time making things for myself.

J W Don't you feel you have been making things for yourself?

T E It's more like 'make hay while the sun shines'. I don't mean financially, I mean if I have the ability to do the idea it's like 'make it now' because I might dry up in six months' time, and I might not feel like making it and that happens to me sometimes. I would like to make some things really for me, like the curtains I designed for my new house. I really would have liked to have made them, but I had to get my

208

friend to make them. I don't have time to do that kind of thing.

J W Something we haven't discussed is *My Bed*, 1998, and the criticism of it that 'anyone could have done it' and the public controversy it aroused.

T E But they haven't done it. It was a shame about the Turner Prize when it got over-criticized and people didn't really see it for what it was. I always saw it as a damsel fainting, going 'Aahhhh'. When I showed it in Japan it looked beautiful, because you saw it in long view before you saw it close up, and it became disgust- ing and dirty and there was supposed to be something that happened to the viewer when they saw it. What happened at the Tate, by the time they saw it, they knew what they were going to be looking at, so it lost that frisson. But I was pleased that Charles Saatchi bought it and it became like an icon, as opposed to a sculpture. I didn't want to sell it, I wanted to keep it for myself. It is just a mattress and all the objects actually fitted into one dustbin bag.

J W Why did you want to keep it?

T E I wanted to keep it as a pension and I thought if I could keep this large sculp- 209
ture it would be a really good thing to bring out when I was older.

J W Can we talk about your interest in philosophy?

T E I have always liked philosophy, and to put my head in someone else's mind. I quite enjoyed the mental gymnastics and I liked Spinoza and then I liked Nietzsche as well, although they are poles apart, but Spinoza as a theorist, it's really beautiful, it's lovely.

J W And why Nietzsche?

T E It's like reading pornography, because in a way you think 'and when the ham- mer strikes' and all that. When you are feeling weak it's like a self-help manual. Spinoza I like because of all the invisible lines connecting and I've always believed in that. It's a pity that he was so religious, but then it's a shame that Nietzsche wasn't. We take what we want and need, you don't have to take the whole lock, stock and barrel.

J W 'I need art like I need God' seems like one of your most enduring statements. Do you still think that's true?

T E It would be if I didn't have art, but as I have art I just take it for granted.

NOTES

INTRODUCTION
pp. 6–21

1 P. Schjeldahl, 'Edvard Munch: The Missing Master' (1979), in *The Hydrogen Jukebox* (Berkeley: University of California Press, 1991), p. 21.
2 Ibid., p. 22.
3 H. Foster, *The Return of the Real* (Cambridge, Mass.: M.I.T. Press, 1996).
4 J. Stallabrass, *High Art Lite* (London: Verso, 1999).
5 P. McCartney, 'Helter Skelter' (1968). The modified lyrics are from the version recorded by Siouxsie and the Banshees on their album *The Scream* (1978).

CHAPTER 1
pp. 22–39

1 The quotation is taken from an interview with Tracey Emin by John Humphrys in 'On the Ropes', BBC Radio Four, 24 July 2001.
2 For example, David Lee attacked the dominance of conceptual art, which he likened to a new 'State Academy of Contemporary Art' (*New Statesman*, 4 July 1997), while, conversely, Sheila Jeffreys condemned the young British artists as 'Thatcher's children' lacking in any real political commitment (*Guardian*, 19 April 1997).
3 A. Huyssen, 'Mass Culture as Women: Modernism's Other', in *After the Great Divide: Modernism, Mass Culture and Postmodernism* (London: Macmillan, 1986).
4 J. Roberts, 'Mad for It! Philistinism, the Everyday and the New British Art', *Third Text*, 35, 1996, p. 30.
5 Ibid., p. 29.
6 Ibid., p. 30.
7 Ibid., p. 38.
8 M. Collings, *Blimey! From Bohemia to Britpop: The London Art World from Francis Bacon to Damien Hirst* (Cambridge: 21 Publishing Ltd, 1997), p. 110.
9 S. Sontag, *On Photography* (Penguin: Harmondworth, 1978), p. 154.
10 'On the Ropes'.
11 Emin discussed the cathartic nature of her art as a way of dealing with her past in an interview with Melvin Bragg: 'The South Bank Show', ITV, 26 August 2001.
12 L. Marcus, 'The Face of Autobiography', in Julia Swindells (ed.), *The Uses of Autobiography* (London: Taylor and Francis, 1992), p. 16.
13 A. Kuhn, *Family Secrets: Acts of Memory and Imagination* (London: Verso, 1995), p. 103.
14 This was most evident in Emin's now notorious drunken appearance in a Channel Four discussion following the Turner Prize award in 1997, when she disrupted the proceedings.
15 See J. Spence, *Putting Myself in the Picture: A Political, Personal and Photographic Autobiography* (London: Camden Press, 1986), and *Cultural Sniping: The Art of Transgression* (London: Routledge, 1999); C. Steedman, *Landscape for a Good Woman* (London: Virago, 1999); V. Walkerdine, 'Behind the Painted Smile', in P. Holland and J. Spence (eds), *Family Snaps: The Meaning of Domestic Photography* (London: Virago, 1992); and Kuhn, *Family Secrets*.
16 P. Smithard, 'Grabbing the Phallus by the Balls: Recent Art by Women', *Everything*, 21, 1997, p. 8.
17 J. Smith, 'What's the Problem with Women?', *Guardian*, 20 February 1998, p. 2.
18 Marcus, 'Face of Autobiography', p. 13.
19 W. Januszczak, review of 'You Forgot to Kiss my Soul', *The Sunday Times*, 6 May 2001.
20 Claire Macdonald, 'Assumed Identities: Feminism, Autobiography and Performance Art', in Swindells, *Uses of Autobiography*, pp. 188–9.
21 Ibid., p. 190.
22 The relationship of Emin's work to the feminist practices of American artists such as Judy Chicago and Faith Wilding is discussed by Smithard, 'Grabbing the Phallus', pp. 5–9. Here I focus on Emin's links to artists working in Britain in the late 1970s and early 1980s.
23 *Issue: Social Strategies by Women Artists* (London: Institute of Contemporary Arts, 1980), n.p.
24 For detailed documentation of feminist exhibitions held in London in the early 1980s and their reception, see R. Parker and G. Pollock (eds), *Framing Feminism: Art and*

the Women's Movement 1970–1985 (London: Pandora Press, 1987), pp. 185–260.
25 'South Bank Show'.
26 R. Parker, *The Subversive Stitch: Embroidery and the Making of the Feminine* (London: The Women's Press, 1984), p. 208.
27 K. Deepwell, 'Bad Girls? Feminist Identity Politics in the 1990s', in J. Steyn (ed.), *Other than Identity: The Subject, Politics and Art* (Manchester: Manchester University Press, 1997), p. 56.
28 There has been a re-evaluation of feminist artworks of the 1970s that challenges the former view of its essentialism, most notably in A. Jones (ed.), *Sexual Politics: Judy Chicago's 'Dinner Party' in Feminist Art History* (Berkeley: University of California Press, 1996).
29 J. Beckett, 'History (Maybe)', in *History. The Mag Collection: Image-Based Art in Britain in the Late Twentieth Century* (Kingston upon Hull City Museums, Art Galleries & Archives, 1997).
30 Imelda Whelhan discusses the relation of younger women to feminism in *Overloaded: Popular Culture and the Future of Feminism* (London: The Women's Press, 2000).
31 Parker, *Subversive Stitch*.

CHAPTER 2
pp. 40–59

I am grateful to Stella Sandford and Francis Mulhern for critical comments on draft versions of this essay.
1 Collings, *Blimey!*, pp. 118–19.
2 Stallabrass, *High Art Lite*, pp. 36–43, 48.
3 Ibid., pp. 2, 46, 43, 39.
4 F. Schlegel, 'Concerning the Essence of Critique' (1804), in J. Schulte Sasse et al (eds), *Theory as Practice: A Critical Anthology of Early German Romantic Writings* (Minneapolis: University of Minnesota Press, 1997), pp. 268–77; W. Benjamin, 'The Concept of [Art] Criticism in German Romanticism' (1920), in *Selected Writings, Vol. 1: 1913–1926*, edited by M. Bullock and M.W. Jennings (Cambridge, Mass.: Harvard University Press, 1996), pp. 116–200.
5 See P. Osborne, *Philosophy in Cultural Theory* (London: Routledge, 2000), ch. 2: 'Sign and Image'. The *menstrum universale* was an imagined liquid capable of dissolving all solids – an ultimate goal for medieval alchemists, second only to turning base metals into gold.

6 P. Bourdieu, *The Rules of Art* (1992; Stanford: Stanford University Press, 1996); N. Luhmann, *Art as a Social System* (Stanford: Stanford University Press, 2000). It is an ironic effect of Bourdieu's positivism that its application to the historical constitution of 'art' as a distinct cultural field reinstates the discursive terms of philosophical Romanticism on positive historical grounds. Something similar occurs in Luhmann's systems-theoretic analysis, although more immanently connected to Romanticism as a philosophical tradition, via the concept of auto-poesis.
7 I use the term 'reflects' here in the triple sense of mirroring something, reflecting upon it and, most importantly, unfolding this process of reflection immanently, within the work, through the internal relations of its elements. This third sense conveys a distinctly artistic mode of reflection. For without this third sense – dependent on the paradoxical but central notion of the artwork as an object that is itself a quasi-subject of reflection – there is no art in the emphatic, distinctively modern sense. Cf. Benjamin, 'Criticism', p. 151. Ironically, in setting out merely to explain 'high art lite' (rather than interpret it), Stallabrass reproduces a theoretical variant of precisely that culturalism which he attacks in the works.
8 In his essay on Goethe's *Elective Affinities*, Benjamin distinguished between two different types or modes of writing about art, 'commentary' and 'criticism': 'Criticism seeks the truth content of a work of art; commentary, its material content.' That is, criticism includes a theoretical element by virtue of which the work is related to the philosophical concept of truth, via the Romantic notion of 'art', while commentary involves only the reconstruction of its empirical historical content. The two activities are, however, closely related. The critic begins with commentary and moves, via the 'systematic referability' of the work, towards criticism, which aspires 'to grasp the system absolutely' through the systematic intention of the individual work. (The intention of the work, note, not the artist. Intention and reflection are understood here as properties of the work itself.) Benjamin, 'Goethe's *Elective Affinities*' (1919–22), in *Selected Writings*, Vol. 1, p. 297.
9 M. Foucault, *The History of Sexuality:*

NOTES

An Introduction [The Will to Knowledge]
(London: Penguin, 1976), pp. 67–73. On more
recent explosions of sexual discourse see also
M. Merck, 'Introduction: In Your Face', in
In Your Face: Nine Sexual Studies (New York:
New York University Press, 2000).

10 S. Freud, 'On Transformations of Instinct
as Exemplified in Anal Eroticism' (1917), in
*Pelican Freud Library, Vol. 7: On Sexuality:
Three Essays on the Theory of Sexuality and
Other Works* (London: Penguin, 1977), p. 296.

11 See K. Marx, *Capital, Vol. 1: The Process of
Production of Capital* (1867; 1881; London:
Penguin, 1976), chs 3, 4. G.W.F. Hegel,
Phenomenology of Spirit (1807; Oxford:
Clarendon Press, 1977), ch. 4.

12 S. Freud, 'The History of an Infantile
Neurosis (The Wolf Man)', ch. 5: 'Anal
Eroticism and the Castration Complex',
in *Pelican Freud Library, Vol. 9: Case Histories II*
(1918 [1914]; London: Penguin, 1979), p. 322.

13 H. Marcuse, *Eros and Civilization:
A Philosophical Enquiry into Freud* (1956;
London: Ark Paperbacks, 1987), pp. 35–45.

14 J. Laplanche, 'Psychoanalysis as
Anti-Hermeneutics', *Radical Philosophy* 79,
Sept–Oct 1996, pp. 9–12. Cf. 'Dialogue
with Psychoanalysis', in Osborne, *Philosophy*,
pp. 113–18.

15 Stallabrass's claim (*High Art Lite*, p. 47)
that Emin's work is 'post-psychoanalytic' in
the sense that 'psychoanalysis is simply
ignored as irrelevant' – 'the passions and
anxieties' it displays, 'far from being the
product of repression, are the conscious
playing out of excess' – is as naïve about
psychoanalytic theory as it is about Emin.

16 T. Adorno, *Aesthetic Theory* (1970;
London: Athlone Press, 1997), pp. 225–8.

17 A. Bazin, 'The Ontology of the Photographic
Image' (1945), in *What Is Cinema?* (Berkeley:
University of California Press, 1967),
pp. 15–16. Cf. 'Sign and Image', in Osborne,
Philosophy, pp. 28, 46.

18 See J. Roberts, *The Art of Interruption: Realism,
Photography and the Everyday* (Manchester:
Manchester University Press, 1998).

CHAPTER 3
pp. 60–78

1 C. Baudelaire, 'Journaux intimes XIII:
Fusées no. 20', in *Oeuvres complètes*, vol. 1
(Paris: Gallimard, 1975), p. 662. *Poncif* in its
etymological origin can be translated as both
the perforated paper pattern used to transfer
a drawing onto a canvas or dressmaker's toile
(mid-sixteenth century) as well as an artistic
cliché or commonplace that is repeated
without any trace of originality (1820s).
The word *ponce*, from which *poncif* derives,
denotes (from around 1725) a special ink
made from oil and lampblack that was used
to mark and trace outlines on fabric. Here
we find the idea of the trademark, the special
expression to render a product instantly
recognizable. The fact that the *poncif* is a
means to reproduce identical copies of a
design indicates the significance of repetition.
Following Baudelaire and Benjamin, I have
chosen these latter coinages of the *poncif* for
its contemporary interpretation.

2 Edgar Degas, *Mary Cassatt in the Louvre*,
1880, pastel on paper, Philadelphia Museum
of Art.

3 See Tracey Emin, *Naked Photos – The Life
Model Goes Mad*, 1996. Documents of a
performance at the Galeri Andreas
Brändström, Stockholm.

4 Indeed, the pose in *Vogue* is a direct copy
of the Collishaw photo of Emin for the
Westwood ad.

5 W. Benjamin, 'Zentralpark', in *Gesammelte
Schriften*, vol. 1.2, p. 664; translated by
L. Spencer (with M. Harrington) as 'Central
Park', *New German Critique*, 34, winter 1985,
p. 37.

6 Westwood's logo, the orb that appears on
her labels and perfume bottles, is interesting
in this respect because it is most probably
adapted from the pattern of a tie which the
Surrealist Max Ernst wears in a photographic
portrait by Man Ray (*Surrealist Circles*, c. 1935).
Westwood therefore positions herself as a
latter-day Schiaparelli, a designer who uses
her connection to the fine-art world as pictorial
basis and cultural point of reference for her
extravagant and fantastic fashions.

7 Gustave Courbet, *Origine du monde*, 1866,
oil on canvas, Musée du Louvre, Paris.

8 See also Emin and Sarah Lucas, *From Army
to Armani*, 1993, a commodified Grand Tour
to Switzerland to upgrade their combat
fatigues to branded designer ensembles.

9 See Tracey Emin, *All I really wanted was for
you to make love to me*, 1983; *I use to have a good
imagination*, 1997; *All the Loving (Underwear
Box)*, 1997; *Blinding*, 2000; and *Fantasy Island*,

1998. One might even argue that the open tent in *Everyone I Have Ever Slept With, 1963–1995*, 1995, is a variation on the spread legs; a gesture à la Niki de Saint-Phalle where the viewer is asked to literally enter the artist's creative persona through a central parting in the sculptural object.
10 Gustave Courbet, *Atelier*, 1855, oil on canvas, Musée du Louvre, Paris.

CHAPTER 4
pp. 79–101

1 A. Comini, *Egon Schiele's Portraits* (Berkeley: University of California Press, 1974), p. 62.
2 A. Gide, *Journal, 1889–1939* (Paris: Librairie Gallimard, 1951), p. 41. My translation.
3 See, for example, D.206–D.213.
4 Cited in J. Kallir, *Egon Schiele: The Complete Works* (London: Thames & Hudson, 1990), p. 75. While Schiele may, *pace* Comini, have needed the income from the commision of pornographic drawings, we might compare D.800 to a strikingly similar and indeed more gynaecologically explicit drawing in pencil and crayon by Klimt, in the collection of the Neue Gallerie, New York, dated to 1913 – a point in the artist's career when he certainly didn't need the money – which indicates a more general delight by Viennese artists of the era in the subject of the sexually enraptured female.
5 Contrast D.948, where Schiele grasps his erect penis, with both D.947 and D.949, where it is obscured.
6 Comini, *Egon Schiele's Portraits*, p. 92.
7 P. Werkner, 'The Child-Woman and Hysteria: Images of the Female Body in the Art of Schiele, in Viennese Modernism, and Today', in P. Werkner (ed.), *Egon Schiele: Art, Sexuality and Viennese Modernism* (Palo Alto: Society for the Promotion of Science and Scholarship, 1994), p. 72.
8 S. Gilman, 'Male Stereotypes of Female Sexuality in Fin-de-Siècle Vienna', in *Difference and Pathology: Stereotypes of Sexuality, Race and Madness* (Ithaca: Cornell University Press, 1985), pp. 54–5.
9 S. Freud, *Three Essays on Sexuality* (1905), in *The Standard Edition of the Complete Psychological Works of Sigmund Freud. Vol. VII* (London: Hogarth Press, 1953), p. 191.
10 Ibid.
11 J. Carroy, 'L'hystérique, l'artiste et le savant',

in J. Clair (ed.), *L'âme au corps: Arts et sciences 1793–1993* (Paris: Editions de la Réunion des Musées Nationaux/Editions Gallimard, 1993), p. 446. My translation.
12 Ibid., p. 453. My translation.
13 See, *inter alia*, Werkner, 'Child-Woman and Hysteria'.
14 Comini, *Egon Schiele's Portraits*, p. 133.
15 E. Cadava, *Words of Light: Theses on the Photography of History* (Princeton, N.J.: Princeton University Press, 1997), p. 7.

CHAPTER 5
pp. 102–18

1 Held at the University in Baltimore, Maryland, in the spring of 1999. Participants included Lauren Berlant, Candace Vogler, Sharon Willis, Michael Moon and Robert Reid-Pharr, as well as graduate students and faculty at Johns Hopkins.
2 L. Bersani, 'Is the Rectum a Grave?' (1988), in D. Crimp (ed.), *AIDS Cultural Analysis/ Cultural Activism* (Cambridge, Mass.: M.I.T. Press, 1988), pp. 197–222.
3 Ibid., p. 218.
4 C. Vogler, 'Sex and Talk', in L. Berlant (ed.), *Intimacy* (Chicago: University of Chicago Press, 2000), p. 76.
5 Ibid., p. 78.
6 This is, in many ways, the basic insight of Eve Kosofsky Sedgwick's *Between Men* and *Epistemology of the Closet*. See also S. Hartmann, *Scenes of Subjection: Terror, Slavery, and Self-Making in Nineteenth-Century America* (Oxford: Oxford University Press, 1997), in which she explores the dependency of whiteness and white privilege on sexually charged spectacles of black abjection.
7 For more on this, see, for example, Kobena Mercer's essay 'Reading Racial Fetishism' in *Welcome to the Jungle: New Positions in Black Cultural Studies* (London: Routledge, 1994), pp. 171–220; and video artist Ming Yuen S. Ma's study of queer Asian subject positions in gay porn 'Slanted Vision' (itself a response to Richard Fung's work).
8 Bersani, 'Is the Rectum', p. 222.
9 Vogler's essay is about heterosexual men and women looking for non-expressive, depersonalized forms of intimacy in, respectively, sex and talk. Vogler, 'Sex and Talk', p. 49.
10 January 1861, letter from Rebecca Harding

Davis to Mrs Fields. University of Virginia Special Collections.

11 This is a subject I take up in 'Sex, Scandal, and Thomas Eakins's *The Gross Clinic*', *Representations*, Fall, 1999.

12 Peggy Phelan briefly discusses *Where Is Your Rupture?* in 'Andy Warhol: Performances of Death in America', in A. Jones and A. Stephenson (eds), *Performing the Body/ Performing the Text* (London: Routledge, 1999), pp. 223–36. She describes Warhol's work as pivoting around the tension between performance and the performative. She does not pursue that tension explicitly in relation to this work, but I take her implication to be that this is one of the dynamics described by these paintings.

13 I would contrast Emin's portraits of sex with the work of, for instance, Henry Miller. In Miller's novels, as Gore Vidal has written: 'Everyone he meets either likes or admires him, while not once in the course of *Sexus* does he fail in bed. Hour after hour, orgasm after orgasm, the great man goes about his priapic task.' Henry Miller puts fucking women at the centre of his work; his literary persona is derived from a mythic sexual genius (that drives women crazy). Vidal continues: 'For a man who boasts of writing nothing but the truth, I find it more than odd that not once in the course of a long narrative does anyone say, "Henry, you're full of shit."' G. Vidal, 'The *Sexus* of Henry Miller', in *Sexually Speaking* (San Francisco: Cleis Press, 1999), pp. 23–8.

14 M. Collings, 'Just How Big Are They?' (1998), in *Tracey Emin* (London: Jay Jopling/White Cube, 1998), pp. 58–9.

15 D. Bowie, 'Bowie on Emin', *Harper's Bazaar*, November 2001, pp. 195–6.

16 See, for instance, G. Bendel, 'Being Childish', *New Statesman*, 129:4493, 3 July 2000, p. 4. Bendel dismisses Emin as deriving her work from ex-lover Billy Childish. 'Too often, her art is like his – but diluted, made more palatable for the market.'

17 S. Smith and J. Watson, 'The Rumpled Bed of Autobiography: Extravagant Lives, Extravagant Questions', *Biography*, 24:1, winter 2001, pp. 1–14.

18 R. Schneider, *The Explicit Body in Performance* (London: Routledge, 1997), p. 38.

19 M. Fried, 'Art and Objecthood', in *Art and Objecthood* (Chicago: University of Chicago Press, 1998), pp. 148–72. A small but dedicated battery of scholars – Amelia Jones, Rebecca Schneider, Carol Mavor – theorize and correct this vacuum in writing on aesthetics. See A. Jones, 'Art History/Art Criticism: Performing Meaning', in Jones and Stephenson, *Performing*, pp. 39–55; Schneider, *Explicit Body*; C. Mavor, *Becoming: The Photographs of Clementina, Viscountess Hawarden* (Durham, N.C.: Duke University Press, 1999).

20 G. Spivak, 'Displacement and the Discourse of Woman', in N. Holland (ed.), *Feminist Interpretations of Jacques Derrida* (University Park, Pa.: Pennsylvania State Press, 1997), pp. 43–71.

21 Jones, 'Art History', p. 50.

CHAPTER 6
pp. 119–33

An earlier version of this essay appeared in *Women: A Cultural Review*, 11/3, 2000, pp. 252–61.

1 S. Kent, 'Tracey Emin Flying High', in *Tracey Emin*, p. 35.

2 S. Freud, 'On the Sexual Theories of Children' (1908), in *On Sexuality*, Pelican Freud Library, Vol. 7 (Harmondsworth: Penguin, 1977), pp. 198–200.

3 L. Bersani, *The Freudian Body* (New York: Columbia University Press, 1986), pp. 62–3.

4 Foster, *Return of the Real*, p. 168.

5 H. Molesworth, 'Before Bed', *October*, 63, winter 1993, pp. 71–9.

6 See J. Leggio, 'Robert Rauschenberg's *Bed* and the Symbolism of the Body', in J. Leggio and H.M. Franc (eds), *Essays on Assemblage* (New York: The Museum of Modern Art, 1992), pp. 79–117.

7 S. Morgan, 'The Story of I', *Frieze*, 34, May 1997, pp. 56–61.

8 F. Gibbons, 'Satirists Jump into Tracey's Bed', *Guardian*, 25 October 1999.

9 E. Benveniste, *Problems in General Linguistics* (Coral Gables, Fla.: University of Miami Press, 1971), pp. 217–38.

10 D. Paterson, 'Imperial', *God's Gift to Women* (London: Faber and Faber, 1997), p. 37.

11 M. Augé, *NonPlaces: Introduction to an Anthropology of Supermodernity* (1992; London: Verso, 1995), pp. 36–8.

12 W. Brown, *States of Injury: Power and Freedom in Late Modernity* (Princeton:

Princeton University Press, 1995), p. 69.
13 N. Walter, 'It's Time for Emin to Make her Bed and Move On', *Independent*, 25 October 1999.
14 Kent, 'Tracey Emin', p. 36.
15 Brown, *States*, p. 71.
16 Augé, *NonPlaces*, pp. 26–7.
17 P. Dodd and Z. Smith, 'Capital Gains', *Tate*, 21, 2000, p. 38.
18 R. Adin, 'The Entertainers', *The Sunday Times*, 'Culture' section, 28 May 2000, p. 5.
19 L. Grossberg, 'History, Imagination and the Politics of Belonging', in P. Gilroy, L. Grossberg and A. McRobbie (eds), *Without Guarantees* (London: Verso, 2000), p. 149.
20 S. Jeffries, 'Victoria's Values', *Guardian*, 'Friday Review' section, 11 August 2000, p. 3.
21 A. Billen, 'The Andrew Billen Interview', *Evening Standard*, 19 July 2000, p. 30.

CHAPTER 7
pp. 134–54

Thanks first to Joanne Morra, Craig Richardson and Mary Smith who kindly invited me to present an early version of this paper at the annual conference of the Association of Art Historians in 2001. My warmest thanks to Jane Beckett for her thoughtful comments and to MA students at Sussex for stimulating discussions. I'd especially like to thank Honey Luard and Sophie Grieg at White Cube, and Juliet Gray at Lehmann Maupin for their generosity in helping me to access material and for providing the images.
1 Miwon Kwon, 'One Place after Another: Notes on Site Specificity', in E. Suderberg (ed.), *Space, Site, Intervention: Situating Installation Art* (Minneapolis: University of Minnesota Press, 2000), pp. 52–3.
2 K. Mercer, 'Ethnicity and Internationality: New British Art and Diaspora-Based Blackness', *Third Text*, 49, winter 1999, pp. 53–5.
3 When *The Hut* was exhibited in the Saatchi Gallery's 'Ant Noises 2' exhibition, it was re-titled *The Last Thing I Said To You Is Don't Leave Me Here*, and interpreted as a weekend retreat for the artist and her boyfriend. G. De Cruz, *Ant Noises at the Saatchi Gallery 2* (London: Saatchi Gallery, 2000), n.p.
4 S. Spaid, 'Tracey Emin: Lehmann Maupin,

New York', *New Art Examiner*, 27:1, 1999, p. 56; R. Preece, 'Review of Tracey Emin, Lehmann Maupin, New York', *Sculpture*, 18:10, December 1999, p. 68.
5 C. Bagley, 'True Confessions', *W*, April 2001, p. 320.
6 R. Smith, 'Tracey Emin', *New York Times*, 11 June 1999, p. 11.
7 J. Avgikos, 'Tracey Emin: Lehmann Maupin, New York', *Artforum*, 38:2, October 1999, p. 139; *The New Yorker*, 31 May 1999.
8 G. Burn, 'Clever Tracey!', *Guardian*, 26 October 1999, pp. 2–3.
9 *News of the World*, 31 October 1999.
10 S. Wavell, 'In Bed with Tracey: At Least the Naughty Schoolgirls Liked It', *The Sunday Times*, 24 October 1999, p. 4; *Sunday Mirror*, 31 October 1999.
11 R. Cork, 'Art Mavericks Win Over the Sceptics, *The Times*, 29 November 1999, p. 42.
12 R. Rugoff, 'Screaming for Attention', *Financial Times*, 'Weekend' section, 20–1 November 1999, p. vii
13 R. Dorment, 'Pick Me I'm Tracey', *Daily Telegraph*, 20 October 1999.
14 Walter, 'It's Time'.
15 G. Pollock, 'Artists Mythologies and Media Genius', *Screen*, 21:3, 1980, pp. 57–96.
16 M. Maloney, 'Everyone a Winner! Selected British Art from the Saatchi Collection 1987–97', in B. Adams et al, *Sensation: Young British Artists from the Saatchi Collection* (London: Royal Academy of Arts and Thames and Hudson, 1997), p. 31.
17 Kent, 'Tracey Emin', p. 37.
18 Stallabrass, *High Art Lite*, pp. 17, 41–3.
19 Collings, *Blimey!*, p. 110.
20 M. Pointon, 'Savaged by Sewell', unpublished paper given at the Association of Art Historians annual conference, 2001.
21 Quoted in Burn, 'Clever Tracey!', p. 3.
22 The sobriquet comes from the 'Bad Girls' exhibitions at the ICA, London 1993 and New Museum of Contemporary Art, New York, 1994.
23 B. Tonkin, 'Profile: Confessions of a Tease: Hanif Kureshi', *Independent*, 23 October 1999.
24 D. Alberge, 'It's Not a Dirty Bed, It's a Turner Prize Entry', *The Times*, 20 October 1999, p. 14; 'The Information on the Turner Prize Exhibition', *Independent*, 27 October 1999.
25 N. Reynolds, 'Tate Warns that Soiled Bed May Offend', *Daily Telegraph*, 20 October 1999.

26 Brown, 'God, Art and Tracey Emin', in *Tracey Emin*, p. 4; Burn, 'Clever Tracey!', p. 2.
27 M. Merck, 'Bedtime', in this volume.
28 J. Derrida, 'Living On: Border Lines' (1979), in *A Derrida Reader*, ed. by P. Kamuf (London: Harvester, 1991), p. 256.
29 J. Derrida, 'Signature Event Context' (1972), in *A Derrida Reader*, pp. 82–111.
30 S. Kent, 'Bleeding Art', *Time Out*, 8–15 October 1999, p. 24.
31 See www.mad4real.com. E. Welsh, 'Mad for Real: An Escape into "Brit Art"', posted www.mad4real.com, 2001
32 Quoted in D. Kennedy, 'Feathers Fly after Tate Pillow Fight', *The Times*, 25 October 1999.
33 J.H. Reiss, *From Margin to Center: The Spaces of Installation Art* (Cambridge, Mass.: M.I.T. Press, 1999), p. xv.
34 Kent, 'Bleeding Art', p. 25.
35 Ibid., p. 24.
36 Saatchi Collection, London.
37 Arts Council Collection, London.
38 On the living conditions of asylum-seekers, see Refugee Council Asylum Briefing at www.gn.apc.org; 'ECRE Country Report, 1999', and other materials posted on the website of the European Commission on Refugees and Exiles, www.ecre.org; and www.asylumaid.org.uk. Although profound crises in Africa, Asia, Latin America and the Middle East have increased forced migration, only a minority of refugees seek asylum in Europe, the majority moving to neighbouring countries; nevertheless attacks on migrants to and refugees in Europe have increased. For Shelter, a British charity particularly concerned with homelessness, to be homeless is not just to sleep rough. Instead, the homeless are inclusively defined as having access only to temporary, inadequate or unsafe accommodation: see www.shelter.org.uk.
39 G. Bennington, 'Postal Politics and the Institution of Nation', in H. Bhabha (ed.), *Nation and Narration* (London: Routledge, 1990), pp. 121–37.
40 L. Himid, 'Beach House', in G. Pollock (ed.), *Generations and Geographies* (London: Routledge, 1996), pp. 149–55; L. Himid, *Beach House* (Rochdale: Rochdale Art Gallery, 1994); J. Beckett and D. Cherry, 'Clues to Events', in M. Bal and I. Boer, *The Point of Theory: Practices of Cultural Analysis* (Amsterdam: Amsterdam University Press, 1994), pp. 48–55.
41 P. Marfleet, 'Europe's Civilising Mission', in P. Cohen (ed.), *New Ethnicities: Old Racisms* (London: Zed Books, 1999), pp. 19–30; S. Collinson, *Shore to Shore: The Politics of Migration in Euro-Arab Relations* (London: Royal Institute of International Affairs, 1996).

CHAPTER 8
pp. 155–71

1 Modern Culture at the Gershwin Hotel, What People Are Saying About Tracey Emin, www.bway.net/~modcult/emin.html.
2 See page 219 of the present volume for a full list of Emin's video and film works.
3 S. Morrissey and S. Street, 'Everyday Is Like Sunday', from the album *Viva Hate* (1988).
4 M. Gisbourne, 'Life into Art', *Contemporary Visual Arts*, February 1999, p. 9.
5 Stallabrass, *High Art Lite*, p. 39.
6 R. Barthes, 'The Grain of the Voice' (1977), in S. Frith, A. Goodwin and L. Grossberg (eds), *Sound and Vision* (London: Routledge, 1993), p. 297.
7 A. Goodwin, 'Sample and Hold: Pop Music in the Digital Age of Reproduction', in Frith, Goodwin and Grossberg, *Sound and Vision*, pp. 258–74.
8 The Ambassadors, *We Love You*, CD and book (London: Booth-Clibborn, 1998).
9 T. de Lauretis, *Technologies of Gender: Essays on Theory, Film and Fiction* (London: Macmillan, 1987), p. 108.

CHAPTER 9
pp. 172–94

1 Morgan, 'Story of I', p. 56.
2 For an example of this hegemonic trajectory of art history, see M. Rosenthal, 'The Pioneers', in *Abstraction in the Twentieth Century: Total Risk, Freedom, Discipline* (Solomon R. Guggenheim Foundation: New York, 1996). For the few extant challenges to the history of spiritual art, see K.J. Regier (ed.), *The Spiritual Image in Modern Art* (London: Quest Books, 1987) and M. Tuchman (ed.) with J. Freeman, *The Spiritual in Art: Abstract Painting 1890–1985* (New York: Abbeville Press, 1985).
3 R. Smith, 'Tracey Emin'.
4 Tracey Emin, interview with Renée Vara, New York, 22 October 2001.
5 Morgan, 'Story of I', p. 58.
6 Ibid., p. 59.

7 M. Sawyer, 'Arty Spice', *Observer*, 'Life' supplement, 20 July 1997, p. 8.

8 Interview with Renée Vara. In studies of the esoteric, alchemy has a specific meaning. See Tuchman, *Spiritual*, p. 368.

9 Morgan, 'Story of I', p. 58. Emin explains in the interview: 'He was holding a Benson and Hedges packet just before he died. It looked like real gold. In my family when we die we are cremated and our ashes are thrown into the sea amongst the seagulls. I love seagulls. I'd like to be one.'

10 S. Corrigan, 'New Art Riot', *i-D*, 147, December 1995, p. 36.

11 Morgan, 'Story of I', p. 59.

12 R. Buchland, *Doors to Other Worlds: A Practical Guide to Communicating with Spirits* (St Paul, Minnesota: Llewellyn Publications, 1993). The book has gained such prominence in both American and British popular culture that it is now in its seventh reprint.

13 Ibid., p. 2.

14 Ibid., p. 4.

15 It is important to note that Spiritualism as denoted by a capital 'S' is recognized in historical and occult studies as different from 'spiritualism' because of its codified practices and thoughts.

16 See J. Hazelgrove, *Spiritualism and British Society between the Wars* (Manchester: Manchester University Press, 2000).

17 Unlike Compston – who was never financially successful – Emin proved to be a wise entrepreneur. When she opened 'The Shop' a year later with Sarah Lucas, she approached Stuart Evans, a well-known collector of contemporary art and partner in the law firm of Simmons & Simmons, for advice. His support and legal aid were paid for by barter, with Emin exchanging works such as *Outside Myself (Monument Valley)*, 1994, for his firm's services. Compston was a regular patron and he purchased the last item not consumed in Emin's ceremonial cremation of all her works when it closed two years later, his cheque remaining uncashed to this day. See J. Cooper, *No Fun without U* (London: Ellipsis, 2000), pp. 180, 190.

18 Ibid., p. 80. The inaugural fête was held on Saturday, 31 July 1993.

19 T. Gibbons, 'British Abstract Painting of the 1860s: The Spirit Drawings of Georgiana Houghton', *Modern Painters*, 1:2, spring 1988, p. 36.

20 Ibid., p. 37. For the original argument attesting such genealogy for spiritual abstraction, see S. Ringbom, 'Transcending the Visible: The Generation of the Abstract Pioneers', in Tuchman, *Spiritual*, pp. 130–63.

21 H. Bridges, *American Mysticism: From William James to Zen* (New York: Harper & Row, 1970), p. 4. See also pp. 375–7.

22 Gisborne, 'Life into Art', p. 34.

23 Tuchman, *Spiritual*, p. 376.

24 L. Barber, 'Show and Tell', *Observer*, magazine, 22 April 2001, p. 11.

25 Cooper, *No Fun*, p. 76.

26 Cited in ibid., p. 178.

27 J. Hogrefe, 'Tracey Emin: Totally Naked and Totally Vulnerable?', *New York Observer*, 10 May 1999, p. 29. Also see S. Morgan, N. Wakefield, R. Flood and D. Fogle, *Brilliant: New Art from London* (Minneapolis: Walker Art Center, 1995).

28 See L.A. Rickels (ed.), *Acting Out in Groups* (Minneapolis: University of Minnesota Press, 1999)

29 R. Gott, 'Sexual In-tent', *Guardian*, 'Weekend' section, 5 April 1997, p. 29.

30 P.G. Berman, *Munch and Women: Image and Myth* (Alexandria, Va.: Art Services International, 1997), p. 147. Berman discusses in the context of mysticism how K.G. Kobler's influential publication, *Ein neues Weltall*, saw the 'originary experience' as one 'suspended outside of time'.

31 L.D. Henderson, 'Mysticism, Romanticism, and the Fourth Dimension', in Tuchman, *Spiritual*, p. 219.

32 Interview with Renée Vara. Emin studied him intensely between the ages of eighteen and twenty-three.

33 See C. Lathe, 'Munch and Modernism 1892–1903', in M.-H. Wood (ed.), *Edvard Munch: The Frieze of Life* (London: National Gallery Publications, 1993), pp. 39–44. Also see Lathe's seminal study *Munch and his Literary Associates* (Norwich: Norwich City Art Gallery, 1979). As Lathe has documented, Munch's first exhibition at the Verein Berliner Kunstler in 1892, a conservative German association of academy painters, created a scandal that catalyzed the formation of a new group of dissident sculptors, architects, painters and engravers called the Freie Veriningung Berliner Kunstler. This caused a falling out of the Berlin Academy, and in 1893 three sympathetic

professors were charged by the press with being radical Secessionists, and asked to resign. This group of dissidents had formally regrouped under the leadership of Walter Leistikow by 1899 and became what is now recognized as the movement of the Berlin Secessionists. What this show represented was, according to Lathe, an attempt by 'the more radical members of the Association [who] probably hoped to provoke a confrontation, anticipating the contempt with which Munch's work would be received by their more conservative colleagues'. Lathe notes that this stunt by art radicals 'was recognized as a test case' and they were 'horrified' by the work's technique (or style) rather than its content, closing Munch's exhibition six days later.

34 Ibid., p. 42.

35 Ibid.

36 Tuchman, *Spiritual*, p. 14.

37 Henderson, 'Mysticism', p. 33.

38 B. Smith, *Modernism's History: A Study in Twentieth-Century Art and Ideas* (New Haven: Yale University Press, 1984), p. 70.

39 Ibid., pp. 65–93.

40 Ö. Storm Bjerke, *Edvard Munch and Harald Sohlberg: Landscapes of the Mind* (Oslo: Labyrinth Press, 1995), p. 21.

41 *Madonna*, 1895, lithograph (60 x 44.1cm [25 x 17in]). There are other versions of this image, including the colour woodcut and lithograph print (1895; 1902 printing), which were derived from the painting *Madonna*, 1889, which was central to his 'Frieze of Life' series. *Encounter in Space*, 1899, a colour woodcut printed in red, green and black (19 x 25.2cm [7 x 10in]). See Berman, *Munch and Women*. Cat. nos 19, 34, 118, 147.

42 Ibid., p. 118.

43 Bjerke, *Edvard Munch*, p. 32.

44 P. Hougen, *Edvard Munch and Henrik Ibsen* (Northfield, Minnesota: St Olaf College, 1978), pp. 41–2.

45 Berman, *Munch and Women*, p. 19.

46 'Tracey Emin, Exploration of the Soul', *Independent on Sunday*, 19 September 1999, p. 18. See also T. Emin, *Exploration of the Soul* (London: Tracey Emin, 1995).

47 A. Eggum, *Edvard Munch: Paintings, Sketches and Studies* (Oslo: J.M. Stenersens Forlag, 1984), p. 10.

48 S.L. Gilman, *Disease and Representation: Images of Illness from Madness to AIDS*

(Ithaca: Cornell University Press, 1985), pp. 217–38. Also see Berman, *Munch and Women*, p. 19.

49 Bjerke, *Edvard Munch*, p. 21. For more on Jaeger, see Lathe, *Munch*, pp. 4–7. Many of Jaeger's ideas are contained in his novel *From the Christiania Bohème*, 1885, from which Munch formulated many of his early ideas on the twisted nature of love.

50 Ibid.

51 G. Woll, 'The "Frieze of Life" Graphic Works', in Wood, *Edvard Munch*, p. 49.

52 W. Self, 'A Slave to Truth', *Independent on Sunday*, 21 February 1999, p. 8.

53 H.P. Blavatsky, *Isis Unveiled: A Master Key, II* (Pasadena, CA: Theosophical University Press, 1998), p. 567. The text states that 'The universal substance, with its double motion, is the great arcanum of being: blood is the great arcanum of life.'

54 Munch stated that the inspiration for *The Scream* was a poem and there are many critics and historians who consider him, much like Emin, as much of a poet as an artist. When *The Scream* was first published as a lithograph in *La Revue*, December 1895, it was to illustrate a poem.

55 See A. Besant, *The Ancient Wisdom: An Outline of Theosophical Teachings* (India: Theosophy Publishing House, 1939), pp. 50–1, plate 1.

56 For a cursory discussion of Emin as 'feminist' artist, see H. Reckitt and R. Phelan, *Art and Feminism* (London: Phaidon Press, 2001), p. 174. For a fuller debate see both Betterton and Healy in this volume.

57 A. Owen, 'Women and Nineteenth-Century Spiritualism: Strategies in the Subversion of Femininity', in J. Obelkevich (ed.), *Disciplines of Faith* (London: Routledge, 1987), pp. 130–53. See also Owen, *The Darkened Room: Women, Power and Spiritualism in Late Nineteenth-Century England* (London: Virago, 1989).

FILM AND VIDEO WORKS
BY TRACEY EMIN

Why I Never Became a Dancer
1995
Single-screen projection and sound, shot on
 Super 8
Duration: 6 mins, 40 secs

How It Feels
1996
Single-projection and sound, shot on Hi-8
Duration: 24 mins

Emin & Emin
Cyprus, 1996
Single-screen projection, shot on Super 8
Duration: 4 mins

Finding Gold
1996
Single-screen projection and sound, shot on
 Super 8
Duration: 2 mins, 40 secs

Tracey Emin's CV. Cunt Vernacular
1997
Single-screen projection and sound, shot on
 Mini-DV
Duration: 10 mins

Sperm
1997
Single-screen projection and sound, shot on
 Super 8
Duration: 3 mins

The Crystal Ship
1997
Single-screen projection and sound, shot on
 Mini-DV
Duration: 4 mins

*Homage to Edvard Munch
 and all My Dead Children*
1998
Single-screen projection and sound, shot on
 Super 8
Duration: 1 min, looped

Riding for a Fall
1998
Single-screen projection and sound, shot on
 Mini-DV
Duration: 3 mins, 30 secs

Reading Keys
1999
Single-screen projection and sound; shot on
 Mini-DV
Duration: 6 mins, 5 secs

The Hut
1999
Single-screen projection and sound, shot on
 Hi-8
Duration: 2 mins

The Interview
1999
Single-screen projection and sound, shot on
 Mini-DV; monitor, two chairs and two pairs
 of slippers
119.5 x 119.5 x 63.5cm (47 x 47 x 25in)
Duration: 16 mins

Love is a Strange Thing
2000
Single-screen projection and sound, shot on
 Mini-DV
Duration: 2 mins, 43 secs

I Don't Think So
2000
Single-screen projection and sound, shot on
 Mini-DV
Duration: 7 mins, 44 secs

*Sometimes the Dress is Worth More Money
 Than the Money*
2000–1
Single-screen projection and sound, shot on
 Mini-DV
Duration: 4 mins

(With Sarah Lucas)
Tracey Emin and Sarah Lucas Talk Shop
2001
Single-screen projection and sound, shot on
 Mini-DV
Duration: 16 mins, 16 secs

The Bailiff
2001
Wooden cabinet, DVD (shot on Mini-DV),
 monitor
261 x 82.5 x 91cm (102³/₄ x 32¹/₂ x 35¹³/₁₆in)
Duration: 4 mins, 43 secs

Conversation With My Mum
2001
Two children's chairs, DVD (shot on Mini-DV),
 TV and table
101 x 41 x 32cm (39³/₄ x 16³/₈ x 12⁵/₈in)
Duration: 33 mins

The Perfect Place to Grow
2001
Wooden birdhouse, DVD (shot on Super 8),
 monitor, trestle, plants, wooden ladder
261 x 82.5 x 162cm (102³/₄ x 32¹/₂ x 63³/₄in)
Duration: 2 mins

NOTES ON CONTRIBUTORS

Rosemary Betterton is Reader in Women's Studies, Institute for Women's Studies, Lancaster University. She is the editor of *Looking On: Images of Femininity in the Visual Arts and Media*, Pandora Press, 1987, and *An Intimate Distance: Women, Artists and the Body*, Routledge, 1996.

Peter Osborne is Professor of Modern European Philosophy and Tutor on the Postgraduate Programme in Aesthetics and Art Theory at Middlesex University. He is the author of *The Politics of Time*, 1995, *Philosophy in Cultural Theory*, 2000, and *Conceptual Art*, 2002. He is an editor of the journal *Radical Philosophy*.

Ulrich Lehmann is Senior Lecturer and Research Fellow at the Kent Institute of Art & Design. He writes and curates projects on the cultural and intellectual history of the nineteenth and twentieth centuries. Among his recent publications are *Tigersprung: Fashion in Modernity*, 2001, and *Chic Clicks: Creativity and Commerce in Contemporary Photography*, 2002.

Chris Townsend is Lecturer in the Department of Media Arts, Royal Holloway, University of London. He is the author of *Vile Bodies: Photography and the Crisis of Looking*, 1998, *A World at Random: The Art of Boyle Family*, 2002, and *Rapture: Art's Seduction by Fashion since 1970*, 2002.

Jennifer Doyle is Assistant Professor of English at the University of California at Riverside. She is co-editor of *Pop Out: Queer Warhol*, Duke University Press, 1996, and is author of 'Sex, Scandal, and Thomas Eakins's *The Gross Clinic*', *Representations*, Fall 1999. She is currently working on her first book, tentatively titled *Sex Objects*.

Mandy Merck is Professor of Media Arts and Director of the MA in Gender and Sexuality on Screen at Royal Holloway, University of London. Her most recent book is *In Your Face: Nine Sexual Studies*, 2000.

Deborah Cherry has published extensively on British art. She is currently completing *Living with the Dead: Reinventing the Victorians in the Twentieth Century* and co-editing a collection of essays entitled *Studio, Space and Sociality: New Narratives of Women Artists*. She is the editor of *Art History* and Professor of the History of Art at the University of Sussex.

Lorna Healy was Curator of Adult Learning at Tate Britain. She worked as an artist, arts broadcaster and critic, and was lecturer in Cultural Studies at the National College of Art and Design, Dublin. Lorna Healy died while this book was in preparation.

Renée N. Vara is an Adjunct Professor at NYU School of Art & Education and Continuing Education. She also serves as the National Fine Art Specialist for Private Collection Services for the Chubb Group. She has independently curated shows for the Hunter Art Gallery and John McEnroe gallery.

Jean Wainwright is completing a Ph.D at Wimbledon School of Art. A regular interviewer for Audio Arts, she has compiled a formidable dossier of interviews with many of the world's leading artists. Her writing has appeared in a number of leading art magazines including *HotShoe*, *Portfolio* and *Tate*. She is currently preparing a book on the Warhol sound archives.

ACKNOWLEDGMENTS

The publishers and authors would like to thank: Gemma, Tracey Emin's assistant; Honey Luard and Sophie Grieg at White Cube[2]; and David Maupin and Juliet Gray at Lehmann Maupin. Illustrations: Courtesy Jay Jopling/White Cube frontispiece, 3, 4, 5, 6, 7, 8, 10, 12, 13, 14, 15, 16, 17, 18, 19, 20, 21, 22, 23, 24, 27, 28, 29, 30, 31, 33, 34, 35, 39, 41, 42, 43, 44, 45, 46, 47, 48, 49, 50, 52, 53 (photos Stephen White frontispiece, 4, 6, 7, 10, 14, 15, 16, 17, 18, 19, 20, 21, 22, 23, 24, 27, 28, 29, 30, 31, 33, 34, 39, 46, 48, 49, 50, 52, 53; Masayuki Hayashi 35); Collection of William and Ruth True, Seattle. Courtesy of Lehmann Maupin, New York 2; © Vivienne Westwood (Tracey Emin & Vivienne Westwood) 1; © Donald Goddard/Courtesy Ronald Feldman Fine Arts, New York 9; © Gerhard Richter 11; Graphische Sammlung Albertina, Vienna 25; Private Collection. Courtesy of Andy Warhol Foundation for the Visual Arts/ARS, New York (2002) 26; Collection of the Saatchi Gallery, London. Courtesy of Lehmann Maupin, New York 36, 40; Isabella Prata and Idel Arcuschin Collection. Courtesy of Lehmann Maupin, New York 37; Courtesy of the Artist and Lehmann Maupin, New York 38; Courtesy Carlier/Gebauer, Berlin 51

INDEX